TESTIMONY

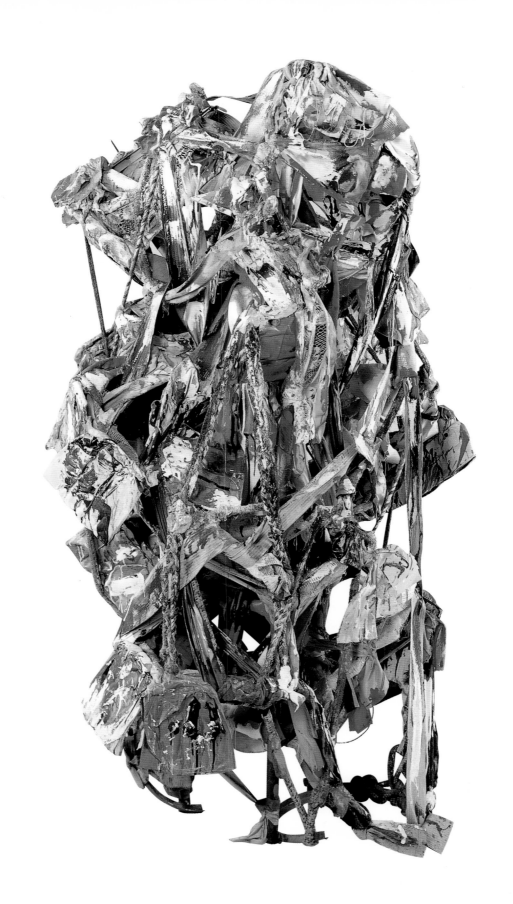

TESTIMONY
Vernacular Art of the African-American South

THE RONALD AND JUNE SHELP COLLECTION

Essays by

Kinshasha Conwill

Arthur C. Danto

Edmund Barry Gaither

Grey Gundaker

Judith M. McWillie

HARRY N. ABRAMS, INC., PUBLISHERS, IN ASSOCIATION WITH
EXHIBITIONS INTERNATIONAL AND THE SCHOMBURG CENTER FOR RESEARCH IN BLACK CULTURE

PROJECT MANAGER FOR
HARRY N. ABRAMS
Margaret Rennolds Chace

EDITOR
Elisa Urbanelli

DESIGNER
Ellen Nygaard Ford

PROJECT COORDINATOR FOR
EXHIBITIONS INTERNATIONAL
Osanna Urbay

EDITOR
Anne Hoy

Library of Congress Cataloging-in-Publication Data

Testimony : vernacular art of the African-American
south : the Ronald and June Shelp
collection / essays by Kinshasha Conwill ... [et al.].
 p. cm.
 Includes bibliographical references and index.
 ISBN 0-8109-4484-7
 1. African American art—Southern States—
Exhibitions. 2. Outsider art—Southern States—
Exhibition. 3. Art, American—20th century—Exhibitions.
4. Shelp, Ronald Kent—Art collections—Exhibitions.
5. Shelp, June—Art collections—Exhibitions. 6. Art—
Private collections—United States—Exhibitions. I.
Conwill, Kinshasha.

N6538.N5 T425 2001
704.03'96073075'07174171—dc21
 2001022407

This book was published in conjunction with the
exhibition "Testimony: Vernacular Art of the African-
American South," organized by The Schomburg
Center for Research in Black Culture of the New York
Public Library and Exhibitions International, New
York. This exhibition and book are made possible
in part by a generous grant from the Rockefeller
Foundation.

PARTICIPATING INSTITUTIONS

Kalamazoo Institute of Arts
Kalamazoo, MI
September 15–November 19, 2000

Columbia Museum and
Gibbes Planetarium
Columbia, SC
January 12–March 10, 2002

The AXA Gallery
New York, NY
April 25–July 11, 2002

Tubman African-American Museum
Macon, GA
October 1–December 9, 2002

Terrace Gallery, City of Orlando
Orlando, FL
November–January, 2004

Frontispiece: Thornton Dial Sr. *The Top of the
World*. 1998. Metal, fabrics, paint can lids, rope,
nails, industrial sealing compound, 78 x 50 x 47"
(198.1 x 127 x 119.4 cm). Ronald and June Shelp
Collection, New York

Harry N. Abrams, Inc.
100 Fifth Avenue
New York, N.Y. 10011
www.abramsbooks.com

Printed in Japan

Contents

Foreword
Howard Dodson and David A. Hanks **6**

Introduction
Anne Hoy **8**

CRITICAL VANTAGE POINTS **10**

**African-American Art and
Contemporary Critical Practice**
Judith M. McWillie **11**

The End of the Outsider
Arthur C. Danto **30**

**Becoming Art: Life Spans, Biographies, and the
Shelp Collection**
Grey Gundaker **42**

Feeling at Home with Vernacular African-American Art
Kinshasha Conwill **54**

**Witnessing: Layered Meanings
in Vernacular Art**
Edmund Barry Gaither **64**

THE ART AND THE ARTISTS **83**

Witness to History
Leroy Almon, Joe Minter, Purvis Young, Thornton Dial Jr.,
Charlie Lucas **84**

Allegorical Animals
Thornton Dial Sr., Ronald Lockett, Mose Tolliver,
Joe Light **106**

Biblical Scenes
Mary Proctor, Herbert Singleton Jr., Felix "Harry" Virgous,
Arthur Dial, Lorenzo Scott **126**

Iconic Human Figures
Mary Tillman Smith, Archie Byron **142**

Spiritual and Protective Messages
John (J. B.) Murray, Hawkins Bolden, Ralph Griffin,
Bessie Harvey, Lonnie Holley, Richard Dial, Richard Burnside **154**

Direct Observation
James "Son" Thomas, Henry Speller, Georgia Speller,
Jimmy Lee Sudduth **170**

List of Plates **183**

Endnotes **184**

Selected Bibliography **187**

Index **190**

Foreword

Testimony: Vernacular Art of the African-American South is selected from the Ronald and June Shelp Collection, a notable holding that represents twenty-seven of the most significant self-taught artists at work in the South over the last twenty years. This catalogue and the exhibition it accompanies were organized by the Schomburg Center for Research in Black Culture of the New York Public Library and by Exhibitions International, New York. We are delighted by this first collaboration between our organizations, and very proud that we are united by this project in particular—our first opportunity to pay tribute together to the visual expression of African Americans who live and work in the South.

The Schomburg Center is the leading public research library in the world devoted exclusively to documenting and interpreting the histories and cultural heritages of people of African descent worldwide. Its collections number more than 5 million items, including over 3.5 million manuscripts, 750,000 photographs, 170,000 volumes, and 20,000 artworks and artifacts. Through exhibitions such as *Testimony*, educational and cultural programs, and special events, the seventy-five-year-old Harlem-based center seeks to broaden and deepen public and scholarly understanding of significant issues and themes in the global black experience.

Exhibitions International, a nonprofit organization, is a service for museums, institutions, and collectors. It organizes and circulates significant art exhibitions in the United States and abroad, provides their educational materials, and produces their accompanying publications. EI is pleased to circulate the exhibition of *Testimony*.

Representing the collection of Ronald and June Shelp, *Testimony* reflects this couple's identification with the South and the experiences conveyed by its artists. The Shelps were both born in the South and educated there during the Civil Rights movement. Their interest in this work was sparked in 1988 when they met William Arnett, the Atlanta collector, researcher, and scholar of some of the artists. Over the last twelve years the Shelps have assembled a collection of art exclusively by self-taught African Americans of the South. They have lent examples to exhibitions in the United States and Japan, and have donated important paintings and assemblages to the Museum of American Folk Art, where Mr. Shelp was a trustee, the Philadelphia Museum of Art, the Newark Museum, the Studio Museum in Harlem, and the Hirshhorn Museum and the National Museum of American Art, both of the Smithsonian Institution.

A selection from the Shelp collection was the subject of the Schomburg Center's 1997 exhibition "Bearing Witness: African-American Vernacular Art of the South." The help that Ron and June Shelp gave to that undertaking and to this one was constant and unwavering; it covered the largest question and the smallest detail. The couple's

generosity with their time and experience speak of their commitment to the artists represented here.

We would like to thank Osanna Urbay, exhibition coordinator at Exhibitions International, for the utmost professionalism and dedication with which she made both this exhibition and this publication become a successful reality. For their contributions to this project, we also thank the articulate and resourceful Kinshasha Conwill, and Lowery Sims, whose graciousness led us to Judith McWillie, our expert reader and contributor.

In bringing this book to fruition, we are indebted to our five eminent contributors: Kinshasha Conwill, Arthur Danto, Edmund Barry Gaither, Grey Gundaker, and Dr. McWillie. Their probing and provocative essays—the majority about the much-debated reception of this contemporary work—are at the heart of *Testimony*, as is the work itself. For her open-handed sharing of her learning, counsel, and research, we thank Dr. McWillie, who participated in numerous aspects of creating the book. Anne Hoy, editor for Exhibitions International, applied tireless expertise to preparing the texts for the exhibition and for publication. At Harry N. Abrams, managing editor Margaret Rennolds Chace championed the project and senior editor Elisa Urbanelli shepherded it smoothly into this handsome book, designed by Ellen Nygaard Ford. The photographs of the art were the admirable work of Thomas Birdwell, Ken Cohen, and Alan Zindman; Bill Arnett kindly lent the insightful images of the artists, as did Dr. McWillie. For their invaluable contributions to realizing the book and exhibition, we are also grateful to Roberta Yancy, Assistant Director of Public Affairs and Development at the Schomburg Center, and Dorys Codina, Jill Grannan, and Joan Rosasco of Exhibitions International.

HOWARD DODSON
Chief
The Schomburg Center for Research in Black Culture
The New York Public Library

DAVID A. HANKS
Director
Exhibitions International

Introduction

For the last twenty years, African-American vernacular art of the South has attracted growing art-world interest under labels such as "folk" and "Outsider" art. Countering generalizations, scholars of African-American culture have sought to identify the legacies of West Africa and the Caribbean in these works and to situate them in their communities. The first admiring group claims this art for modernism, as a late and passionate embodiment of its history of mad geniuses, visionaries, and social solitaries. Some invoke postmodernism, because this art's emotive brushwork and accretive assemblage techniques resemble mainstream currents of Expressionism and appropriation. The second group locates this art within African-American anthropology and material culture studies, with certain observers even heralding it as the most authentic expression of Afro-Atlantic experience. How is this emotionally charged, aesthetically powerful, culturally complex work best seen?

Testimony: Vernacular Art of the African-American South is intended to stimulate debate as it surveys the field, through the eyes of five distinguished scholars and critics: Judith McWillie, Arthur Danto, Grey Gundaker, Kinshasha Conwill, and Edmund Barry Gaither. That field is represented here by twenty-seven significant artists, the majority now at work in Alabama, Georgia, Mississippi, and Tennessee. They range from the most celebrated practitioners—among them, Thornton Dial Sr., Bessie Harvey, Lonnie Holley, Ronald Lockett, and Purvis Young—to less known but no less fascinating figures, such as Archie Byron, J. B. Murray, Lorenzo Scott, and Georgia and Henry Speller. The largest group of works are by Dial and by members of his extended family—Arthur and Richard Dial, Thornton Dial Jr., and Ronald Lockett—permitting a survey of the relations within this Alabama dynasty of artists. Almost all the works date from the 1980s and '90s, when these Southerners first came to attention from the dominant art world and its public—an attention that continues to grow.

Those familiar with modern and postmodern art, from Jackson Pollock and Jean Dubuffet to Cy Twombly and Jean-Michel Basquiat, will find affinities for it in *Testimony*. In fact, comparison between works by schooled and these unschooled artists reveals no visible differences, as the critic Arthur Danto observes in his essay, "The End of the Outsider." Neither group of practitioners cares about imitation, illusionistic representation, "correct" drawing, or other traditional pictorial skills. Each invents with exhilarating technical freedom and creates in an emphatically personal idiom. All might consider themselves marginalized within the larger society, though the art market has begun to welcome almost every one of them. But there the similarities end.

The artists of *Testimony* form two generations: those who grew up during segregation in the South and lived through the Civil Rights movement; and those who came of age in the more politically active 1960s and '70s, and who now judge the promises against the changed economic realities of their Southern counties. Bridging the work of these generations are six overlapping themes: their witness to history; their representation of allegorical animals, biblical scenes, and iconic human figures; their spiritual and protective messages; and their direct observation.

More deeply, the work shown here is united by its sources in extended families and close-knit communities, both urban and rural; by its creolized inheritance—blending West African traditions with Native-American and European-American influences; by its reflection of the triumphs and tragedies of black experience in the South; and by its commitment to the moral possibilities of visual expression. While much recognized African-American art (visual, verbal, musical, theatrical) is by Northern artists or those who migrated North, this art comes from those who were born and reared in the South, and stood their ground. While much mainstream art has been ironic, intellectualizing, and self-absorbed until recently, this work is full-throated and aimed directly at a responsive audience. As in gospel singing or blues, the "bearing witness" of this art—as Edmund Barry Gaither writes in his essay—"offers a vivid affirmation of a human community created through sharing commonly held, publicly proclaimed truths." The artists of *Testimony* are unashamed to avow their faith and to praise their God—if not religious institutions. "They made much of their work," writes Grey Gundaker, "to point to better ways of living in the world." It openly concerns "concepts of justice, reverence, and love of one's neighbor."

Are the diverse works illustrated in *Testimony*—from looming assemblages to intimate, subtly hued works on paper—united as the art of poor artists? In her essay, Kinshasha Conwill implicitly questions the value of the question. Black nationalism in the late 1960s and '70s equated "authentic" black culture with lower-class culture, she writes. The association further marginalized working-class self-taught blacks, and it separated them from their trained black colleagues, even though some of their works were mutually inspirational. The schooled artists suffered, while the unschooled rose in reputation. For both groups, the process had and continues to have a price, according to Gundaker. "With time and talk, the identity of the skilled *welder* sweating over a blowtorch in a *workshop* is effaced by that of the *sculptor* confronting the problems of Art in a *studio*." Understanding of the home ground and originating purpose of the maker can be lost.

This understanding is what all the authors of *Testimony* seek to preserve, as they applaud the weakening of dichotomies such as Outsider/Insider, vernacular/cultivated, and folk/urbane applied to this art. The interweaving in this book of the artists' biographies with the illustrations of their work is therefore fitting. Enriched with their own words where possible, these biographies are meant to convey the individuality of the artists within their generations, social positions, and varied Southern communities. Their art and their lives are inseparable. And they ask viewers for understanding of both. These Southerners communicate as all serious artists do, writes Judith McWillie, through "an ongoing, and often surprising, reciprocal relation between artist and audience."

ANNE HOY
Exhibitions International

Critical Vantage Points

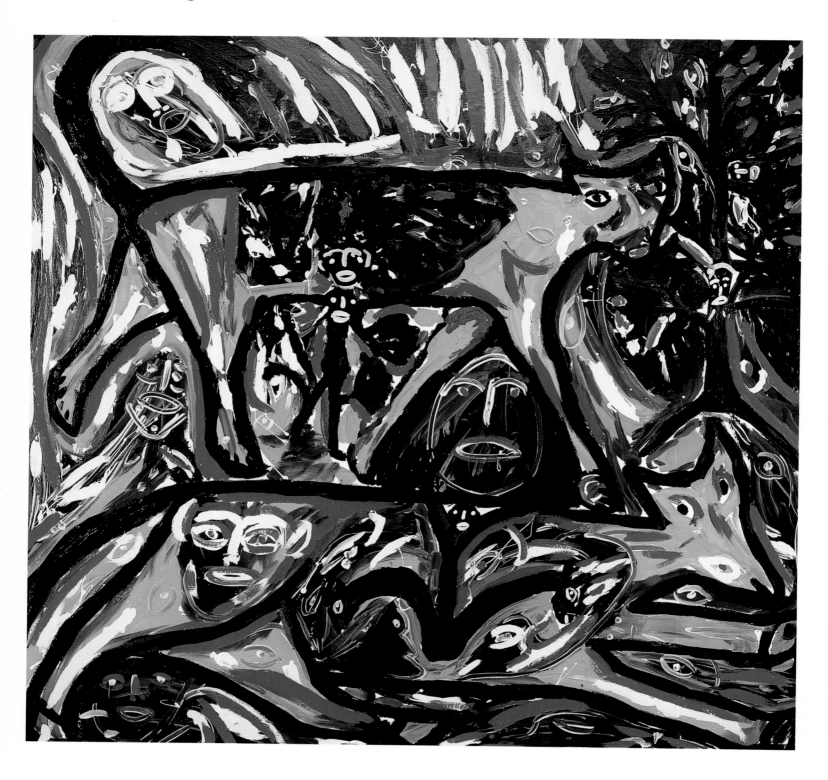

African-American Vernacular Art
and Contemporary Critical Practice

JUDITH M. McWILLIE

In a monumental canvas in the collection of the Hirshhorn Museum and Sculpture Garden in Washington, D.C., swarms of black, red, green, and white paint strokes converge on two yellow tigers whose eyes confront the viewer with expressions more knowing than fierce. Black lines and graphic shapes coalesce into forms that suggest human figures, while disembodied eyes and faces move in and out of focus, dissolving and recomposing without regard for the boundaries of species and environment. Though relatively modest in size, Thornton Dial Sr.'s *The Coal Mine* (1989; opposite) can be described as monumental through its genesis in one of the defining periods of twentieth-century American history. Both the artist and the painting are emblematic of a generation of working-class African Americans who grew up in the South during the era of segregation and lived to witness and participate in the social transformations of the American Civil Rights movement. This is the generation whose parents and grandparents brought blues out of the cotton fields of Mississippi, Alabama, Arkansas, and Georgia into Northern urban centers, where it merged with popular theatrical idioms and was exported to the rest of the world. Like all timely innovations, vernacular art forms such as blues are rooted in traditions and aspirations that find their voices in more than one aesthetic medium. Blues is "not just musical, but cultural," says the contemporary art historian Richard J. Powell. It emerged "from the social conditions of black Americans as they entered and dealt with the modern era."[1] *The Coal Mine* and other works by Thornton Dial Sr. use many of the same expressive strategies found in the more familiar African-American musical legacy, including "fractured" syncopation, double entendre, and "signifying" titles.[2]

The Coal Mine is more a work of empathy, however, than one of history or biography. It is an act of will as well as an act of remembrance. Dial Sr. spent most of his adult life as a sheet-metal worker manufacturing railroad cars for the Pullman Standard Company in Bessemer, Alabama. Although the title of his painting presumably refers to the mining industry of north Alabama, he addresses both the collective experience of Southern African Americans and, by extension, others caught in the ethical and spiritual discrepancies of the culture at large. Allegorical rather than narrative, *The Coal Mine* physically resembles Jackson Pollock's early work (page 13) and the experiments of the CoBrA artists in postwar Paris, such as Karel Appel, more than the works of better-known African-American artists such as Jacob Lawrence, Benny Andrews, or Jean-Michel Basquiat.

THORNTON DIAL SR. *The Coal Mine.* 1989. Oil on canvas mounted on wood, 68 x 72" (172.7 x 183 cm). Hirshhorn Museum and Sculpture Garden, Smithsonian Institution, Washington, D.C., gift of Ronald and June Shelp

Although Dial Sr.'s achievements as a "self-taught" artist were celebrated by Amiri Baraka and Thomas McEvilley in the monograph *Thornton Dial: Image of the Tiger* (1993), he and other African-American vernacular artists from the South have been persistently linked with the "Outsider" movement, a connection reinforced by the movement's most comprehensive publication, *Raw Vision: The International Journal of Intuitive and Visionary Art*, a magazine issued in New York, London, and Paris with a bilingual text in English and French, and by blockbuster exhibitions such as the Los Angeles County Museum of Art's "Parallel Visions: Modern Artists and Outsider Art" (1992), which featured the works of the Georgia visionary John Bunyan ("J. B.") Murray (page 15). In May 1996, *ARTnews* presented a cover story by Jed Tully, "Outside, Inside, or Somewhere In-between," in which Thornton Dial Sr. was described, in "market terms alone," as "a talisman for the burgeoning Outsider movement."[3]

This movement cites its historical provenance in European *Art Brut*, a term invented by the French artist Jean Dubuffet in 1945 to describe works produced by inmates of psychiatric hospitals, works that he collected and later donated to the city of Lausanne, Switzerland. In 1994, Eugene W. Metcalf Jr., a professor of interdisciplinary studies at Miami University in Oxford, Ohio, described the characteristics of Dubuffet's ideas that most influenced collectors of Outsider art. "Still generally viewed in much the same way Dubuffet originally defined it in the 1940s, as the idiosyncratic, self-inspired product of bizarre social misfits and mental patients, Outsider Art, and the people who produce it, are thought to exist somehow apart from culture, in a state unaffected by the influences and pressures of normal social interaction."[4] In his book *Outsider Art* (1972), the British art critic Roger Cardinal spread Dubuffet's views beyond Europe. The 1990 exhibition and catalogue for the Parsons School of Design's "Portraits from the Outside: Figurative Expression in Outsider Art" propagated those views, and the annual Outsider Art Fair, held in New York since 1996, was founded to promote the market in artworks so defined.

That year, curators such as Lowery Stokes Sims, then of the Metropolitan Museum of Art, began to question whether the Outsider paradigm was hurting or helping its artists. "When they're competing in the same arena as professional artists, exhibiting and being marketed by the same individuals who market professional artists, I think the whole Outsider thing begs the question: Is Martin Ramirez, the late Mexican Outsider painter [c. 1885–1960], institutionalized for most of his life in California, any different from Vincent van Gogh? Is Thornton Dial any different from Jean-Michel Basquiat? Why treat them differently? You really have the beginnings of a breakdown in the hierarchy."[5] The answers to Sims's questions are complex. They involve tactical as well as epistemological issues, and they lend credence to the notion that the Outsider movement's appropriation of African-American vernacular art acted as its shield against critical neglect and, at the same time, functioned as a kind of Trojan horse in an exclusionary art world.

In the early 1980s, in the wake of the exhibition "Black Folk Art in America 1930–1980" (1982) at the Corcoran Gallery of Art in Washington, D.C., Southern collec-

tors began seeking new exhibition venues for the artists in this survey, as well as those they were "discovering" on an almost monthly basis. Prior to the 1980s no serious collecting of indigenous art had occurred in the South. Contemporary art criticism had little effect because directors of the region's museums and galleries were preoccupied with educating a public indifferent to modern art in general. The critical attention, not to mention the "market feeding frenzy"[6] that followed the Corcoran exhibition, broke the South's isolation with regard to the visual arts and inspired new collectors—who had both the means and the foresight—to buy large quantities of works from African-American vernacular artists and even to give some of them stipends so they could afford to produce on a full-time basis.

JACKSON POLLOCK. *The Key.* 1946. Oil on canvas, 4'9¾" x 7'1" (1.47 x 2.16 m). Art Institute of Chicago, through prior gift of Mr. and Mrs. Edward Morris. © 1994 Pollock-Krasner Foundation, Artists Rights Society (ARS), New York

Following the Corcoran Gallery's lead, Southern museums along with federally subsidized "alternative spaces" exhibited African-American vernacular art in the context of folk art. While these exhibitions forged new relationships with the Museum of American Folk Art in New York and the National Museum of American Art in Washington, D.C., they did little to address the complex issues lying within the relatively benign contexts in which the art was exhibited.

Subsequently, influential dealers in Outsider art in Philadelphia and New York joined forces with Southern collectors, offering them the tactical advantage of being part of an international constituency that was rapidly gaining momentum and had a stable network of publications and exhibition venues already in place. In turn, the spiritual weight of the African-American experience infused the Outsider enterprise with an implied moral authority that not even Jean Dubuffet and his Art Brut–influenced contemporaries had sought to claim.

One of the most successful maneuvers of the first-generation promoters of African-American vernacular art was their strategy of bringing other collectors, popular writers, and curious art critics, many of whom were already interested in Outsider art, to the homes and communities where the artists lived. For the new, wider audience, this meant "crossing into uncommon grounds," going to towns and neighborhoods they might have ignored under any other circumstances. After one such journey, the art critic Lucy Lippard observed that exhibiting African-American vernacular artists as "outsiders" is "a crisis for the white collector, critic, and audience as much as it is a crisis for those who are misnamed."[7] Lippard pointed to the fact that the marginalized status of African Americans in the United States is more socially complex than the circumstances surrounding European "Outsiders" such as Adolf Wölfli or Louis Soutter. Anticipating the institutional realignments of the late 1990s, she further observed, "From the security of educated whiteness, it can be difficult to realize that change is not change unless it crosses the board"[8]—that is, unless both private and institutional promoters of African-American vernacular artists are, themselves, willing to be changed by them.

When the New York critic Peter Schjeldahl visited the 1997 Outsider Art Fair at the Puck Building in SoHo, he noticed that "a disproportionate number of the most appealing Outsiders are African American" and that buyers seemed to express "a thrill of virtuous power as angels of patronage rescuing primitively authentic creativity from the disdain of the art world's wonks and snobs."[9] As an antidote to the term *Outsider art*, which he viewed as misleading, he pointed to "a tasty show" running concurrently in Harlem at the Schomburg Center for Research in Black Culture titled "Bearing Witness: African-American Vernacular Art of the South from the Collection of Ronald and June Shelp." The Schomburg exhibition featured many of the same artists on display in the Puck Building and marked a turning point in mainstream critical writing on the subject. "I like the term *vernacular art* in the Schomburg show's title," Schjeldahl wrote, "pointing to a collective tradition of Southern Black culture that may be too well developed and densely populated to be termed *Outsider* while too individualistic to qualify as *folk*."[10]

It is significant that the Shelp collection appeared not in the setting of a museum or gallery, but at a library devoted to documenting "the contributions people of African descent have made to the development of human civilization."[11] A year earlier, Sandra Kraskin, director of the Sidney Mishkin Gallery at Baruch College, had curated a smaller exhibition of the Shelp collection presciently titled "Wrestling with History." This initiated a shift in emphasis that would bring African-American vernacular art into what she called the "struggle to deconstruct the exclusionary categories of modernism."[12]

As art critics picked their way through the taxonomical minefields of the 1980s and '90s, academic observers of the art world, some of whom worked in disciplines beyond its institutional matrix, were beginning to question the Outsider movement's European modernist epistemology. Influenced by the postcolonial perspectives of Johannes Fabian in anthropology and Marianna Torgovnick in literary criticism, Eugene Metcalf Jr., a sociologist, complained that "Outsider art has seldom been studied in terms of its relationship to the 'inside.'" Furthermore, he wrote in the 1994 anthology *The Artist Outsider: Creativity and the Boundaries of Culture*, "there is little recognition of the social factors or groups that influence the binary existence of 'outsiderness,' and emphasis is placed instead on the artworks themselves and their aesthetic merit."[13] He warned that "the discourse on Outsider Art does not really think about, observe, or critically study the outsider. It thinks, observes, and studies in *terms* of the outsider."[14] This observation was reinforced two years later by Jed Tully's *ARTnews* article, which, like most popular writing on the subject, concentrated on the economics of the collecting phenomenon and the dramas and controversies surrounding its major players. Metcalf rebuked the art world for its acquisitive disposition: "When creativity and art matter so much more than people, there is no need to attempt to communicate with the makers of Outsider art about what they think their art and lives are about."[15] He struck a nerve. The failure of many Outsider art advocates to acknowledge the uniqueness of the African-American experience, much less communicate with its artists directly, was most conspicuous in Simon Carr's catalogue essay for the Parsons School of Design's exhibition

JUDITH M. McWILLIE

African-American Vernacular Art and Contemporary Critical Practice

MARK TOBEY. *The Avenue.* 1954.
Tempera on paper board, 39⅜ x 29¾"
(100.4 x 75.6 cm). Norton Museum of
West Palm Beach, Florida, purchased
through the R. H. Norton Fund

"Portraits from the Outside: Figurative Expression in Outsider Art" (1990). Carr gave a description of J. B. Murray's work that illustrates what can happen when the constructs of Art Brut are imposed on artworks without firsthand investigations of their makers' thoughts and lives:

> From this apparently ordered framework, the work of Murray drives us headlong into chaos. For if the images and writing can only be "read" by the artist, if the text remains unintelligible, the meaning trapped within the artist, then there is no meaning in any broader, communicable sense. Armed with the tools of order, art and religion, Murray's vision takes him deeper and deeper into landscapes where those tools have no meaning. Haunting stick figures, helpless, deprived of limbs, are left only their staring eyes and the incomprehensible writing that surrounds and tantalizes them. The work finally subverts the great dream of meaning, becoming like the "all out assault on dignity" that Bataille proposed for his own project.[16]

This is the language of propaganda rather than of critique. It is all the more pernicious when applied to an African-American artist motivated by religious experience. J. B. Murray created a personal script that he called "the language of the Holy Spirit"[17] (page 15) and introduced it into several thousand incantatory drawings and paintings, using art materials supplied by a local doctor who also collected his work. In purely formal terms, the textural richness of his abstractions along with their holistic compositions might be compared with works of Mark Tobey (left) and Cy Twombly (page 17, top) or even with Brice Marden's paintings of the mid-1990s (page 17, bottom). But this is the extent of their kinship.

Murray began his "spiritual work" after experiencing a vision of the sun descending into his yard. In his home in central Georgia, he invited visitors to pray with him as he filled sheets of posterboard with sprawling "letters" that he said were "like verses and psalms—the same." He punctuated the writing with dots and paint strokes until each surface was completely covered. Sometimes he filled the negative spaces with figures and faces, which he described as "the evil people, the people that are dry-tongued, that don't know God." He would then raise a bottle of water above the image, ask God's blessing, and give a cogent spiritual interpretation of its message. Murray had no conscious knowledge of Africa other than through popular culture, and, as a devout Christian, he preferred not to be associated with water divination or local "hoo doo." But, among both African and African-American vernacular artists, so frequent is the citation of visionary experience in determining the authority to make art and so widespread is the practice of inventing scripts that, in a larger context, Murray's art enters a procession of works that transcend the limitations of biography and place. The meaning of his life and work greatly expands when seen in conjunction with the visionary experience and invented script of James Hampton, creator of *The Throne of the Third Heaven of the Nations*

JUDITH M. McWILLIE

Millennium General Assembly, on permanent display in the National Museum of American Art in Washington, D.C. Hampton's script survives in a ledger (page 18, right), found after his death in the rented garage where he constructed the Throne. Similarly, Frédéric Bruly Bouabré, an artist born in 1923 on the Ivory Coast, also invented his own system of writing and incorporated it into his drawings (page 18, left). Scholars such as Ivor Miller, Konrad Tuchscherer, Grey Gundaker, Robert Farris Thompson, and others continue to research the idiom, citing the multitude of improvisational scripts found in Africa, South America, the Caribbean, and the United States.[18]

Having embraced African-American vernacular artists, the Outsider movement itself began to change because it was forced to contend with the implications of its premise. Today, there is an increasing awareness of the distinctions among European artists collected under the Art Brut rubric, such as Gaston Chaissac (page 19); solitary outsiders, like Chicago's Henry Darger (page 20), who made a conscious choice to work with no "institutional goals in mind"[19]; and Southern African Americans who consciously and specifically address more broad-based concerns. J. B. Murray made trips to town to distribute sheets of his "language of the Holy Spirit" to neighbors rather than hiding his work in his house as Darger did. Thornton Dial Sr.'s paintings and sculptures approach social issues through sophisticated tropes in which the image of the tiger doubles as a symbol of the canniness needed to negotiate an exploitative world while also serving as a locus of personal and communal identity. Lonnie Holley, conscious of himself as an artist, has been known to lecture spontaneously on Pablo Picasso, Robert Rauschenberg, and the African-American muralist John Biggers. Mary Tillman Smith placed her art outdoors, along a fence on a busy highway, and put up signs that read, "My name is someone" and "Here I am. Don't you see me." As Peter Schjeldahl indicated in his review of the fifth Outsider Art Fair, African-American vernacular art has a distinct "mode of address." In contrast, in Art Brut, "we confront a closed loop, an inside of hermetic association from which we are utterly excluded."[20]

Schjeldahl further observed that the Outsider movement "differs from many past vogues because it is intent less on reforming established taste than on snubbing it."[21] I would add that the movement's history of indifference to contemporary art criticism isolates it far more than the biographies of the artists involved. As Lowery Stokes Sims observed, each "discovered" artist "accrues valuative status according to the pretensions of the discoverer. There are no other standards or criteria applied except for level of education, material wealth, and contact with the mainstream."[22] No further proof is needed that the Outsider context functionally silences its artists.

The collectors, dealers, and writers who affiliated themselves with the Outsider movement, however expedient the strategy, did so at the expense of important collective

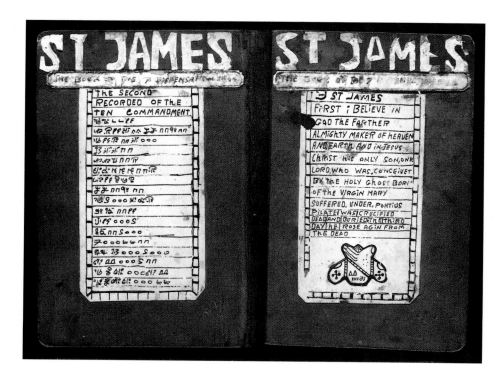

α:0 , :1 , :2 , :3 , :4 , :5 , :6 , :7 , :8 , :9
:10, :11, :12, :13, :14, :15, :16, :17, :18, :19
:20, :21, :22, :23, :24, :25, :26, :27, :28, :29
:30, :31, :32, :33, :34, :35, :36, :37, :38, :39
:40, :41, :42, :43, :44, :45, :46, :47, :48, :49
:50, :51, :52, :53, :54, :55, :56, :57, :58, :59
:60, :61, :62, :63, :64, :65, :66, :67, :68, :69
:70, :71, :72, :73, :74, :75, :76, :77, :78, :79
:80, :81, :82, :83, :84, :85, :86, :87, :88, :89
:90, :91, :92, :93, :94, :95, :96, :97, :98, :99
:100 , :101 :102 , :103 :104
:105 , : 106 , :107 , : 108 ,
:109 , :110 , :111 , : 112 ,
:113, :114 , :115, :116
: 117 , : 118 , : 119 ,
:120 , :121 , : 122 ,
:123 , :124 , :125, :126 ,
:127 , : 128 , : 129 , :130 ,
:131, :132 , :133, :134 ,
:135, :136 , : : 138 ,
:139 , :140 , : 141 .

FRÉDÉRIC BRULY BOUABRÉ.
Untitled. From *Knowledge of the World.* 1988. Ink on paper, 8¼ x 11¾" (21 x 29.8 cm). Courtesy Nexus Press, Atlanta, Ga.

JAMES HAMPTON. *The Book of the 7 Dispensation by St. James.* c. 1950–65. Ledger book, 10 x 8" closed (25.4 x 20.4 cm closed). National Museum of American Art, anonymous lender, Washington, D.C.

histories that play out in philosophical as well as aesthetic ways. With the exception of Thomas McEvilley, who focused almost exclusively on Thornton Dial Sr.,[23] few contemporary art critics have been willing to give African-American vernacular art the level of critical scrutiny they apply to the economics of its emergence.

Fortunately, there are signs of change. In March 1997 the philosopher and art critic Arthur C. Danto published an essay titled "Outsider Art" in the liberal weekly magazine *The Nation,* in which, like Schjeldahl, he cited the fifth Outsider Art Fair and the Schomburg Center's "Bearing Witness" exhibition. The latter, he wrote, was "a marvelous exhibition" more "precisely labeled" than the fair.

> I was struck by the works of Mary T. Smith, a former tenant farmer and cook who began painting in 1978. Part of what struck me was how much her work looked like Dubuffet's. This is not to raise questions of influence on the artist but on us. Dubuffet opened our eyes to painting that might very well have been the same whether Dubuffet had existed or not, but which is acknowledged as art and even very good art in part because of transformations of vision that are due as much to Dubuffet as to anyone.[24]

Danto's essay in *The Nation* identified the epistemological issues at hand, not just the taxonomical ones. As orthodox modernists, he wrote, "artists such as Dubuffet

JUDITH M. McWILLIE

appropriated the outward look rather than the internal motivation" of works of art from other cultures and states of consciousness. This made it possible for them to adopt ethnic art "with the same alacrity with which Pat Boone appropriated 'Tutti Frutti' from Little Richard." Nevertheless, he continued, "the widening of the scope of art through modernism, to include what would earlier have at best anthropological or psychiatric value, has on the other hand made it possible to appreciate, in visual terms, a good bit of what Outsider artists produce."[25] He went on:

> Clearly, we need a better term than "outsider art." "Self-taught artist" will not serve, since there are too many good self-taught artists who by no stretch of the term's extension could be counted outsiders. . . . Whatever the case, the proportion of masterpieces and genius, and the incidence of quality among outsiders, is about what we would find within the art world. The causes, explanations, and meanings, of course, differ from what the art world understands and teaches.[26]

In *After the End of Art: Contemporary Art and the Pale of History*, Danto called for a new kind of critical practice that would include the "countless directions art making can take, none more privileged, historically at least, than the rest."[27] He cited modernism's most influential American critic, Clement Greenberg, who with dogmatic formalism maintained that all advanced art developed out of a progressive narrative dating back to Edouard Manet and that all relevant criticism addressed aesthetic innovations within that narrative. Formalism, which concentrated exclusively on the physical properties of works of art rather than the motives of the artists who made them, made it possible for Danto to cite Mary T. Smith's work alongside Dubuffet's and to view the Outsider Art Fair as "an eye test for artistic quality, irrespective of provenance."[28] At the same time, he acknowledged that, during the 1980s (the period when African-American vernacular art publicly emerged), there was "no favored vehicle for development any longer." This was due to "the explicit sense that painting had gone as far as it could, and in a way that the philosophical nature of art was at last understood." He viewed these conditions as less apocalyptic than liberating. In the only mention of an African-American artist in *After the End of Art*, he described the predicament facing a black modernist. "Robert Colescott accepted the modernist narrative under which painting culminates in the all white painting, but he realized that that had been done by Robert Ryman and the story was over, liberating him to undertake a program there was no room for in Modernism, namely, as he put it, to 'put blacks into art history.'"[29]

However flawed from a postcolonial perspective, modernism was a powerful consolidating force that fostered the growth of arts institutions worldwide, which, in turn, gave the recombinant pluralism of the 1980s and '90s a public forum. After modernism's demise, splinter groups such as the Outsider movement substituted the authenticity attributed to empirical experience for the idealism associated with progressive narratives. Danto admits the need for idealism in art, although one not rooted in a

GASTON CHAISSAC. *Personnages.* 1962. Gouache on paper on canvas, 19 x 13¼" (48.3 x 33.7 cm). Art Forum Ute Barth, Zurich. Courtesy Art Forum Ute Barth

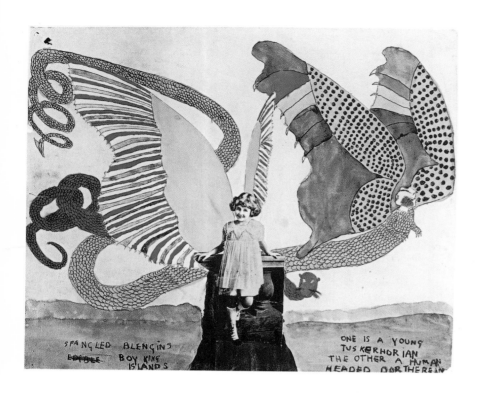

HENRY DARGER. *Spangled Blengins, Boy King Islands: One is a Young Tuskerhorian, the Other a Human Headed Dortherean.* n.d. Collage, carbon tracing, pencil, and watercolor on paper, 14 x 17" (35.6 x 43.3 cm).

narrow strain of formalism, but rather in the development of a more inclusive philosophy of art. "The alternative view would be," he wrote, that "art, construed historically, had reached the end of the line because it had moved onto a different plane of consciousness. That would be the plane of philosophy, which, because of its cognitive nature, admits of a progressive developmental narrative," and this "ideally converges in a philosophically adequate definition of art."[30]

In the wake of these discoveries, art critics such as Danto position themselves to study African-American vernacular artists more precisely in conjunction with famous artists from both the contemporary mainstream and the past. Juxtapositions of works that proved gratuitous twenty years ago when the Museum of Modern Art mounted its infamous exhibition "'Primitivism' in Twentieth Century Art: Affinity of the Tribal and the Modern" (1984) now seem not only timely but essential. In that exhibition, specific works of tribal art were discussed only in relationship to their documented influence on famous modernists. Their aesthetic and philosophical autonomy was ignored. Danto discusses these issues at length in a catalogue essay for the Center for African Art's exhibition "Art/artifact"(1988), in which he describes the MoMA project as "methodologically flawed."[31] Indeed, a more philosophical emphasis might have spared "'Primitivism'" some of the fiercely negative criticism it received.

Two other observations by Danto bear mentioning here because of the doors they open to further critical investigations of African-American vernacular artists. *In After the End of Art*, Danto wrote, "In my own view, the major artistic contribution of the decade [the 1970s] was the emergence of the appropriated image—the taking over of images with established meaning and identity and giving them fresh meaning and identity."[32] In describing appropriation, one of the fundamental tactics of postmodernism, he also points to a strategy that African Americans have long employed in defending themselves against oppression while reinforcing both personal and communal identity. These strategies include taking advantage of syncretisms in which images or objects derived from the dominant culture are assigned new meanings recognizable only to the initiated. Examples include using images of Catholic saints to represent Yoruba Orisha (deities) on *vodoun* altars in New Orleans or, in coastal Georgia, placing wagon wheels and, later, automobile hubcaps on graves to represent African-informed views of the cyclical nature of time. European modernists employed similar tactics in their appropriations of African art but failed to take into account their privileged position within the larger context of Western colonialism. The obvious parallels between modernist

appropriation and today's insider/outsider polemic, along with the fact that appropriation continues to be a leitmotif of today's art, make Danto's statement ironic and double-edged. It might understandably feed the skepticism of activists seeking institutional reform. Few would disagree, however, with his ultimate conclusion that "The artist, the gallery, the practices of art history, and the discipline of philosophical aesthetics must all, in one way or another, give way and become different, perhaps vastly different, from what they have so far been."[33]

Drawing on the resources of philosophy and aesthetics, it is now possible to examine and compare artists such as Mary T. Smith with Jean Dubuffet or Karl Appel (right and page 22) according to the epistemological foundations of their work and the modes of address they use, in addition to the formal affinities they share. It goes without saying that canonical artists such as Dubuffet have been thoroughly researched in this regard, while African-American vernacular artists have yet to be approached. If, as Danto suggested, art has now entered "a new plane of consciousness," this new consciousness might be applied to the past as well as the present, changing the ways we perceive modern artists like Dubuffet as well as Mary T. Smith. For example, while Dubuffet was developing his theories of Art Brut, he was also attempting a theory of "people's creativity" that, presumably, would spawn "an art open to all, to *homme du commun,* or common man,"[34] an idea about which far less is understood. It would be interesting to know if this brief excursion in his career was the result of criticism of his emphasis on psychopathology and why he never developed his *homme du commun* ideas any further. The concept of a popular creativity is worth examining because it appears to share common ground with a distinctly American version of modernism propagated by Alfred Barr, the first director of the Museum of Modern Art.

In a 1995 lecture at the Andy Warhol Foundation, Robert Storr, a senior curator at MoMA, described Barr's version of modernism and also the resistance he encountered as a result of his experimental approach.

From the outset, MoMA's perspective was internationalist and its approach encyclopedic as well as evolutionary. In the effort to establish the modernist canon, MoMA's founder, Alfred Barr, took it upon himself and his collaborators to look wherever the fertile conditions for modern art existed and wherever examples were reported. Although many factors influenced how that ambition was pursued in practice and significant oversight certainly did occur, the belief that modernism was a multifaceted phenomenon was a decisive criterion of Barr's endeavor. . . .

JUDITH M. McWILLIE

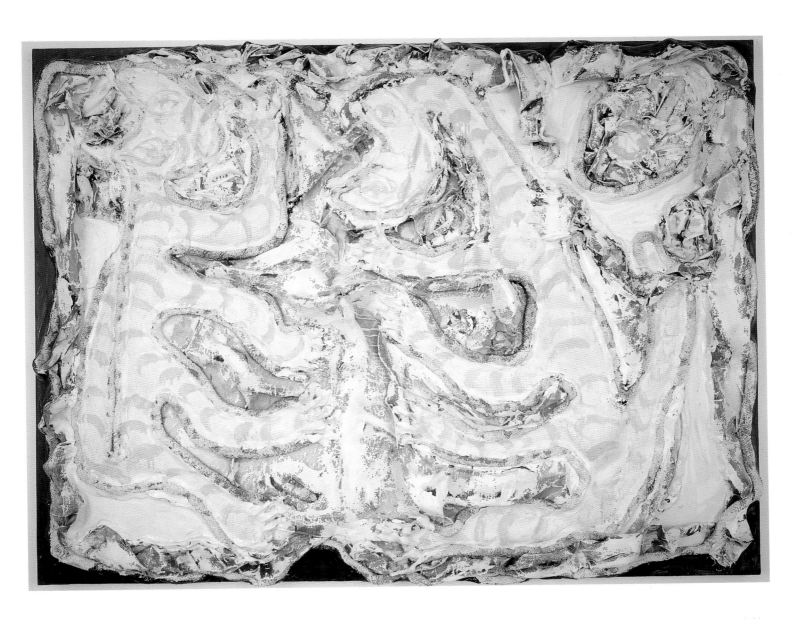

THORNTON DIAL SR. *Taking Care of Old Things (Honoring Lonnie Holley).* 1992. Enamel, burlap, wire screen, rope carpet, and industrial sealing compound on wood, 50¼ x 65" (127.7 x 165.1 cm). Ronald and June Shelp Collection, New York

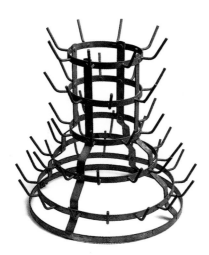

MARCEL DUCHAMP. *Bottle Rack.*
1961 version of 1914 lost original.
Galvanized iron bottle drier, 19⅝"
(49.6 cm) high. Philadelphia Museum
of Art, gift of Jacqueline, Paul, and
Pierre Matisse, in memory of their
mother, Alexina Duchamp

BRUCE CONNER. *Senorita.* 1962.
Assemblage on wood, 34 x 22 x 5"
(86.4 x 56 x 12.8 cm). The Museum
of Contemporary Art, Los Angeles,
purchased with funds provided by
the LLWW Foundation

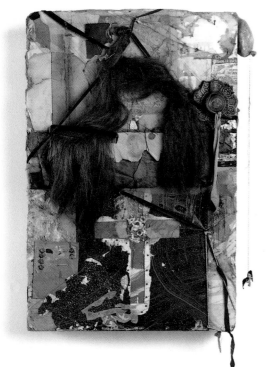

Barr's patrons were at crucial times impatient with or intolerant of his experiments and excursions. In late 1943, after having upset several trustees, in particular the aesthetically conservative board chairman Stephen C. Clark, by offering museum space and sanction to the [Morris] Hirshfield show, and by installing Joe Milone's richly ornamented shoeshine stand in the Museum's lobby, he was fired as the museum's director.[35]

Barr had also been responsible for exhibiting the works of William Edmondson, a stone carver from Nashville, Tennessee, in 1937, marking the first exhibition of an African-American vernacular artist at the Museum of Modern Art. Although he exhibited Edmondson's sculptures because of their physical similarities to certain European modernist works, Barr nevertheless had an empirical approach to collecting in which he actively searched for art beyond "established cultural centers." Barr's downfall, according to Storr, disrupted a curatorial agenda focused on diversity, albeit under the rubric of modernity.

With the exception of the museum's 1944 exhibition "Modern Cuban Painters" and paintings by Jacob Lawrence, Barr's departure broke MoMA's tradition of culturally varied fare for years to come.

In the years since his retirement and death, and even before, the American view of modernism became narrower not broader as American art gained in authority and its institutional base expanded. During the 1960s and '70s historians and critics streamlined the famously churning diagram of the course of modern art that Barr had devised in 1936. To an increasing degree, they concentrated on strictly, often mechanically formal interpretations of the art they deemed worthy of that tightly channeled "mainstream." The break with the founding spirit of MoMA came with this triumph of American formalism and not with the so-called postmodernist reaction to it. Ironically, the rebellion against modernism as it thus came to be narrowly defined, while often interpreted as a demand that the museum reject the whole of its tradition, in many respects challenges the institution and others modeled on it to do the reverse and return to that tradition's generative spirit and empirical approach.[36]

More detailed studies of African-American vernacular artists by contemporary art critics—studies that, of necessity, would include getting to know these individuals without the mediation of market-sensitive promoters—would go a long way toward dissolving the stereotypes applied to them and open new avenues of critical inquiry. In this endeavor, some of the forgotten strains of modernism, like the one detailed in Storr's account, could be reexamined in light of present developments. While the project of modernist criticism is over and may never again be revived, attending to some of its unfinished business would explain a great deal about the somewhat disarming idealism

JUDITH M. McWILLIE

of artists and collectors in regions like the South and elsewhere where the popular understanding of modernism has always more closely resembled Alfred Barr's version than Clement Greenberg's.

Some African-American vernacular artists—Lonnie Holley, for example—are verbally as well as visually eloquent and remarkably explicit about their understanding of the role of art in the world. For Holley, art is both the evidence and the measure of consciousness driven by purpose. The prophetic elements of African-American history are the foundation of his teleology, but it is the wisdom traditions of both Islam and Christianity that he consults in his work. His sandstone sculptures trace both the developmental history of art, as he sees it, and the equanimity of wisdom transmitted across generations.

A sun shine[s] for each time period to show the difference in them. I try to go back and see where man has made great achievements and showed himself to God. . . . I looked at things that man have did as art, as objects of art, that have been left to show what he had achieved. So I seen all of this finally coming to a point because I didn't see anything beyond here. The Spirit didn't show me nothing beyond here. So I saw this as the final stage of man's art and his creating or building up. But then he will have to take these things eventually and show them as an art. . . . If he would just take and consider, "I done went as far as I can go. What would I do with all these objects and material things?" [He would] take them and show them as art.

I'm just a manager on earth—not that I'm going to be here forever. When I create, I want to go all the way back to the beginning and just look at the beginning as an art object, create around the pyramid, try to put the flowers back . . . take things and return them, put them in their natural form. The artist tries to show the world, through his different mediums, what time is all about.[37]

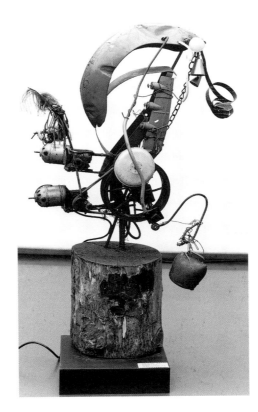

Thornton Dial Sr.'s painting *Taking Care of Old Things (Honoring Lonnie Holley)* (1992; page 23) refers to his friend's found-object sculptures, which Holley makes from things selected not because of their formal associations (their resemblance to body parts, for example) but because their use has given them a sacred status and connotation, like family heirlooms. This is what Holley means when he holds up the iron skillet he retrieved from a landfill and declares, "I've got grandmother." He

LONNIE HOLLEY. *Fighting at the Foundation of the Cross.* 1988. Wood, wire, boots, and electronic panels, 57 x 36 x 15" (144.8 x 91.5 x 38.1 cm). Ronald and June Shelp Collection, New York

PURVIS YOUNG. *Untitled.* 1991. House paint and found wood on plywood, 48 x 73" (121.9 x 185.5 cm). Ronald and June Shelp Collection, New York

JACKSON POLLOCK. *Shimmering Substance*, from "Sounds in the Grass" series. 1946. Oil on canvas, 30⅛ x 24¼" (76.3 x 61.6 cm). Museum of Modern Art, New York, Mr. and Mrs. Albert Lewin and Mrs. Sam A. Lewisohn Funds. © 2000 Museum of Modern Art, New York/Pollock-Krasner Foundation/Artists Rights Society (ARS), New York

PIERRE ALECHINSKY. *Death and the Maiden*. 1967. Acrylic on paper, mounted on canvas. 4'6" x 4'6" (1.37 x 1.37 m). Collection Marion Lefebre, Los Angeles. © 2000 Pierre Alechinsky/Artists Rights Society (ARS), New York

likes to discuss an object's history from its manufacture, to its acquisition and practical use, to, eventually, its final status as art. He then goes further, endowing his selections with attributes that address patterns of human behavior: "I've got grandmother— 'Grand,' someone who has authority and is capable."[38]

Marcel Duchamp used found objects because of their innate physical characteristics, paving the way for their valuation among generations of artists, including Holley's. In contrast with Holley, however, he facetiously chose "readymades" that he recognized as sharing aesthetic similarities with early modernist sculpture (page 24, top). He was less overtly concerned with stimulating metaphoric chain reactions. Neither Holley's nor Duchamp's appropriated objects are one of a kind, nor are those used by Robert Rauschenberg, Bruce Conner, who was once dubbed a "funk artist"[39] (page 24, bottom), David Hammons (page 25, top), or Jean Tinguely. Tinguely frequently selected items that evoke the human figure, as in *Baluba III* (1961; page 25, bottom), in which a pair of lamp switches doubles as a woman's breasts and a metal coil from a particular angle conjures the profile of her face.[40] Many of Holley's sculptures are also anthropomorphic, but they are less romantically sexual, less charming, and more centered on human progeneration. Holley "draws" his figures by bending wire into outlines and gestures in addition to suggesting them through conjunctions of objects. In *Fighting at the Foundation of the Cross* (1988; page 26), wire, supported by an antenna-like extension from the top of the cross, enacts the sublimated body of Christ. The body rises over the wooden armature; at the same time, its crucifixion and death are evoked in a pair of bulky work boots attached to the bottom of the cross where Christ's feet would normally overlap. In some of Holley's works, as in Tinguely's, the human figure is abstracted to such an extent that it is revealed more precisely in photographs than in an encounter with the work in situ. This is also true of the work of the blind Memphis, Tennessee artist Hawkins Bolden (page 46), whose repertoire consists almost entirely of found objects that make or muffle sound—metal lids and containers, soft panels of carpet and fabric.

Although Lonnie Holley may have little in common biographically with Duchamp, Rauschenberg, Conner, or Tinguely, a philosophically oriented art criticism makes it possible to explore these kinds of conjunctions with the goal of clarifying cultural and aesthetic issues. Some of Thornton Dial Sr.'s sculptures (page 31) have formal affinities with those of the ceramic artist Michael Lucero (page 29), although they lack the irony and appropriationism central to

Lucero's work. Ronald Lockett and Julian Schnabel have, at times, used similar imagery and compositional strategies, although they address the world from divergent social perspectives. J. B. Murray and Jackson Pollock (page 28) share an incantatory mode of address, although their paintings differ in provenance and intention. There are stylistic parallels between Purvis Young's paintings and those of the CoBrA artist Pierre Alechinsky (pages 27, 28), but the cultural references involved are worlds apart. Admittedly, the physical characteristics of these works initiate these conjunctions, but within a philosophical frame of reference, formalism introduces multivalent meaning rather than filtering out or excluding specific kinds of artists. Perhaps even more significantly, certain profound differences in the formal characteristics of these works also warrant more detailed critical investigation.

Although the world as "other" may be the point of convergence between African-American vernacular artists and Outsider artists, it is also the point of convergence between them and all important artists who, as an aspect of their lasting significance, will eventually be translated into contexts alien to them. Empathy, not "worldliness," is what makes these translations viable. Thornton Dial Sr.'s *The Coal Mine*, the painting cited at the beginning of this essay, succeeds as art because of its maker's ability "to assimilate by deep affinity" rather than merely to "borrow and display."[41] As in all serious art, this involves an ongoing, and often surprising, reciprocal relationship between artist and audience. "Whatever they may mean, and however they may be perceived and responded to by their contemporaries," Danto writes, "works of art are dense with latent properties that will be revealed and appreciated only later, through modes of consciousness contemporaries cannot have imagined."[42] In the meantime, while the world as "other" may be the point of convergence between African-American vernacular artists and Outsider artists, it is also the point of convergence between them and all important artists who, as an aspect of their lasting significance, will inevitably be translated into contexts alien to them. We need not flinch in the face of this double-edged reality, but we much remember to bear in mind that it is empathy—not just "worldliness"—that makes these translations viable.

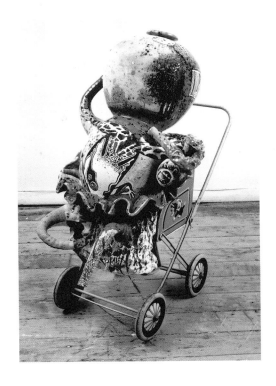

MICHAEL LUCERO. *Anthropomorphic Infant Form with Tutu in Stroller*, from "New World" series. 1993. Wheel-thrown and hand-built white earthenware with glazes and found baby stroller, 27 x 25 x 14" (68.6 x 63.5 x 35.6 cm). Private collection, courtesy the artist

The End of the Outsider

ARTHUR C. DANTO

The inclusion of the artist Thornton Dial Sr. in the Whitney Biennial 2000 exhibition went largely unremarked in the press, and was probably unremarked by most of those who streamed through the exhibition. His work fit smoothly into the context of what the show's curators selected as representative of the present moment in American art, and there was nothing about it to suggest, on visual grounds alone, that Dial is self-taught, a noteworthy "Outsider" artist who was included in the 1997 exhibition at the Schomburg Center for Research in Black Culture, "Bearing Witness: African-American Vernacular Art of the South." Rather, the diversity of work in Biennial 2000, as in the contemporary art world itself, is such that in principle there cannot be specific criteria any longer for distinguishing so-called Outsider from so-called Insider art. On the evidence of how Dial's entries appeared, there would have been no basis for knowing that the artist was not a graduate of Yale or Cal Arts or the Rhode Island School of Design. The Biennial, like the concurrent "Greater New York" exhibition at P.S. 1—or any exhibition that pretends fidelity to the state of visual art today—reflects, like language, according to the French linguist Ferdinand de Saussure, a system of differences. What especially marks contemporary art as a field of differences is that there is no difference, however extreme, that would exclude something from the field on the basis of how it looks. This does not mean that everything is art, but that there is no way of telling by visual inspection alone whether something is art or not. What makes the difference is entirely a matter of philosophical analysis.

Institutionally speaking, the ease with which Dial's work communicated with that of the most highly educated artists of our time is evidence that the borderlines, so difficult to draw, between the artists shown in the Schomburg exhibition and those on view in any venue of contemporary art have lost all relevance. If for no other reason, this made Biennial 2000 a noteworthy occasion. It was an occasion, however, that reflected less on Dial as an artist, or on the Whitney as an institution, than on the way in which art, seen as a system of differences, has evolved in recent times. It also reflects on the structure of contemporary art schools, to any of which Dial could be, or perhaps already has been, invited as a guest artist. The best contemporary art schools no longer see it as their task to teach skills so much as to realize visions. From that perspective, Dial, who knows exactly how to realize his visions, would have little to learn from formal education today.

My aim in this essay is to use Thornton Dial, whose artistic achievements are widely acknowledged, to help bring out the structural transformation in the art world that made his presence in Biennial 2000 at once so remarkable and so unnoticeable.

THORNTON DIAL SR. *Bad Picture (Diana's Last Ride)*, from "The Death of Princess Di" series. 1997–98. Mixed-media assemblage, 87 x 105 x 41" (221 x 226.7 x 104.1 cm). William Arnett Collection, Atlanta

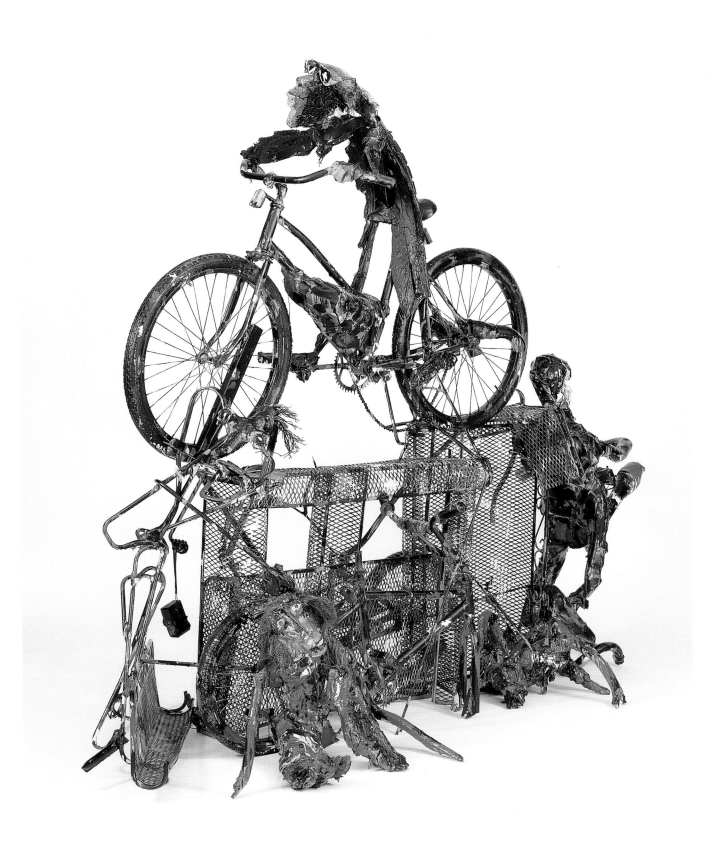

This is not, accordingly, so much a critical essay on Dial as it is a reflection on what has happened to narrow, if not obliterate, the differences between the genre of Outsider artist Dial has heretofore been taken to exemplify, and the kind of artist who would ordinarily be in candidacy for such honorific exhibitions as the Whitney Biennials. It is a momentous transformation, and it calls for an entirely new approach to such artists. It is an approach that in effect demands that, from the perspective of art criticism, they be addressed no differently than artists everywhere. This would go a long way, as Judith McWillie suggests in her essay here, toward dissolving the stereotypes applied to them—and, consequently, to dissolving stereotypes applied to artists of every kind.

There were two works by Dial in Biennial 2000, a painting titled *Stone Walls* and an assemblage, *Bad Picture (Diana's Last Ride)*, both from 1997–98, and each a part of a five-part cycle—"The Death of Princess Di" (pages 31, 34). The two pieces lie on fairly well-marked art-historical paths, which lead naturally into venues such as Biennial 2000. The painting has clear affinities, however the word is to be understood, with certain early canvases of Jackson Pollock, which in turn draw upon innovations in surface, form, and feeling that emerged under Surrealist auspices in New York in the late 1940s and early 1950s. Dial's canvases also physically resemble, according to McWillie, the work of "the CoBrA artists in postwar Paris, such as Karel Appel." The text on Dial in Biennial 2000's catalogue states that "Dial's surfaces, often painted with thickly applied brushstrokes, incorporate the detritus of everyday life: wood, rope, scrap metal, cloth, animal bones, old carpeting, metal fencing, pinecones, fishing lures, rubber gloves, paintbrushes."[1] This goes considerably beyond the occasional cigarette butt and dead housefly that got incorporated into Pollock's canvases, but the incorporation of extraneous materials was entirely in the spirit of his work, which, had Dial been in the art world at the time, would have earned him critical praise for having carried the practice to new heights. The other path, that of assemblage, takes us from Pablo Picasso through Jean Tinguely and many other artists who create work out of discarded objects and fragments of objects with identities in the real world—stove or automobile parts, for example, or old tools. Thus, in *Bad Picture*, Dial uses a girl's bicycle with a slack chain, a boy's bicycle missing a wheel, some lengths of tubing, some steel mesh of the kind used in suburban outdoor furniture, and a camera, as well as some sculptural figures—one riding high, one on the ground, a third perhaps fleeing. And everything is slathered over with paint, in the somewhat scruffy way this was used in the transitional period 1957–64, between Abstract Expression and Pop, especially in the "Combines" of Robert Rauschenberg. Dial's two pieces connect the two sides of his artistic vision—paintings into which pieces of the real world are thickly incorporated, and assemblages of pieces of the real world, thickly overlaid with paint of much the same kind and consistency.

None of this means that Dial himself was influenced by those earlier artists who define these art-historical paths, though I want to leave open that possibility. It means, rather, that visitors to art museums today, most especially to shows of contemporary art, have been sensitized to such parallel features through an internal evolution in the con-

ARTHUR C. DANTO

cept of art, which is so pronounced that it would seem entirely discriminatory to exclude work that possesses these features, merely on the grounds that one of the artists who made use of them is self-taught, or was employed, as Dial was for much of his life, as a metal worker in Bessemer, Alabama. And this is what I mean by the internal conceptual evolution of art. Had Grandma Moses been included in the Whitney Annual of 1943—two years after she had been given, at the age of eighty, a one-person show at the Galerie St. Etienne in New York—there would have been a great deal of grumbling in the critical press and, it is only fair to add, a fair amount of resentment on the part of the artists themselves. She was not, it would have been said, really an artist. Clement Greenberg, who reviewed the Whitney 1943 show for *The Nation*, complained that it showed "how competently and yet how badly most of our accepted artists paint, draw, and carve."[2] Grandma Moses was entirely off the scale in regard to such accomplishments in 1943, and Greenberg would unhesitatingly have dismissed her work as kitsch. One of Grandma Moses's landscapes, incidentally, was the first American work acquired by the Musée de l'Art Moderne in Paris, and she exemplified the American mind to the French mind at that time. This changed in later years, however: in 1961—the year in which Grandma Moses died—Greenberg wrote that now "European critics dwell on how unmistakably Pollock's 'untutored barbaric force'—which supposedly violates rules that Grandma Moses still observes—conveys the youthful energies and recklessness of a people still unschooled in the traditions and refinements of art."[3] My own sense is that had Grandma Moses been included in a Whitney Annual or Biennial at any time during her life, it would have been counted an outrage—a play for popular audiences, as if Norman Rockwell had been included, or Andrew Wyeth. We should be showing *difficult* art, the museum's critics would have said, art on the cutting edge—not crowd-pleasers. Today, it would be entirely normal to include an artist who appropriated the work of Grandma Moses down to the last detail, signature included. (The distinction between a signature and a painting of a signature would be strictly invisible.) Appropriations of Grandma Moses would be difficult enough as art, even if they resembled to perfection art that is familiar from Christmas cards still sold and sent. But nothing like this applies to the work of Thornton Dial in the year 2000! His work does not have an immediate identity as Outsider, Self-Taught, Naïve, Primitive, or Folk. It looks like the art of a very gifted M.F.A. who has had all the advantages, and is well along in a successful career.

There is no other field of cultural expression of which anything like this is true, and it offers us a window into the internal logic of the concept of art. Popular or vernacular music—even music with a powerful ethnic identity, such as the blues, ragtime, jazz, or rap—gets taken up into the compositions of musicians trained in conservatories. The recently commissioned opera *Gatsby*, for example, appropriates the dance music of the 1920s into its exceedingly complex structure. This has always been an available option: Mozart and Beethoven incorporated country dances into their compositions. But except in the spirit of appropriation, one would not expect a contemporary, classically trained musician to compose in a style that could not be told apart from the rap of Snoop Dogg

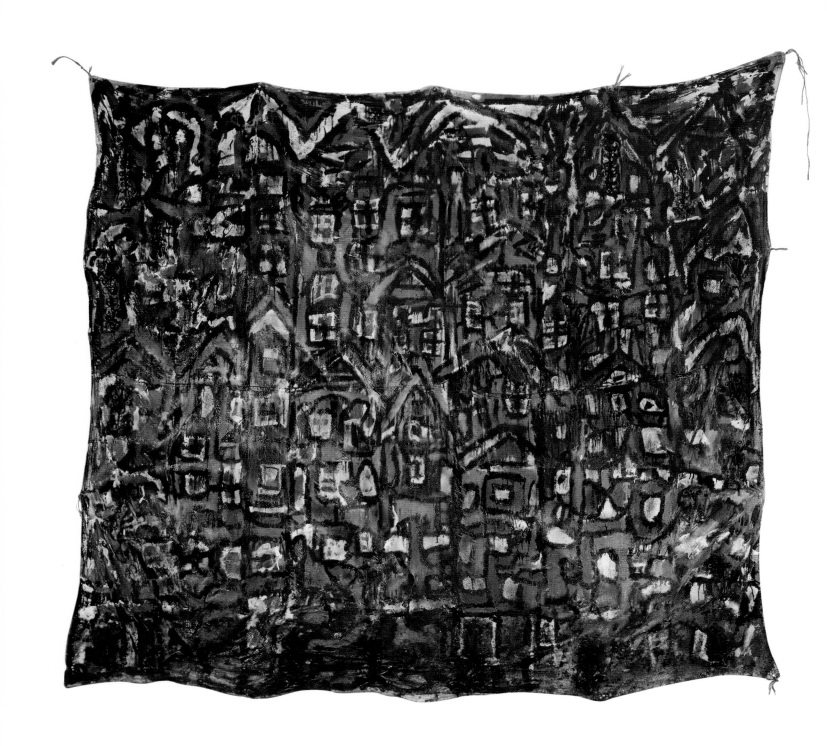

ARTHUR C. DANTO

or Puff Daddy. Nor would the latter represent the cutting edge of conservatory music today. The concept of visual art today, by contrast, has been so revolutionized that it is open to the most highly trained artist to work in any style whatever, no matter how vernacular. In the visual arts, everything is possible and nothing is ruled out.

On the other hand, nothing so blinds us to difference as sameness does. Nothing resembles the Brillo cartons of the mid-1960s more than Andy Warhol's Brillo boxes of that same period, to cite my favorite example. I began my book of 1981, *The Transfiguration of the Commonplace*, with an imagined exhibition consisting of nine identical squares of red-painted canvases, which differed deeply, nevertheless, even to the point that one of them was not a work of art but a mere piece of canvas, square and painted red. The exercise was meant to dramatize what must be added to a physical object to make it a work of art, and the elaboration of this has been the burden of my subsequent work in the analytical philosophy of art.

No one, so far as I know, has undertaken to appropriate a work by Thornton Dial himself, though in "Outsider" art, no less than with Warhol, Marc Chagall, or Salvador Dalí, there are imitators and forgers galore. But it is quite possible to imagine a young artist, entirely out of her own resources, producing a work that resembles "The Death of Princess Di." It could have the same title, since we are engaged in fictionalizing. In her "Artist's Statement," we can imagine her writing, "I had to do it, I just had to do it—for the sake of sisterhood, in acknowledgment of Diana's tragic life and the life of women as victims everywhere." There would, of course, be differences—but these need not be visual differences. The meshwork pieces used in Dial's work, the Biennial catalogue tells us, "are metal fragments from the patio furniture workshop operated by the Dial family."[4] Does this contribute to the meaning of the work? If it does, the work by my imagined female artist would not have the same meaning. The catalogue states that "Ultimately, what Dial weaves into the fabric of his contemporary allegory of a princess is a cycle of death and life." If true, the fact that the meshwork is recycled contributes to the interpretation that Dial's is an "art of regeneration and renewal." Perhaps even the fact that there are bicycles in the work contributes to that meaning, as well as the fact that the five pieces form a cycle. Dial himself says, "Everything in this world gets used up, gets buried in the ground. I dig it up, and give it another life." That is all very powerful—but it does not in the least go with sisterhood and the victimization of women. My imagined artist is not intending a message of reassurance and comfort. She is in a state of lamentation. Had she also made, as part of her project, a painting like *Stone Walls* (opposite), we might ask what meaning inhered in the bent metal flora incorporated into it, as into Dial's painting. Their provenance in Dial's case derives from his biography. He had made these metal flowers years before, as flower holders for his neighbors to set on graves. They carry in his case a precise association with death, and his reuse of them precisely underwrites the idea of death-into-life. It would verge on wild coincidence if our imaginary artist used flower holders that not only were similar to Dial's fragments, but carried that association for her. We would want a pretty clear explanation of how they

THORNTON DIAL SR. *Stone Walls (Diana's Land)*, from "The Death of Princess Di" series. 1997–98. Paint and metal flower holders on canvas, 132 x 144" (335.3 x 365.8 cm). William Arnett Collection, Atlanta

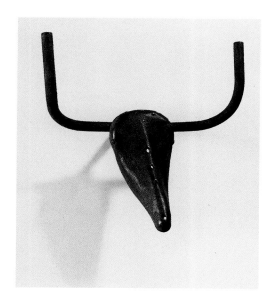

acquired that association. In art as in everything else, there is what metaphysicians call a *principle of sufficient reason* at work. In art there is always a reason why something is there, and it is simply unreasonable that the explanations available to us in Dial's case should hold in the case of someone else.

I have engaged in a piece of speculative art criticism in order to draw attention to *the underdetermination of visual qualities by material means*, and hence to the treachery, we might say, of visual samenesses. There are certain to be deep differences behind such samenesses, almost always, and the evidence of sameness necessarily blinds us to them. So we have to dig into such questions as why a certain piece of material reality is used, and how it contributes to the overall interpretation of a work. It is important to the interpretation of Thornton Dial's work that these pieces of mesh are not so much used as reused, for example—that they have a history of having been discarded, retrieved, and given a new life as part of this work of art.

An interesting difference between Dial and most of the other artists in Biennial 2000 comes out in his biography, which is relatively unusual with respect to those of his fellow exhibitors. The catalogue tells us that when Dial was "discovered" by a collector in 1987, he "had already been making 'things' out of found material for forty-five years. He had never exhibited them, however, nor had he designated them as 'art' or as the work of an 'artist.'" (It was only after his discovery that he began to make large-scale paintings on canvas of the sort that *Stone Walls* exemplifies.) That means that he began to make his "things" in about 1942. The art-historical path I have referred to was laid down roughly at that date, but it is hardly likely that news of assemblage, as it subsequently became called, reached Bessemer at that time. Indeed, Dial may have done one or more of his things before Picasso made his *Bull's Head*, assembled from the seat and handlebar of a bicycle, in 1942 (left). Well before that, of course, art had been made of ordinary objects, and often named on the basis of certain resemblances to them: Duchamp's *Bottle Rack* or *Herrison*—a once-familiar sort of bottle drier—is so named because of its schematic resemblance to a bristling hedgehog (page 24). Whatever the case, *Bull's Head* was unhesitatingly accepted as art because Picasso was, in the first place, an artist by accepted beaux-arts criteria; he had been a prodigy; and he had so revolutionized the concept of pictorial representation that *Bull's Head* seemed a natural step in his career. He had used vernacular materials in his collages—wine labels, oilcloth imitating chair caning, wallpaper. There is a pathway in Picasso that leads to *Bull's Head*; and there is then a pathway leading from it through other artists. Picasso had created a new genre of art, so it was no longer necessary that artists who worked in this genre evolved toward it as Picasso had. They may have seen his *Bull's Head*—or his *Venus de Gaz* (1953) made out of a stove burner—and said: "This is it! This is what, without knowing it, I have been searching for!" But even if it were not a step in their evolution, as it had been for Picasso—even if it meant in their case an abrupt change in direction— they would still need to have been accepted as artists for the new work to be accepted as art.

I cannot sufficiently stress the role that Picasso's prior career and training played in the identification of the *Bull's Head* as art. Could someone else, sometime after the invention of the bicycle, have combined the seat and handlebars, and have said: "Look! A bull's head!" and could the person in question have been recognized, on the basis of the work alone, as an artist? Probably it would have been considered a sort of joke: the art world was not ready for such a thing to be art. Once Picasso and others taught us to see such assemblages as art, others participated in this new genre. But for their work to qualify as art, it was still required—I say this tentatively—that they had already in some way qualified as artists. They had to be able to draw, for example.

The fact, so often invoked in such discussions, is that Picasso *could* draw. He was, furthermore, a marvelous draftsman. That he could draw would have counted, in 1942, toward considering *any* of his work art, and a part of his oeuvre. An ability to draw counts even today, among conservative critics, who feel that such skill at least means that artists are not doing things the way they do because they cannot do otherwise. The lack of trained drawing skill enters into the conservative interpretation of Primitive or Naïve art—that the artists cannot do things "right," and that they would if they could. Until recently they were always measured against a certain academic standard that defined competence and artistic excellence. That the terms *Primitive* and *Naïve* have more or less dropped out of use is as much as anything an index of the fact that criteria for artistic competence have changed.

The history of modernism is in a certain way the history of art schools, which in turn is the history of changing concepts of the artist. Challenging the beaux-arts academy as the standard-bearing, "default" institution, we have had the Bauhaus, the art academy of Vitebsk, where Kasimir Malevich and Chagall taught, Hans Hofmann's schools in New York and Provincetown, Black Mountain College, and finally Cal Arts. These roughly mark the steps in how being an artist was successively taught. (It must also be said that the history of modern art criticism is the history of such art schools. Each implied a different way of appraising art.) It says something about the art of our time that there is no comparable school around—just a lot of different schools, each primarily offering different career advantages.

At a place like Black Mountain, being able to draw, or to draw in a recognizably academic way, no longer counted as validating an artist. Think of the notorious work by Rauschenberg, now in the collection of the Whitney, consisting of an erased drawing by Willem de Kooning—which Rauschenberg insisted had to be a fine de Kooning. He said later that he was interested in the kind of marks an eraser makes, but I see the work as highly symbolic, not so much psychoanalytically—a case of killing the father, as in Harold Bloom's theory of poetic innovation—as art-historically, of the fact that drawing was no longer a means test for being an artist. To this day I don't know if Rauschenberg can "really" draw, but it is scarcely relevant if he cannot.

Let us turn to Thornton Dial's slightly younger contemporary, the distinguished artist Cy Twombly. Twombly began to make assemblages around the same age that Dial

did, in the 1940s. I do not know how many people there would have been, either in Bessemer or in Lexington, who had heard of *Bull's Head*, or who would have considered assemblage to be art in that period. But Twombly certainly knew about Picasso: his first painting, he has said, was a copy of Picasso's portrait of Marie-Thérèse Walter printed on the cover of Jean Cassou's book on the artist. Twombly grew up in an academic community, and his parents were extremely supportive. Beyond that, he had the idea not only of being an artist, but of being a modern artist. This is quite remarkable. Red Grooms wanted to be an illustrator, having seen an advertisement in a matchbook. Robert Mangold wanted to be "like Norman Rockwell." But Twombly had a conception of himself being modern, which determined his choice of schools, and so on. This was not a life plan available to Dial, partly for class, partly for geographic reasons. My point is only that his "things" might not have been seen as art when he put them together, though Twombly's would have been, because the path that led to them was known to Twombly and his circle. Twombly went to Black Mountain, and had his first show in 1951. He knew Rauschenberg, John Cage, Robert Motherwell, and entered into a complex discourse through which his own distinctive style of drawing emerged. Dial could have drawn that way, but it would hardly have occurred to him to do so. One had to belong to an art world for that kind of work to be considered art. By 1987, when Dial was discovered, there was an art world ready to receive him. Meanwhile, it is irrelevant to the appreciation of Twombly's art whether or not he had mastered Beaux-Arts skills.

A final example: the first class entering Cal Arts, in 1970, had the sense that a new generation had come into being through the late 1960s, and that art ought now to reflect their new identity. Eric Fischl has told me and others that the teachers now looked to the students for a direction. All the old distinctions had been wiped out: students and teachers felt they faced a blank tablet. Fischl recalled a drawing class taught by Allan Hacklin, at the time a successful lyrical abstractionist.

> It was about 1970, the peak of crazed liberal ideas about education and self-development. Do your own thing. No rules. No history. We had this drawing class that Allan Hacklin had put together. I arrived late. It started around nine or ten in the morning, but I couldn't get there until eleven. I walked into the studio and everybody was naked. Right! Everybody was naked. Half the people were covered with paint. They rolled around on the ground, on pieces of paper that they had torn off a roll. The two models are sitting in the corner absolutely still, bored to tears. Everybody else was throwing stuff around and had climbed up onto the roof and jumped into buckets of paint. It was an absolute zoo.[5]

Obviously, the ability to draw as understood in the default condition had fully vanished as a mark of validation at Cal Arts. There were comparable developments in music. After a recent concert of electronic music I attended, someone asked what instrument the composer played, and was told that he played no instrument at all. He

ARTHUR C. DANTO

said that he had no interest in that kind of sound. It would be as if one were to ask a DJ, working two turntables for a rap group, what his instrument was. Would it mean anything if he said he had studied the viola? It was John Cage who opened music up to all sounds—the back-up signal from the garbage truck and the rumble of garbage grinding. How important was it that Cage could play the piano, or that La Monte Young could?

Artists who emerged from art schools in the 1970s and afterward were marked not so much by their possession of skills, as by their participation in a kind of discourse. When Fischl went to teach at the Nova Scotia College of Art and Design, in Halifax, it was an exceedingly advanced art school. Painting was taught because there were people who wanted to learn it, but the school rotated around another class of students, the conceptual artists. "The idea was we would go out and learn whatever we needed to do the work

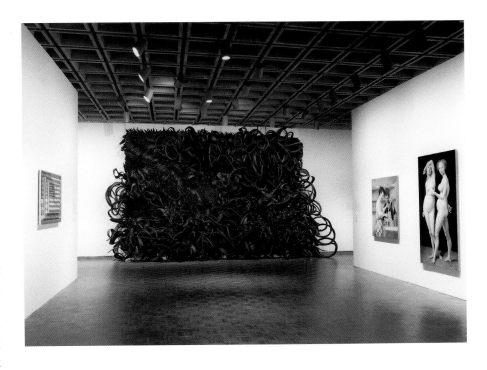

we wanted," an alumna told me. "Paint was no more important than, say, electricity." An art school cannot teach everything a conceptual artist has to know, any more than an art supply store can stock everything a contemporary artist might need—elephant dung, let's say. Fischl, though a Cal Arts alum, got into serious arguments about art education with his colleagues in Halifax, and finally resigned to find his way as a painter. Luckily for him, painting was beginning a spectacular ascent in the early 1980s, and he gained fame and fortune. But in the 1970s, the place of painting was not a given in advanced art schools. What to do about this was part of an institution-defining discourse, and to be a student at Halifax or Cal Arts was to situate oneself with reference to that discourse. What "Outsider" artists were outside of in those years, and through the 1980s, was a body of discourse. The discourse gave art-schooled artists ways to understand what they were doing.

What struck me in Biennial 2000 was that each work on view had its own discourse. One had to infer it in order to identify the work. In a review, I then wrote: "It is as if the works exist on two levels—the level of object and the level of argument, and the wall texts—or catalog entries—assist us in grasping what the work is through explaining what the object means. Often the distance between object and argument is so wide that without the text we would badly misread the object." And I added: "The difference between traditional and contemporary art is that with the former, a certain common culture enabled viewers to know the argument under which objects were intended to be seen, whereas this cannot be counted on in connection with what artists do today. So without the explanation we have no way of knowing what we are looking at."[6]

This is as true of Thornton Dial as of anyone else. Who, looking at the two works I have described, would have been able to infer that they are about the death of Princess Di? The catalogue states: "Swirling forms and colors applied in textured layers tap the deep roots of African-American culture and the pulse of its regenerative inventiveness and spirituality." That sounds like the discourse of identity politics, but I am not sure it was Dial's discourse. I am uneasy about identity politics in art. Critics who subscribe to it are anxious to establish "roots" in an artist's gender or ethnicity. Had an African-American artist made a piece exactly like *Bull's Head*, it would almost certainly have been conjectured that there was an unconscious memory of Africa, so like an African mask does *Bull's Head* appear to be. Enthusiasts for the great African-American artist Bill Traylor are in constant pursuit of African antecedents for what he drew. This sort of speculation is nearly epidemic: in the catalogue for the memorable show of Chaim Soutine at the Jewish Museum in 1998, there was a concerted effort to explain his motifs with reference to early experiences in the shtetl, although Soutine himself was emulating the great masters in the Louvre, in whose company he felt he belonged. That does not refute the shtetl explanation, since the question may remain as to why he selected just the Old Masters he did for emulation—and not Chardin, with his bloody birds and rabbits, for example.

Who knows the capillary pathways of the human mind? I know that Picasso actually saw African art, and that it made a great impression on him. I know, on Dial's own testimony, that his metal floral pieces played a role in ceremonies of death in his own African-American community in Alabama. The African-American artist Chakaia Booker showed an immense wall piece at Biennial 2000, made of twisted automobile tires (page 39). It was of course more eloquent than the piles of old tires one might see behind one of the Flat Fix shops on 110th Street in Manhattan, near my apartment. Alan Kaprow re-created just such a sight at the Martha Jackson Gallery in the early 1960s, and I can imagine the sculptor David Hammons doing something acerbic today along those lines as well. But the elegance of Booker's tires? An identity theorist might say this is a mark of her African-American identity, perhaps thinking about this urban phenomenon in South Harlem. But after my review appeared, I received a fascinating letter from "a visitor to West and Central Africa," who wrote about "the artful displays by African car-parts and car-repair shops" there. What makes these places so striking "are the displays of wares laid out on the side of the road. Hubcaps in all their polished brilliance set out in patterns to catch the sun and bedazzle the passing drivers, tires 'sculpted' into shapes intended to advertise and appeal to the eye."[7] Susan Vogel, former director of the Museum for African Art, writes about African aesthetics as present in the way things are displayed in homes and roadways on that continent today.[8] Whether in the genes or soul, Booker could have learned this aesthetic, whether she ever saw those displays or not.

Let's grant the identity theorist the connection. The greatest piece in Biennial 2000 was by Sharin Neshat, an Iranian woman, an outsider by two counts—or three, if you like, since she is an outsider to her own culture at this point. Do we really want to

segregate her work as Irano-American? She was, at least as a videomaker, self-taught. My view is that she is an artist *sans phrase*, without further qualifying words, with a discourse in which her knowledge of her cultural heritage figures prominently. That is how it is with Thornton Dial as well, and indeed with all the marvelous vernacular African-American artists we have learned about in recent years. They all have their own discourses, and have each found ways to embody these in what they make.

The interesting question has now become: what difference does it make whether someone went to an advanced art school or not? Dial's lack of art schooling has meant that he is treated as an artist of a qualified sort—"Outsider," "Self-Taught," or the like. Why this qualification? Why not simply class him and his peers as artists *sans phrase*? My guess is that a number of writers and collectors are still invested in the existence of an art alternative to Official Art, especially because Official Art represents such a wide system of differences that any artists can fit into it. This is the kind of investment earlier thinkers had in the idea of the folk, the primitive, and the like. With this exclusionary nomenclature, artists who had not had the benefit of art education could still be appreciated, collected, and exhibited. It is against this that the act of including an artist like Dial in Biennial 2000 has special meaning.

There are those who have vested interests in artistic segregation, but I have a vested interest in pluralism, and I would like to see more and more of what Biennial 2000 did—yesterday's "outsiders" side by side with all the bright M.F.A.s. At the very least, the discourse of the Outsider is up for serious revision. In the year 2000, for my part, there is no longer an art of the Outsider.

Becoming Art: Life Spans, Biographies, and the Shelp Collection

GREY GUNDAKER

In an influential article published in 1989, the anthropologist Igor Kopytoff coined the useful phrases "biography of an object" and "biographical approach to things."[1] He reminded us that things do not exist solely in the forms that we recognize most easily—"egg beater," "ice cream," "Art." Rather, things have life spans stretching from raw components, through production and use, to destruction, dissolution, discarding, and occasionally on from there to resurrection through recycling and reuse. The main events in a life span vary among objects, historical eras, societies, and segments within them. While homemade objects put to immediate, local use make up a minute sector of production in the United States, most things are designed and produced in capitalist enterprises to be marketed as commodities. Markets develop so that the things that matter most to consumers can be obtained only after several monetary exchanges have taken place, from production through warehousing to retail purchase. Thus the things, the desire to own them, and the functions they serve all grow up more or less in concert, while at the same time spanning great distances, many people, and numerous, changing settings.[2]

At least since the Renaissance, Art in the West has shared in the characteristic process involving creation of demand, selective distribution, and scarcity along with other costly commodities. Further, as thinkers from Duchamp to Danto have pointed out, all sorts of objects—from urinals to giant replicas of clothespins—may sojourn for part of their life spans under the rubric Art, given the right setting and the right words to label them. Art, in the Capital A, Western sense, is that which finds a place in the discourses of Art criticism and Art history, and the settings of Art acquisition and display, by way of demonstrated market desirability.

The biographies of artworks, then, must take all this and more into account as essential parts of the lives of the works: a tall order, and a different one from customary approaches to art writing and artists' biographies. Fine-tuned to the Art world and the market to which it contributes, such writing usually focuses on slices of life keyed to specific events like exhibitions. This essay is also occasioned by an exhibition and by the Art market, broadly construed, but is, I hope, not limited to their interests. I will discuss some of the cultural practices that help make art Art, including the works in the Ronald and June Shelp Collection, and suggest at least some of what fuller biographies of the works and their making could include. My main concern is the process by which things made from palpable materials continue to be remade by the framing potentials

of different settings, talk, and writing. All this affects how works look, and even what they are.

To examine this process, the following essay moves back and forth along the life spans of people and things, and in and out of varied settings, from the home ground where some of the works were made and first used, to the "middle distance" that the works passed through when they were collected (or harvested) for market, and to their current settings in the Shelp residence, in this exhibition, and as subject matter in catalogue reproductions. The points of view I bring to this task come from my background as a white Southerner, a product of schooling in studio art and art history, a former employee of a couple of large art museums, and, finally, as a cultural anthropologist whose research focuses on art, landscape design, and the production of knowledge in the African diaspora.

This research has put me in touch with numerous people working out of their homes and yards whose work is usually not contained or delimited by the Art world or its market, but nevertheless has much in common with works collected for it—including some in the Shelp collection—in terms of philosophy and materials, if not portability (page 44, top).[3] As people who have selected visual, tactile, and spatial modes rather than, say, musical performance, for their primary expressive media, these artists seem to have much in common. They draw on an extensive pool of cultural resources and historic concerns, but they also make works with a highly individual stamp, works they put to highly personal purposes.

This is their only difference from so-called schooled artists. Schooled Art or studied Art tends toward a more limited range of purposes, formats, materials ("art supplies"), and physical placements (such as walls and pedestals), which its public recognizes easily and which permit it to move from one setting to another without much change in "meaning." Schooled art fits the specs for distribution and sale in gallery-like spaces, even if the preponderance of what is made spends most of its existence on a family-room wall or in a closet.

Most of the work in the Shelp collection seems to bridge these differences. Its formats fit easily into Art world expectations, but the work also retains a strong foothold on the kind of home ground that continues to be largely invisible in the Art world, except perhaps recast as a vague, exotic, and authentic Elsewhere. This is work that comes from the place of Raw Vision, the same mythic universe that encompasses mental hospitals, Darkest Africa, Remote Cathay, and Mississippi. (And it excludes the realm of lofts, clubs, and magazines, though that realm alludes to such places in its texts, images, and decor.)

How should we refer to the art and artists in the Shelp collection? A major reason the term *self-taught* is absurd is that it could fit all artists equally well: indeed, instructions for recognizing and making Art saturate the culture, even if schooled credentials do not. *Self-taught* is not a descriptive term but a marketing tool: it doesn't provide reliable information about works or artists, but it markets both as authentically original and American—as self-described, self-taught American artists as far back as Thomas Cole

EDWARD HOUSTON. "Dressed" yard of painted shoe/souls, chair/ throne, pillars with stones/heads, whirligigs, and root formations. Center Star, Ala. 1988

HAWKINS BOLDEN. His house and backyard. Memphis, Tenn. 1986

and Jasper Cropsey well knew.[4] *Vernacular* also poses problems. While it is a useful word for talking about language use, especially the ways people distinguish everyday from high speech varieties, its usefulness for talking about art/Art is undermined by the cultural dynamic that substitutes less offensive-sounding terms without substantive change in what the words refer to. Thus, for example, *primitive* peoples came to be called *preliterate* people, but the same groups of people receive the same type of marginalization either way. In the same vein, as things stand now, *vernacular* is just a more PC way to designate the same old self-taught, folk, authentic-because-not-schooled market niche(s).

Making Places for Art

Unless or until commodification occurs, the members of the artists' communities I am discussing here are as disinclined as anybody else in America to call their work Art. Whereas the Art world depends on talk, writing, and textual classification systems, people in these artists' communities also work with an additional set of ground rules that calls for treating the meaning of the work as self-evident—especially when the artist has placed it in, and more likely, made it for, his or her house or yard. The photograph below reproduces a photograph of Hawkins Bolden's backyard taken before much had been removed from the site for sale. The photograph on page 45 shows not only the "scarecrow" faces for which the artist is well known but the mutually reinforcing placement and massing of his figures. Also clear from these photographs by Judith McWillie (but not from Art reproductions like that on page 46) is the visual bond between the work and the rest of the yard, the resonance between the textures and shapes of the materials Bolden used and those of his clapboard house and fence (an integration every bit as important to this work's raison d'être, I would argue, as the Arena Chapel is to Giotto's frescoes), and their stark contrast to the modernist concrete building looming over the Bolden residence. But the photograph on page 46 has its uses, too, drawing the eye into the details of this work as a singularity, with lots of blank space to fill in with appreciative and critical talk. Today, on page 46, we see a wonderful sculpture; in 1986, the photograph on page 45 captured an obviously well-watched enclosure made by a man who could not see.

The contrast in approaches implicit in these illustrations becomes even more apparent if we compare the sheer volume of explanation fomented by something wrapped by Christo with the amount about the tree planted, pruned, and wrapped by Sam Hogue (page 47). In neighborhoods like Mr. Hogue's, as well as Hawkins Bolden's, a special power of the visual is that what's *seen* doesn't have to be *said*. In this way, seeing is diagnostic both of mother wit and acquired knowledge.

In the photograph on page 48, if you can't see the cruciform that becomes a spiral form in the turning fan and the roses—the ephemeral red circle they make together as the fan blades move—and if you have to *ask* why that matters, then why would you be a person worth *telling* in the first place?

The tacit, unspoken, and unspeakable dimensions of verbal-visual relations are deeply entrenched ways of seeing and understanding throughout the world, but precisely what remains unsaid and unsayable changes with context and setting.[5] Changing criteria for the sayable vary across the lives of artworks, which is why the biography of an artwork must account for many forms of talk, not just the usual Art ones. Biographers of artworks must also recognize that what people say or do not say is itself a form of action, and not a reliable indication of what or how much or how little people know. Similarly, in many Art world settings, it is regarded as tasteless to talk about Art in monetary terms, but this certainly does not stem from ignorance about prices.

Much of the work of making art into Art involves channeling talk that defines a segment of the work's biography, setting its future life course. When artworks enter the market, dealers often try to enhance their value by getting the work talked about, placing objects advantageously in collections that make them more desirable. In the Shelp loft, beyond furniture grouped for conversation, works by Joe Light and Lonnie Holley form their own "conversation" clustered in one corner, one that relates them in ways previously impossible in their makers' homes (page 49). When the loft was illustrated in *House & Garden*, the caption copy opened even more connections and new conversations, adding an interior designer, rug manufacturer, and a retailer of garden furniture to the mix, and displacing Art from the content of the collection to the quality of the display: "High ceilings and ample wall space allowed [Jeffrey] Bilhuber to display the Shelps' collection in interesting ways. . . ."

Most of the work now in the Shelp collection was initially acquired, warehoused, and distributed by an Atlanta dealer and collector, William Arnett, who kindly showed me his collection in December 1987 and discussed his business and personal relationships with the artists. In the huge Arnett home, rooms upstairs and down doubled as storage and display spaces. In their sheer volume and the diversity of materials, the works jumbled together combined to resembled miniature, interior yard shows, in many ways more like actual yards such as Lonnie Holley's (page 50) than the usual rooms of a suburban house. The main organization of the collection came not so much from the works themselves or their placement as from the fabric of stories that Arnett built up around them as he talked, including the assertion that the best of everything the artists had produced belonged contractually to Arnett alone, through the right of first refusal. This fabric of talk about the work and also as a form of acquisition of it has spread over the intervening decade through numerous other voices. They culminated in *Souls Grown Deep*, a massive catalogue of the exhibition, during the 1996 Olympics in Atlanta, of Arnett's collection and the work that has passed through it. While this document seems once and for all to assert authoritatively the Artness of the work, at the same

HAWKINS BOLDEN. Assemblages in his backyard. Memphis, Tenn. 1986

HAWKINS BOLDEN. *Scarecrow.*
c. 1988. Found metal, carpet, wood,
and nails, 79 x 25 x 14" (199.8 x 63.5
x 35.6 cm). Ronald and June Shelp
Collection, New York

time it also seems to strive to place one art dealer's imprimatur on as many textual avenues to the work as possible, in effect managing the marketplace of ideas as well as the market for the objects themselves.

Making a Place in History

All this shows that although special sites exist for art sales, the Art market overall is a more diffuse arena, where placement, talk, and writing create equivalences between monetary value and quality through accounts of objects and their makers' lives. As a result, success, when and if it comes, seems "natural": not a matter of chance or marketing, but a logical outcome of the excellence of the work and the talent of the maker.

The Shelp collection has already been written about in ways that show these cultural processes in action, placing the work critically and art historically, and in the process renegotiating the works' value and standing as Art. In the 1996 catalogue for the Shelp collection (as it then was), *Wrestling with History: A Celebration of African-American Self-Taught Artists,* Sandra Kraskin opened her thoughtful essay with a series of questions, including: "Why do the works of self-taught artists radiate such intensity, such visual power?" and "Why do well-trained 'mainstream' artists appropriate elements of so-called 'outsider' art created by self-taught artists?"[6] Kraskin's reply is that all artists must confront their history. Building on the literary critic Harold Bloom's assertion that unlike weak artists, "major figures . . . wrestle with their strong precursors, even to the death," Kraskin argues that the education of "mainstream" artists compels the most serious among them to respond to the history of Western art. In contrast, she says, self-taught artists like those in the Shelp collection bear no such burden; they "create themselves," and "directly confront their own history, their own vision of the world, or other aspects of their cultural heritage."[7] This, she proposes, is why the work of "non-Western[ers] . . . children . . . and mentally handicapped patients" provided source material for early modernists like Picasso and why Abstract Expressionists mined sources like jazz and shamanic rituals.[8] African-American "self-taught" artists also fill the bill, with Thornton Dial Sr., for example, embodying the "postmodern struggle to deconstruct the exclusionary categories of modernism."[9] If this sounds reasonable, it is in part because writing like this about Art also contributes to the criteria for reasonableness itself. In short, as Clifford Geertz pointed out many years ago, common sense, like Art, is a cultural system.[10]

This means that statements like Kraskin's—and mine—are *inside* the processes they are also *about*: the history of art and the dynamics of Art-world making. Reciprocally, they contribute to all sorts of other relationships, including political, economic, and social relationships that affect virtually everyone in the West or the "world system" one way or another. If enough people strive to do so, the inequities in these relationships can be changed, but at present they are endemic. Thus, not surprisingly, the same categories of persons who are excluded from the modernist canon, and who offer a valuable

SAM HOGUE. "Dressed" tree, Chattanooga, Tenn. 1988

SAM HOGUE. *Untitled.* 1988.
Electrical fan with collage. Collection
of the artist, Chattanooga, Tenn.

resource pool of styles for academically trained artists to emulate, are also those least likely to directly benefit financially from the resale of their work. However much the sale and display of the work may seem emblematic of "the postmodern struggle to deconstruct the exclusionary categories of modernism," exclusion is an Art-world given, for without scarcity there is no demand and no commodity value. Thus the rationales for the works' place in Art history are crucial aspects of their biographies.

For works in the Shelp collection, according to Kraskin, major rationales for inclusion consist of the artists' "self-creation," "their own vision of the world," and their "directness." She points out that Thornton Dial's "history is the history of the black experience in America, not the history of American art."[11] It is clear what she means: Dial can get along just fine without addressing Thomas Eakins, Henry Tanner—or Picasso. From the standpoint of cultural processes, however, the implication is also that somehow the history of art in America exists apart from the history of race, commodity capitalism, politics, and all the rest. One solution is to invoke postmodernism at this point and to explain works like those in the Shelp collection as quintessentially postmodern in style and outlook. Whereas the old order of art was exclusive and apolitical, the new one is inclusive and sensitive to politics, et cetera. A key feature of this line of argument is that it presupposes a conceptual space for the so-called self-taught that Kraskin calls "their own," a space distanced from the history of "Western art." This argument is a serviceable one, recurring in varied forms from at least the late nineteenth century through the present. Indeed, it is itself a well-entrenched part of the Western cultural heritage.

The argument has at least two elements: first, that "strong" artists break free of precedents; and, second, that members of some categories of people have less trouble doing this than others. Implied as well by words like *major, minor, strong, weak, radiate, power, intensity,* and *create*—linked closely to words like *self*—is a parallel hierarchy of values. In that hierarchy, a highly valued artwork in market terms implies a highly autonomous self in psychological terms. This cultural outlook is integral to the very designations *Western* and *non-Western* alike. For example, non-Western art is in part defined through the ascription of Other "cultural heritage(s)" by travelers, politicians, art historians, and anthropologists (like me). Such Western ideological complexes as individualism have helped to represent the history of art in a narrative of periods, movements, and the individuals who made them. For example, Cimabue and Giotto "broke free" of the conventions of medieval art, turning the tide toward the deep pictorial space eventually realized in High Renaissance art. Or, "in 1907, Picasso transformed the history of Western art with bold distortions of the human figure based on his study of African masks and Iberian sculpture."[12] Picasso, then, took advantage of preexisting works (non-schooled art) to transform (schooled) Art. Ditto Abstract Expressionists, who

appropriated ideas from Zen and jazz. Artists like those in the Shelp collection, however, do not need to shop in the multicultural marketplace of Othered arts because they are designated Other already—more primal, more authentic, closer to "real" history as opposed to "art" history, more folked, more heritaged, more "Outsider," more whatever is best marketed. In sum, built into the cultural heritage of Western Art is a striking parallelism among: (a) the territorial expansion of colonialism; (b) the market expansion of capitalism; and (c) the ever-receding horizon of individual "creativity."

Becoming Art, Becoming an Artist

Within this global scenario, the life spans of particular artworks and the people who make them entwine and diverge in ways that form important parts of the biographies of both. At the same time that a work is becoming recognizable as Art, it is also taking on a life of its own through fetishization. As a result, the work seems less to be acted upon by the people who produce, exchange, and talk about it, than to become a quasi-living agent in itself, with inherent value and the capacity to act upon human beings and their environment.[13] A necessary part of market success is the distancing of producers of artworks from the products of their labor in a number of important ways. Physically, collecting inevitably takes objects from one place to another, or perhaps through a long series of places, over many years and even generations. Experientially, the exchange of the concrete work for the abstraction money is alienation in the classic Marxian sense, for whatever use-value an object might have had initially is obscured by its value as a commodity.

Today, alienation also involves a more postmodern politics of identity because success entails reclassification of objects and producers alike, drawing on a pool of possible identities and criteria. In places where objects are exchanged, housed, and discussed—where, in effect, objects become Artwork—the same activities that bring Artworks and artists into the public eye also obscure much that is local and particular about them. Without McWillie's documentation to guide them, most viewers would have as much difficulty imagining a Bolden sculpture in the Bolden yard as a toddler would have in connecting her cup of milk to a cow.

The evolving reputations of makers remain associated with their Art objects but become increasingly remote from even the most important aspects of everyday existence, like making a living and being part of a family and community. With time and talk, the identity of the skilled *welder* sweating over a blowtorch in a *workshop* is effaced by that of the *sculptor* confronting the problems of Art in a *studio*. He or she, in turn, may emerge as a full-blown Artist like Picasso or Thornton Dial Sr.: a creative personage who has "confronted history" to triumph over those who have gone before—if discerning dealers, collectors, and critics open the way with placements in collections and museums and there is sufficient talk and writing about the work. Eventually, in settings like the Shelp collection, the phrase "a Holley" is more likely to refer to the work on page 51 than to a member of the Holley family in the photograph on page 53.

Living room of the Shelp home, showing works by Joe Light, Lonnie Holley, Mary T. Smith, Ronald Lockett, and Mose Tolliver

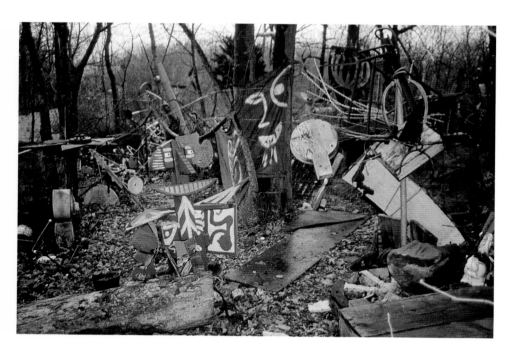

LONNIE HOLLEY. His backyard facing south, Birmingham, Ala. 1992

Opposite: **LONNIE HOLLEY.** *Untitled.* c. 1988. Mixed media, 52 x 20 x 17" (132.2 x 50.9 x 43.3 cm). Ronald and June Shelp Collection, New York

Parallel transformations that make art Art and artists Artists also go on in the talk of viewing and reception and personal identity. Work that neighbors and even makers themselves call *junk* or *fooling around* or a *hobby* or *art therapy* becomes *composition, assemblage,* and so forth. Association with venues from garages to galleries, stylistic labels like *Abstract Expressionist* or *Cubist,* training-oriented terms such as *self-taught* and *M.F.A.,* and cultural ascriptions like *African-American* and *vernacular* all help to transform specific producers with concrete biographies into tokens of the types that matter in narratives of Art talk, Art criticism, and Art history. The basic terms of transformation like *better* and *worse, in* or *out,* remain pretty much the same regardless of the market niche, be it folk or fine, kitsch or kindergarten.

Nevertheless, niches rarely seem to remain stable in the formative years of an artist's reputation. In addition to the problems that categories like *tribal, folk, Outsider,* and *self-taught* pose to cultural hierarchy and power, from the marketing standpoint such labels also have a kind of "yes, but" ring to them. Work marketed under them may cost more than a lot of schooled Art (hence the resentment by the schooled of the success of the unschooled), but the labels still project latter-day Primitivism, if not downright racism, by ascribing "simpler" social conditions and a "more direct," "unmediated" emotional climate to the maker's social milieu. In exhibition catalogues (page 52), the biographies of artists labeled *Outsider* or *folk* more often take the form of stories while those of artists considered schooled take the form of lists of dates and events, even though the exhibition has ostensibly leveled such outmoded distinctions. This difference in mode of representation seems to imply that the schooled have "careers"—that the life spansof the objects they made include many important stepping-stones and that the artists themselves are the primary architects of their own success—whereas those cast as unschooled (true or not) have instead been "discovered" by someone else, and that their lives before this momentous event are important mainly as an authenticating backdrop to it.

Whenever the work's value and prestige increase within a classificatory niche like folk art or when the account of the maker's career is constrained by close identification with a particular subculture or ethnic group, pressure mounts to find more "accurate" labels. But given the demand for novelty, most market categories have a limited shelf life. Even boredom may be a factor. The reviewer Michael Kimmelman wrote in the *New York Times* when part of the Shelp collection was exhibited:

It's crucial to the drama of vernacular or outsider art, whatever it's called, that it involve discovery: the cliché of the neglected artist found making masterpieces in the backyard (schoolroom, asylum, et cetera). Yet outsiderism is now a business, buoyed by popular interest—some of it dubious interest in the exotic—which means the luster of discovery has been dulled by routine.[14]

When transitions from one category to another are occurring, the concrete details of production and even some of the most important events in the artist's life may seem to "get in the way" of "progress" to "better understanding." For example, a recent review of an exhibition of the work of Nellie Mae Rowe at the Museum of American Folk Art in New York stated that it was inappropriate for the show's labels and catalogue to mention biographical details like Rowe's employment as a domestic worker, or her childlessness in connection with the many dolls that she made.[15] The implication was that these factors were irrelevant to the work itself, tended to exoticize the artist's life, and diminished her personal accomplishment by treating culture as an explanatory factor for her when for nonfolk artists it is not. The reviewer pointed for comparison to concurrent retrospective exhibitions elsewhere in the city of paintings by Vincent van Gogh and Jackson Pollock, where the accompanying texts did not discuss the artists' lives but only the aesthetics of the work. Forgotten was the fact that vastly more biographical information on Van Gogh and Pollock than on Rowe is already available. For the former, then, culture is a tacit rather than explicit factor because it is assumed to coincide with audience expectations. Also, in contrast to Rowe's, the lives of Pollock and Van Gogh have already been assimilated into the Western cultural stories of Art and artistic greatness. (On the other hand, it was also forgotten that aspects of their lives like Van Gogh's notorious ear, and production methods like Pollock's my-kid-could-do-it paint pouring, have also offended the finer sensibilities of some Art writers while flowing easily into the narratives of genius and rebellion "even to the death" penned by others.)

The complaint about the Rowe show illustrates that where artists' reputations are concerned, their "getting a life" involves a damned if you do, damned if you don't situation—for all concerned. Obviously, biographical accounts of artists and objects alike do not comprise simple factual information passed along unmediated to audiences for their edification. Rather, information about the artist or omission of it is part of the social production of Art as a commodity. The need for such information on the audience's part, and the kind of information that it would attend to, depends a great deal on its general education—though not necessarily its schooling. If the audience is content within the Western paradigm that presupposes aesthetic universals and a separation between Art and daily life—and if it accepts that arts connected to daily life like folk and decorative arts deserve an inferior status—then it seems unlikely that information about the artist's life and community will ever be more than a backdrop to the main aesthetic event. Indeed, when such information is offered, it seems inevitable that some critics will claim that the artist is belittled, because if the work seems reducible to culture or tra-

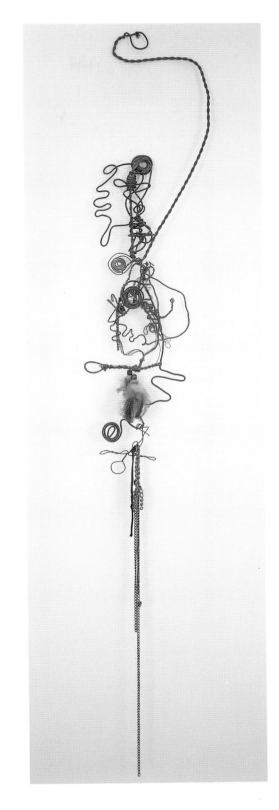

Page from Southeastern Center for Contemporary Art, *Next Generation: Southern Black Aesthetic*, exh. cat. (Winston-Salem, N.C.: University of North Carolina, 1990), 131

dition, then the artist seems equally to have flunked—to have wrestled with history, perhaps, but to have stopped short of the essential goal of "self-creation."

Of course, elements of biography also serve as authenticating tools for the market. One reason is that in contemporary Europe and America it is virtually traditional that anything far-out enough can signify successful self-creation. This is quite clear when the stamp of vicarious rebellion adheres to the thoroughly schooled artists who collect and imitate the work of "Outsider" artists, and also when "Outsider" music venues like House of Blues rely on work by such artists as Mose Tolliver to create ambience. In today's market, this ostensible yet nonthreatening rebelliousness not only recasts provocative work into a decorative art backdrop for the hip audience-members' own performances, it also provides a perfect complement to the universalistic aesthetic approach it seems on the surface to resist. Both approaches—outsiderism and aestheticism—pave the way equally for collectors, dealers, viewers, art historians, and anthropologists—everyone, in fact, except the artist—to take over the role of primary agent in the Art-making process. All of them can display their own discernment and connoisseurship by making "discoveries" that put the artist and the site of the work's production at a safe distance. This not only downplays artists' lives, ideas, and communities; it also implies that the audience already has a full grasp of the work and that nothing more needs to be learned. If values different from those this Art world, now, considers relevant were important in the life of the artist or the making of the work, they no longer matter. What was intended to carry moral force in society has now become part of the epic narrative of Art history. Safe. Contained.

For the works in the Shelp collection and others like them, this is a great loss. If my conversations with these and like-minded artists are any indication, they made much of their work to point to better ways of living in the world. Concepts of justice, reverence, and love of one's neighbor motivated much of this work, but in the contemporary Art scene, the words have at best a corny, didactic ring; at worst they seem sentiments that only a naïve outsider could possess. But these artists and these works deserve a lifetime of consideration. They earn their places in the history of art philosophically as well as visually because the demands they make are not so much rebellious as revolutionary. They already engage epistemological issues. They certainly do not need to be theorized into profundity by professional philosophers and critics (although such talk and writing will probably increase their market value). Rather, putting the arrogance of aestheticism and outsiderism aside opens the way to asking more interesting questions: What would a well-lived life involve, according to Mary T. Smith or Hawkins Bolden? What instructions for living such a life can be found through their work? The answers may prove highly unsettling.[16]

In any case, if the goal is Art-world success and endurance, works like those in the Shelp collection must shed the skin of lesser classifications and assume the full raiment of Art per se, reckoned among the best of their era. Much of the Shelp collection is on the cusp of this transition and, to the extent that this art world has a "top," Lonnie Holley, Ronald Lockett, and many others are as deserving as any to hold this position. The problem is that, like relabeling, the means of transformation are double-edged. Although Art claims to occupy a kind of intellectual and moral high ground, based in part these days on its increasing inclusion of women and minorities (who, of course, outnumber white males anyway), it remains the case that in an economy based on scarcity, only a few can get in. The much-hailed democratization of Art is, and must be, demographic, not quantitative. On their new, rarefied plane, not all the artists in the Shelp collection will be created equal.

Lonnie Holley with his wife and two of their children

In practice, physical adaptability may be as important a factor for this art's elevation as its aesthetics and evocations of self-creation. Some works in the collection—for example, drawings and paintings on rectangular surfaces like those by Thornton Dial Sr., Purvis Young, and Mose Tolliver—correspond in their flatness and shape to interior walls. The surfaces and edges of such works seem to make them easy to move from one mainstream interior to another without an appreciable effect on the work or the viewer. (Of course, this illusion depends on the role of Art history and criticism in orchestrating expectations.) Other works in the collection also adapt well to modernist interior conventions, probably because these conventions still serve for most viewers as the best conditions for viewing Art. The charge for diversity, and the necessity in these postmodern, pluralist times for navigation in multiple domains of cultural knowledge, remains effectively contained within the part of its life span a work leaves behind, along with its initial community, and the specifics of its production within the maker's moral universe.

Distinctions from worse to better, from ordinary to adequate to great, so thoroughly saturate contemporary American experience that people find it hard to recognize or describe socially worthwhile selves without resorting to such language. Like monetary exchange value, personal worth often finds expression in terms of rarity; only in Garrison Keillor's utopian Lake Wobegon are the children "all above average." Hence, the current contestation over labels like *folk* and *Outsider*, as well as *American, Art, Literature, literate, learning disabled,* and so forth: all mediate access to or denial of opportunities, resources, institutions, and identities, and help inequities thrive. Indeed, the positive tone of "rarity" and the negative one of "inequity" seem flip sides of the same coin; how can one be possible without the other? As a result, Art institutions must not only help to educate people to appreciate Art but also show them *how not to appreciate,* how not even to recognize as art vast amounts of the aesthetic-productive activity that takes place around them—until or unless the work shifts identity from whatever it was in everyday life to Art.

Feeling at Home with
Vernacular African-American Art

KINSHASHA CONWILL

In the fall of 1990 I was invited to participate in the symposium "Cult, Culture and Consumers: Collecting Self-Taught Art in Twentieth Century America," convened by the National Museum of American Art and the Archives of American Art, in Washington, D.C., to discuss the work of self-taught African-American artists. The editors of *American Art*, the journal of the National Museum of American Art, subsequently asked me to write an essay based on my symposium paper that would emphasize the relative acceptance of self-taught black artists versus that of trained black artists. At that time I wrote:

> In the past two decades, the art of self-taught African-American artists has been increasingly in demand. What is it about this art that is so engaging that curators, collectors, dealers, critics, and trained artists have devoted major exhibitions, publications, hours of discussion, and passion to its study and acquisition? Is it mere coincidence that so many of the artists are southern, poor, black, and without formal training and that those who collect their work are often white, educated, and affluent? Why are some of these same individual collectors and institutions apparently less interested in the work of trained black artists, such as Maren Hassinger, Melvin Edwards, or Howardena Pindell? Is the incorporation of formalist strategies by these artists a liability? Is the work of self-taught artists somehow more "authentic" because it is, as artist and collector Roger Brown asserts, "produced outside the mainstream art world hierarchy," the place where the "*only* real artists are nurtured"?[1]

Not unlike the complex web of social, political, and cultural history, and the current practice in which it is embedded, the role of all African-American visual artists remains contentious and unresolved. While in the intervening years my views on the subject have become more nuanced, as has the larger dialogue on vernacular African-American art, I am still powerfully attracted to the work of self-taught African-American artists, with its overtones of romanticism and the lure of "pure" or "authentic" or "primitive" expression. Yet I find definitions of it no less complex. A part of the complexity lies in the oppositional nature of the conversation about it. This dialogue pits the work of self-taught artists against that of the trained, in a zero-sum game that privileges the "outsider" over those in what Roger Brown calls "the mainstream hierarchy."[2]

FAITH RINGGOLD. *Tar Beach*, from "Woman on a Bridge" series, part I. 1988. Acrylic on canvas; bordered with printed, painted fabric, quilted, and pieced cloth, 74⅝ x 68½" (189.5 x 174 cm). Solomon R. Guggenheim Museum, New York, gift of Mr. and Mrs. Gus and Judith Lieber

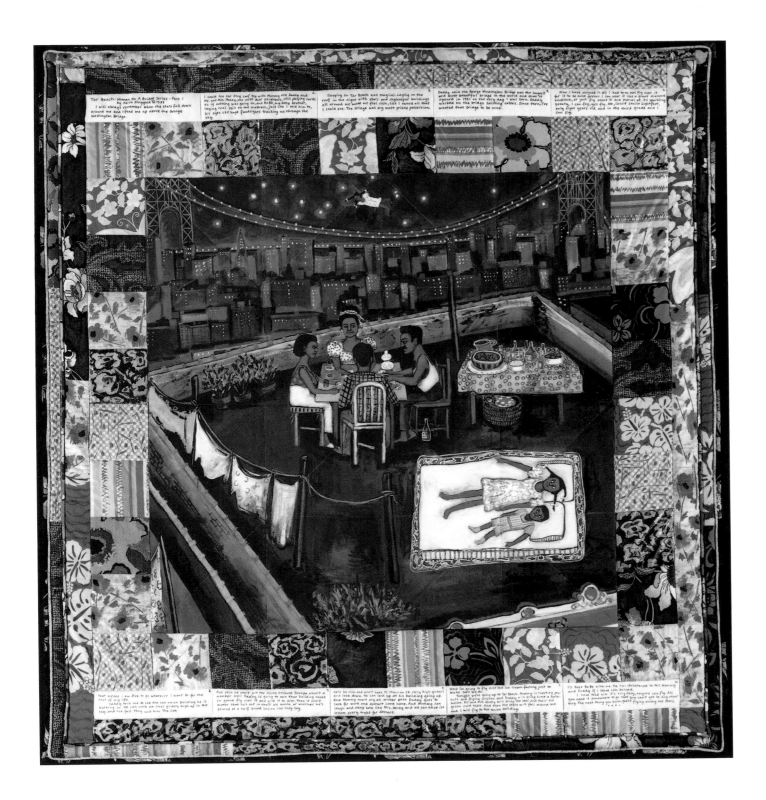

Tar Beach—Women On A Bridge Series - Part I
by Faith Ringgold © 1988
I will always remember when the stars fell down around me and lifted me up above the George Washington Bridge.

I could see our tiny roof top with Mommy and Daddy and me and Mrs. Honey, our next door neighbors, still playing cards as if nothing was going on, and BeBe my baby brother, laying real still on the mattress, just like I told him to, his eyes like huge floodlights tracking me through the sky.

Sleeping on Tar Beach was magical. Laying on the roof in the night with stars and skyscraper buildings all around me made me feel rich, like I owned all that I could see. The bridge was my most prizing possession.

Daddy said the George Washington Bridge was the longest and most beautiful bridge in the world and that it opened in 1931 on the very day I was born. Daddy worked on the bridge hoisting cables. Since then, I've wanted that bridge to be mine.

Now I have claimed it All I had to do was fly over it for it to be mine forever. I can wear it like a giant diamond necklace, or just fly above it and marvel at its sparkling beauty. I can fly, yes fly. Me, Cassie Louise Lightfoot, only eight years old and in the third grade and I can fly.

That means I am free to go wherever I want to for the rest of my life. Daddy took me to see the new union building he is working on. He can walk on steel girders high up in the sky and not fall. They call him the Cat.

But still he can't join the union because Grandpa wasn't a member. Well Daddy is going to own that building cause I'm gonna fly over it and give it to him. Then it won't matter that he's not in anybody else union, or whether he's colored or a half-breed Indian like they say.

He'll be rich and won't have to stand on 24 story high girders and look down. He can look up at his building going up. And Mommy won't cry all winter when Daddy goes to look for work and doesn't come home. And Mommy can laugh and sleep late like Mrs. Honey and we can have ice cream every night for dessert.

Now I'm going to fly over the ice cream factory just to make sure we do.

Tonight we're going up to Tar Beach. Mommy is roasting peanuts and frying chicken and Daddy will bring home a watermelon. Mr and Mrs. Honey will bring the beer and their old green card table. And then the stars will fall around me and I will fly to the union building.

I'll take BeBe with me. He has threatened to tell Mommy and Daddy if I leave him behind.

I have told him it's very easy, anyone can fly. All you need is somewhere to go that you can't get to any other way. The next thing you know you're flying among the stars.

Despite the arguable nature of the concept "mainstream," it is generally true that most trained African-American artists are evaluated by its standards. Thus such artists, when compared to their self-taught counterparts, are in the ironic position of being cast as representatives of a traditional hierarchy, a hierarchy that has systematically under-recognized their achievements. The class implications in such an analysis are also inescapable. The scholar Henry Louis Gates speaks of how the black nationalist movement of the late 1960s and '70s fostered for some the belief that "'authentic' black culture . . . was lower class culture" and that "to be black and middle class was to betray, somehow, one's black heritage."[3] What could be a more class-laden construct than mainstream art, what more attractive candidates for those marginalized by such a system than poor and working-class self-taught black artists, and what more obvious candidates for "inauthenticity" than those who are trained?

Brown's viewpoint has been reiterated, with less eloquence, in both anecdotal and published comments from collectors and critics. Their remarks reinforce, often intentionally, the outsider status attributed to black vernacular artists.[4] Too often at odds are the two perspectives on self-taught African-American art, the private relationship and the public one between viewer and work, mediated by forces such as critics, scholars, collectors, galleries, dealers, auction houses, and museums that constitute the marketplace. It is the latter arena, beyond the one-on-one relationship between viewer and object, where a good deal of the value, meaning, and availability of these objects is determined. Yet given the current state of critical study and public awareness of vernacular art, the marketplace is often the least satisfactory venue for a deeper understanding of the work. In some ways, then, the best way to enter the art of vernacular artists may be by seeking new models of critical analysis and a closer, fresher examination of the work itself.

Much of my emerging appreciation of the work of self-taught or vernacular artists has come from my direct experience of presenting it in my years at the Studio Museum. (And one of the greatest lessons of that experience is that not all vernacular artists are self-taught. William H. Johnson, one of the most significant African-American painters of the mid-twentieth century, had several years of formal training, yet painted in a deliberately "naïve" style.[5]) Through traveling exhibitions of the work of Nellie Mae Rowe and Elijah Pierce, as well as the inclusion of artists such as Rowe, Thornton Dial Sr., Sister Gertrude Morgan, Jimmy Lee Sudduth, and Bill Traylor in the museum's permanent collection, I have come to know this work on an intimate level. My warmer appreciation for the work was fueled by the visual acumen of these prominent practitioners, and my respect and appreciation for it have grown immensely. Seeing Dial's and Sudduth's paintings was crucial to my education in the genre. Meeting Lonnie Holley and Charlie Lucas also gave me the rare opportunity to interact, albeit briefly, with artists whose work I was beginning to know and understand more deeply.

Like many of my peers in art museums, my greatest exposure to the work of black self-taught artists began with the Corcoran Gallery of Art's seminal exhibition "Black Folk Art in America, 1930–1980" (1982). James "Son" Thomas and Mose Tolliver,

included in "Testimony," the exhibition this catalogue accompanies, were among the many extraordinary artists whose work was introduced to a national audience by the "Black Folk Art" exhibition. The experience was something of a watershed for the visibility and acceptance of self-taught African-American art, beyond the confines of institutions such as historically black colleges and universities, and beyond the writing of scholars such as Dr. Regenia Perry[6] who had long championed the work.

It was also in 1982 that the Studio Museum in Harlem included Sister Gertrude, Pierce, Rowe, Horace Pippin, and Harriet Powers in "Ritual and Myth: A Survey of African American Art," one of its inaugural exhibitions in its newly renovated building in central Harlem. The exhibition provided what was then the rare opportunity, in a highly visible public venue, to view the works of vernacular artists alongside those of their trained peers such as Romare Bearden, Beverly Buchanan, Melvin Edwards, Betye Saar, and Joyce Scott. "Ritual and Myth" also made the implicit connection between the works of artists with different backgrounds but a common commitment. In speaking in the introduction to the catalogue of the contemporary trained artists in the exhibition, the then-director Mary Schmidt Campbell noted that "it is in the work of contemporary black artists that modernism and traditional ritual and myths coexist in the most startling new forms. They have re-created a visual dictionary that is at once modern and traditional."[7]

In the decade since 1990, the interest in self-taught art in general and in African-American self-taught art has boomed. Gallery exhibitions of the work of Minnie Evans, Dial Sr., Traylor, and others abound. The annual Outsider Art Fair at the Puck Building in New York is but one venue that draws large and enthusiastic crowds. Recent one-person exhibitions of Pierce (1992), Dial Sr. (1993), Pippin (1993), and Rowe (1999) have been shown in venues across the country, generating tremendous critical and popular attention. Coverage beyond the art press has included major features, including a segment of the broadcast *60 Minutes* that concerned Dial Sr. Seminars and symposia on the subject, such as a program in 1997 on the vernacular in African-American art held by the Schomburg Center for Research in Black Culture in conjunction with the exhibition of the Ronald and June Shelp Collection in an early form, as well as series at the Museum of American Folk Art, among other institutions, have offered important opportunities to explore this rich area of creativity.

Major museums around the country, including the High Museum in Atlanta and the New Orleans Museum of Art, regularly feature the works of self-taught African-American artists, and it is increasingly common to come across artists like Dial, Traylor, Pierce, and Holley in the installations of permanent collections. Several of these artists are represented in the nationally traveling exhibition, "To Conserve a Legacy: American Art from Historically Black Colleges and Universities" (1999), organized by the Addison Gallery of American Art and the Studio Museum in Harlem. Indeed, no institutions have been more active for a longer time than historically black colleges in giving vernacular African-American art a home. Reflecting the diverse nature of collections in black

WILLIE BIRCH. *A House for My Father*. 1996. Papier-mâché, mixed media, 20 x 15 x 14½" (50.8 x 38.1 x 36.8 cm). Courtesy Luise Ross Gallery, New York

BEVERLY BUCHANAN. *Frank Owen's Blue Shack*. 1989. Pine, tin, acrylic paint, 17 x 8 x 10" (43.2 x 20.4 x 25.4 cm). Columbia Museum of Art, Columbia, S.C. Courtesy Bernice Steinbaum Gallery, Miami, Fla.

colleges, the practice of exhibiting vernacular art in conjunction with traditional fine art has not been an uncommon occurrence.

In 1990, the Southeastern Center for Contemporary Art (SECCA) organized the exhibition "Next Generation: Southern Black Aesthetic,"[8] which made the critical link between the Southern traditions of both vernacular artists and more traditionally trained artists. The exhibition also marked a critical juncture in my own coming to terms with vernacular art. It included the work of self-taught vernacular artists such as Holley and Hawkins Bolden, trained artists who worked in the vernacular idiom such as Jesse Lott, and examples by trained contemporary artists such as Terry Adkins, Beverly Buchanan, and Joyce Scott, which were not commonly seen in such a context. With the Southern African-American experience as a common factor, the works of these disparate artists seemed to be "at home" together, at least visually.

In their power and authority, the artworks by Holley and Bolden stood shoulder to shoulder with those of their contemporaries. In its physical juxtaposition of art with similar themes and visual aesthetics, the exhibition went beyond other worthy traditions of exhibiting vernacular art. Before, vernacular art had usually appeared in large survey shows or in installations of permanent collections. Few explicit connections among the works of vernacular and traditionally trained artists were drawn. And even one-person exhibitions, which by their nature emphasize the singularity of the artist, could not make concrete the fact that vernacular artists are part of, and not apart from, the larger art-making enterprise. "Next Generation," on the other hand, made explicit that artists such as Holley and Bolden are peers not only of Buchanan, with whom they have a direct affinity, but of Adkins, whose apprehension and embrace of postmodern visual language are unmistakable. Thus the exhibition's organizers challenged either/or dichotomies in the representations of African-American artists as authentic or unoriginal, Outsider or Insider, and exposed the language of their shared marginalization as less than integral to the story of American art.

"Next Generation" made the telling point that artists with an affinity for the vernacular were nurtured or influenced by the American South, the source of much of black vernacular culture. But other contemporary African-American artists, whose birthplaces and touchstones are varied, have a resonant relationship to vernacular art too. Among the trained artists who have incorporated vernacular images and art-making traditions into their work is Faith Ringgold. In *Tar Beach* (1988; page 55), one of her many story quilts, she honors a tradition learned from her seamstress mother, Willie Posey. Willie Birch's *A House for My Father* (1996; left, top) is from a recent series of sculptures based on his personal history living in the South. Although his work, like Buchanan's *Frank Owen's Blue Shack* (1989; left, bottom), references vernacular Southern architecture, it is also clearly in the modernist vein. Betye Saar incorporates elements from a variety of cultures in her assemblages and installations. In *Indigo Mercy* (1975; page 60), she adds a mixture of found and personal objects to an old-fashioned mirrored dressing table, turning it into an altar of accumulative cross-cultural power.

THORNTON DIAL SR. *The News.*
1992. Charcoal, graphite, and colored
pencil on paper, 29½ x 41½" (73.7 x
104.2 cm). Ronald and June Shelp
Collection, New York

Melvin Edwards's *Working Thought* (1985; page 61), from his seminal "Lynch Fragment"
series, incorporates found objects such as nails, spikes, and chains, and draws from a
combination of sources, from his Texas roots to his years of participation in the art world
of Los Angeles and New York.

Yet notwithstanding these affinities, problems persist with the tandem presenta-
tion and analysis of more traditionally trained artists who work in vernacular styles and
self-taught vernacular artists. For though the latter continue to be embraced as original
figures in American art, the former still struggle to create work that is accepted on its
own terms. In this, artists such as Ringgold are caught "between traditions," as the art
historian Lizetta LeFalle-Collins notes.[9] She further remarks that work that combines
elements of fine art and folk sources "is likely to be considered as quaint, interesting, but

BETYE SAAR. *Indigo Mercy.* 1975.
Assemblage, clock, stool, palms,
42 x 13 x 13" (106.7 x 33.2 x 33.2 cm).
The Studio Museum in Harlem, New
York, gift of the Nzingha Society, Inc.

not 'cutting edge,'" and worse, that "though making reference to folk culture at times hinders the careers of African-American artists, the art establishment consistently embraces the work of white artists who co-opt these traditions."[10] Thus the fluid crossing of boundaries between "fine" and "folk" or trained and self-taught, which is navigated so ably by many African-American contemporary trained artists, is seen not as inventive, but rather as romantic, or even retrogressive.

But isn't transgression of expected boundaries and preconceptions the birthright of all artists? And are we not all the beneficiaries of these inventive creators, no matter their category? And what of the role of intentionality and references? If a contemporary artist sets out to create work that is clearly in the modernist idiom, with a vivid understanding of centuries of world art and a deliberate nod to its acknowledged tenets and "masters," is that qualitatively different from the seemingly serendipitous connections made by vernacular artists? And who got there first anyway? Much as Picasso and his peers drew from African art to invent Cubism, vernacular artists draw from a vast inventory of countless images created both in their own imaginations and in an increasingly seamless stream of popular culture, transmitted through every conceivable vehicle of print and electronic media.

There is perhaps no more apt example of the transformation of contemporary culture and the vernacular tradition than the protean work of Thornton Dial Sr. From works like *Everybody Got a Right to the Tree of Life* (1988; page 62), whose complex composition and visual language are firmly in control, to the inventively abstract *The News* (1992; page 59), whose charcoal smudges wittily mimic the newsprint that comes off on the hands of any reader, Dial is clearly in the driver's seat. If the first work—with its anthropomorphism, brilliant colors, vivid patterning, and outsized human figure—is almost a primer of the traditions of mid- to late-twentieth-century self-taught art, does that matter? If the latter brings to mind the art of Kurt Schwitters or Cy Twombly, do we care? And are formal parallels beside the point? Dial Sr.'s work is replete with references to contemporary popular culture and he appropriates with the ease of a seasoned postmodernist. Yet Dial asserts, "I'd never seen any artist's works. I can't copy off anybody because it's something I do my own self."[11] Dial's work itself provides the strongest evidence that canniness and visual acuity are not the sole purview of the trained artist.

The work of Lonnie Holley, Charlie Lucas, and Purvis Young stands more clearly in the center of current art production, given their evident mastery of a vocabulary that is at once vernacular and modernist. Holley and Lucas refashion the detritus of daily life with a sensitivity matching that of trained counterparts such as Terry Adkins and Nari Ward. Holley's *Fighting at the Foundation of the Cross* (1988; page 26) references world traditions of religious art and displays a sure and judicious hand with found objects. In *Children of the World Reaching Out* (1989; page 103), Lucas exhibits a command of welded metal and a discipline that literally bends it to his artistic purposes. Young's paintings are rich with multiple connections and a palette that manages to bring to mind both the tradition of the self-taught and the practices of contemporary painting of the

1980s. His work is devilishly hard to categorize: its composition and subject matter are reminiscent of both Susan Rothenberg *and* Jimmy Lee Sudduth. And as with Dial, they all attract first with their artistry, and later invite analysis. Indeed, if it were not for the former, the latter would be irrelevant.

The artists in "Testimony" appear to be aware of, but unfettered by, the constraints and devices of the larger art world, while maintaining singular visions and a robust style. These are not, in any sense of the word, naïve artists, who beguile because they are guileless. Rather, they are confident followers of their own muses.

As one who has resisted the lure of vernacular art, largely out of suspicion of the motives of some of its supporters, I have finally been won over by the work itself. I have also come to see this art as a window onto larger issues of creativity and artistic practice. This is particularly true in the work of "transitional" artists such as Purvis Young, whose vernacular style and imagery in works like *Wild Horses* (1978; page 124) is grounded in a cognizance of contemporary art issues. Young's choice, along with that of other trained artists such as Willie Birch, Beverly Buchanan, Faith Ringgold, and Joyce Scott, to create in a style that may previously have been said to echo the "primitive" or "naïve," both validates and is validated by traditions that connect to the earliest instances of African-American artistic expression. These artists and their peers offer links to their self-taught brethren and to broader cultural areas, including literature, the blues, and a myriad of folk traditions.[12] Their work, their "testimony," bears witness to both a cherished tradition and a lively contemporary expression. Thus, given its rich antecedents, vernacular art, rather than being marginal to the larger discourse on contemporary art, becomes essential to its fuller delineation.

In the end, then, one of the greatest gifts of vernacular artists, beyond their intrinsic creativity, is this ability to force us to rethink, if not abandon, our ways of seeing and talking about contemporary art and its mix of histories, affinities, and responses to current market pressures. As we struggle with language and analogy, with precedent and notions of originality and authenticity, we are engaged, in spite of ourselves, in ways that are regrettably rare in current art discourse. The freedom to think in different ways, to step outside the constrained and contentious arena of the art of the moment, can mean a welcome respite. The fierce intelligence of much of this art and the assurance of the artists themselves in forging their own ways are remarkable. Perhaps these are not the trendiest or most influential artists of our time, but they may be among the wisest.

MELVIN EDWARDS. *Working Thought*, from the "Lynch Fragment" series. 1985. Welded steel, 54 x 28 x 20" (137.2 x 71.2 x 50.9 cm). The Studio Museum in Harlem, New York, gift of the artist

THORNTON DIAL SR. *Everybody Got a Right to the Tree of Life*. 1988. Enamel, tin, glass
marbles, and industrial sealing compound on wood, 48 x 96¾" (122 x 245.8 cm).
Philadelphia Museum of Art, gift of Ronald and June Shelp

Witnessing: Layered Meanings in Vernacular Art

EDMUND BARRY GAITHER

The sermon builds toward its climax. The church is alive with a fervor that like fire rages across the sweating faces of the congregation, sweeping some into a shout, a holy dance intensified by hallelujahs. Above it all rings an urgent question: "Can I get a witness?" Instantly, overlapping testimonies fill the air. Black Southern church tradition, especially as still found in rural hamlets and small towns, prizes "bearing witness." For in the act of "witnessing," a necessarily communal endeavor, the collective soul is restored, community becomes possible again, and the lone witness is reintegrated. In this restorative process, bearing witness is a central tenet of—perhaps even a requirement for—spiritual, physical, and psychological wholeness. Without the bonding intimacy of witnessing, the force that mediates relationships and helps folks rise above their spiritual deficiencies would fail, and they would never muster the tender, personal sharing that underpins communal caring and makes compassion possible.

Bearing witness has found countless forms—most with social sanction—within the black world of the South. In African-American music, whether drawn from the texts of Protestant hymns shared by blacks and whites (like those by Dr. Isaac Watts,[1] et al.), or from the rich body of "Negro" spirituals, songs admonishing personal testimony are highly valued. With no effort, one recalls such familiar tunes as "My Soul is a Witness for My Lord," "I Know the Lord Laid His Hand on Me," "Testify," or the still more personalized "Were You There?" imploring whether—in your mind's eye—you witnessed the Crucifixion. Nor is witnessing restricted only to the world of the spiritual; it is also a vitally meaningful aspect of secular music. Historic blues and its descendants rhythm and blues and soul all retain the offering of personal testimonies as dramatic, performative devices. From B. B. King and Bobby Bland to Aretha Franklin, from Mahalia Jackson to Shirley Caesar, all of these great songsters interject personal witnessing into their musical delivery. Additionally, blues musicians are especially fond of the practice dubbed "signifying," which is, in fact, just another mode of witnessing by innuendo and insinuation.

All of these dimensions of bearing witness have in common a willingness to relate an intimate and compelling personal experience in a communal setting. The governing assumption is that the confession or declaration will receive a favorable reception, that is, others present will identify with its contents and recognize its sincerity. They will offer their joy or commiseration, whichever is appropriate. Restoration will be possible because their peers, through a "call and response" engagement, expressly acknowledge

ARTHUR DIAL. *Adam and Eve.* 1989. Tubing, carpet, and sealing compound on plywood, 39¾ x 39¾" (101 x 101 cm). Ronald and June Shelp Collection, New York

64

the truthfulness of the account proffered. They embrace the witness who tells his story in his own emotion-infused words. Emotional directness and sincerity are markers of the truthfulness of witnessing.

Perhaps bearing witness came to have greater importance in black tradition because it challenged some long-standing injustices of the Old South. During the period of slavery, Southern states did not allow blacks to testify against whites in the courts, so the veracity of black witnessing was not just discouraged, it was denied. Truth was a white monopoly, and could not be told by an African American when the culprit was white. Well after emancipation, customary practice in many parts of the South made it risky for a black person to presume to testify against whites, so there continued to be no opportunity to tell the truth publicly. To violate this practice was to risk loss of home and livelihood, and possible loss of life itself. True witnessing could occur only in African-American settings, or by the practice of some form of guile, some form of "wearing the mask."[2]

In the context of these realities, witnessing was and still is vastly important, for it offers a vivid affirmation of a human community created though sharing commonly held, publicly proclaimed truths. By the act of bearing witness, people are brought together and called upon to fortify and support each other while acknowledging their frailties.

Within the current discussion of black vernacular art, bearing witness assumes another, more subtle meaning, for it may be understood to refer to the lingering intuitive[3] presence of African cultural features in the visual arts production of African-American folk and self-taught artists. Indeed, I would suggest that the art itself bears witness to the continuity of African expressive ideas in the American South. Right away, some critics will reject this idea, insisting that black and white Southern folk and self-taught artists are more alike than different. This objection, however, misses the point. Indeed, Southern blacks and whites share a huge and rich arena of overlapping cultural ideas, practices, and attitudes, but this fact in no way denies the power of a distinctly black social and cultural identity among African Americans of the South. And it is within this consciousness, rooted in an overwhelming sense of common identity and history, that echoes of Africa still ring.

African Americans of the South—like the vast majority of blacks throughout the Americas—have lived since arriving on these shores within black communities where they shared a consciousness arising from their highly racialized encounters with white peoples and their cultural, economic, and political domination. Within this framework, an identity as blacks was at once protective, realistic, even inescapable. Its attendant consciousness was internalized as a matter of basic socialization. Along with it, much African cultural baggage was internalized, eventually often losing any hints of its original source or meaning. Elements of expressive behaviors and representations remained.[4] Sometimes the synthesis of African, American Indian, and European elements yielded altogether new forms such as blues and jazz—genres born bearing the stamp of essential

EDMUND BARRY GAITHER

African cultural values, such as improvisation. Thus, I would assert that in black American culture survives an unconscious, intuitive dimension fed by Africanism embedded in black socialization, and manifested through cultural practices and dispositions.

To this unconscious, internalized, African-derived expressive stream might be added, especially in recent decades, a more self-conscious reclamation of African ideas and representations. First during the black renaissance of the 1920s and again during the Civil Rights era of the 1960s, African themes assumed heightened importance for African Americans everywhere. Changes in the social matrix led blacks to an awareness of Africa as part of the African American's symbolic legacy, an appreciation of Africa as fundamental to the cultural nationalism evinced by sociopolitical movements such as Garveyism,[5] greater knowledge of Africa stimulated by the death of colonialism and the visual spectacle of Africans at the United Nations, renewed excitement about the African presence in biblical sources, including ancient Kush and Egypt, and, finally, increased interest in Africa and Afro-America in the media and in popular culture. Even in the most isolated poor communities, television, radio, and the movies gave young and old African Americans new ways of conceiving and representing Africa, as well as fresh incentives to include Africa in their expressive works.[6]

Black vernacular art, in addition to testifying in conscious and unconscious ways to African heritage, engages its themes with extraordinary visual power and emotional clarity. Jane Livingston, in the introduction to *Black Folk Art in America: 1930–1980,* correctly observes: "The artists working in this esthetic territory are generally untutored yet masterfully adept, displaying a grasp of formal issues so consistent and so formidable that it can be neither unself-conscious nor accidentally achieved."[7] Certainly her comments are wonderfully applicable to paintings such as those by Thornton Dial Sr., or sculpture such as that by Charlie Lucas.

Black *vernacular art*, a descriptive term characterized by greater accuracy and flexibility than *folk art*,[8] is heterogeneous, exhibiting forceful and sometimes highly individualized expressive products. Like blues, work songs, and gospel—musical traditions with roots in the experiences of black poor and working-class people—vernacular art prizes first-person narratives, compelling personal visions, and spiritual interventions. In many instances, philosophical musings are expressed indirectly through the engagement of stories that are "coded" and whose meanings are layered. At times, the art uses an iconography of black and white American public figures who have distinguished themselves as fair and just, and whose images have become well known. Typically, these figures are associated with the struggle for freedom, justice, and equality—themes important to African Americans. Frequent use is made of biblical and historical stories that comment on the immediate human predicament, as well as on the broader human condition. Many works in the Ronald and June Shelp Collection exemplify these subject categories.

Several works explore the origins and conditions of humankind via the biblical stories of Adam and Eve, the Garden of Eden, the Tree of Life, Moses and the Ten

RONALD LOCKETT. *Adam and Eve.*
1988. Enamel on tin on plywood relief,
48 x 49 x 10" (122 x 124.5 x 25.5 cm).
Ronald and June Shelp Collection,
New York

EDMUND BARRY GAITHER

RONALD LOCKETT. *Garden of Eden.*
1988. Enamel on laminated particle-
board tabletop, 35½ x 47½" (90.2 x
120.7 cm). Ronald and June Shelp
Collection, New York

Commandments, the Crucifixion, and Jesus as a child. Consider, for example, Arthur
Dial's painting of Adam and Eve flanking a centrally placed tree abundant with red and
green fruits (page 65). In the immediate foreground is the serpent, whose head falls
midway between our primordial forebears along the lower portion of the tree. The orig-
inal couple faces us, with ruddy complexions, the nudity of their chunky bodies altered
only by the strategic placement of the fig leaves. Their spaceless setting is defined by
short dabs of blue and green paint on a white ground. The snake likewise is white with
green spots. The moment Dial has chosen to represent is just after the eating of the
proverbial apple when the voice of God calls out, and Adam and Eve first seek to hide
their nakedness. The couple's faces register alertness to God's call, even as the snake
camouflages himself from the divine eyes. No element of harsh feeling appears in the
picture; rather, its prevailing emotion is surprise.

By contrast, Ronald Lockett's Adam and Eve are situated very differently in this
age-old story (page 68). Here the dominant presence is nature itself. The landscape of
the Garden is elaborately presented, with large, brown mountains in the distance; the
River of Life replete with waterfalls fills the middle ground, balanced by a pair of birch-
es and a handsome tree with reddish brown leaves. In a constructed foreground, Adam
and Eve appear to the right as if they are no more important that the other animals
inhabiting their plane. The serpent has not yet made his appearance, and all is peaceful

EDMUND BARRY GAITHER

in the Garden. God's ire has not been provoked, and the lion stirs no fright in the hare. Here, again, harshness is absent and tranquillity reigns. Neither Adam nor Eve has internalized profound guilt, and no expulsion seems imminent. Perhaps it is significant that these artists have given such gentle depictions of this pivotal story of the introduction of sin into the world. They depart from many traditional representations wherein the sword of God appears, driving the grief-stricken couple from Paradise, or the snake performs as a formidable agent of Satan. Urgent fear and anxiety are both missing from these representations, suggesting more about the possibilities inherent in human beginnings than about the existential dilemma of freedom.

The spirit of Lockett's *Garden of Eden* parallels that of his *Adam and Eve* (page 69). Indeed, the original parents appear again in this Paradise, running with sprightly steps across the landscape that they share with several animals—a horse, a dog, and a lion. Once more, the River of Life divides the upper and lower registers of the painting, setting off mountains that resemble ghostly figures dancing beneath a bird and a blue sky.

An underlying or covert meaning in these paintings of stories of origins is their emphatic declaration of our common roots. If Adam and Eve are the parents of the human family, then all humans are brothers and sisters. Discrimination against any of the children of this ancestral couple is therefore wrong, for ultimately everyone is part

Dahomey appliqué, Republic of Benin. Early twentieth century. Cotton, 36 x 62" (91.5 x 157.5 cm). Museum of the National Center of Afro-American Artists

EDMUND BARRY GAITHER

of one family. Here is an antiracist assertion, rooted in the shared text of the Bible, and made plain by the paintings for all to see. It offers a power perspective on equality, a contemporary issue still crucial for blacks—framed in what seems at first glance an old, traditional religious story about presumption and carnality.

Archie Byron's *Family Pain* offers another insight into the primordial couple of Christian and Hebraic scripture (page 153). Here the curse of pain during childbirth—traditionally interpreted as one of the consequences of Eve's sin—is implied in a complicated representation of parents, perhaps torn apart by imminent divorce, tugging at a child who seems embedded in them. Though physically one unit—the mother and father are merged via their arms, legs, and pelvic area—they are emotionally, psychologically disharmonious. And while the child addresses his attention to them, the father stares at us with a pained expression, and the mother closes her eyes, denying access to her inner feelings. Human familial stresses are the subject of this episode, but those stresses are not particularly racialized. Instead, they recall human frailty, conflict, selfishness, and violence as omnipresent problems for all of humanity.

Concern with the nature of family life has loomed large in black American experience. The ravages suffered by families during and after slavery continue to have a negative impact on this most basic of social units. Some twentieth-century innovations such as welfare programs, ostensibly intended to help, have further undermined and distorted family life. These tragedies are the subject of still other works such as Arthur Dial's *Welfare Office* (opposite) and the homeless themes rendered by Archie Byron and Ronald Lockett.

What of the retention of African culture in the African-American South? Richard Burnside's *Swords and Shields and Odds and Ends* evokes the appliqué traditions of Africa's centralized kingdoms, especially Dahomey and Ghana (pages 70, 71). In its form, the enamel on wood looks strikingly like a Dahomean palace decoration, or a Haitian voodoo flag (page 75). Works in both of the aforementioned traditions eliminate space by the use of a flat, dark ground, and describe images as if they were floating. Both have roots in the pictorial and relief sculptural traditions of the Fon and Akan peoples of West Africa. There is a hint in the title of the biblical theme found in Isaiah 2:4, where peace is visualized by the turning of swords into plowshares and spears into pruning hooks. This is an ancient and popular image of the transformation of war and conflict into peaceful, positive human activity.

Scarecrow by Hawkins Bolden recalls the traditional African notion that power can be aggregated by combining many different materials into the making of a single power figure (page 46).[9] This is the notion embodied in *nkisi* fetishes from the Congo region, and explored so brilliantly in the work of the young, African-American installation artist Rene Stout, and others. Bolden, most probably with deliberate reference to *nkisi* practice, brings together in his work materials such as wood, found metal, carpet, and, of course, the all-important nails that are key items in Congo fetishes. *Scarecrow*, at once a type of cross and a mask with a superstructure, is strangely anthropomorphic and

ARTHUR DIAL. *Welfare Office.* 1989. Enamel and industrial sealing compound on plywood, 40 x 39¼" (101.6 x 101 cm). Ronald and June Shelp Collection, New York

simultaneously modern in its use of the associations of found materials. It expresses more of the aesthetic values of a shaman's ritual object than those of a farmer's field protector, so one is led to wonder just what sort of evils it is designed to frighten off—perhaps not crows but less material menaces.

Africa is directly referenced in *King of Africa* by Thornton Dial Jr., in which the dominant symbol is the lion (page 76). The lion, of course, calls to mind two common meanings with respect to Africa. On the one hand, this great feline has been called the King of the Jungle, and, as such, is regarded as the most powerful of the many beasts of the second-largest continent. Everyone is familiar with this designation, since it is perennially renewed by productions such as *The Lion King* by Walt Disney Studios. On the other hand, the lion is a traditional symbol of kingship in Africa, as characterized in the royal symbolism of the court of the late Haile Selassie of Ethiopia. Known as the "Conquering Lion of Judah," Selassie maintained pet lions, dressed his honor guard with lions' manes, and employed the image of the standing lion among his royal emblems, flags, and publications. Many other traditional kingdoms of Africa also used the lion, or parts thereof, in royal regalia. Thus Dial's *King of Africa* is simultaneously an embodiment of royalty, an attribute of kingship itself, and the great beast of the African savannas.

Another means by which Africa is embraced by African Americans is through biblical characters regarded as sons or daughters of that continent. Most highly romanticized in this way is the legendary object of Solomon's dreams, Sheba. Joe Light evokes this queen as a bird in enamel on wood, suggesting lightheartedly her endowment with grace and beauty (page 140). Variously placed, Sheba is associated with both Nubia and Ethiopia, as well as the ancient land of Saba, which is now Saudi Arabia. Other African-American artists, including Romare Bearden and Jon Oyne Lockard, have also depicted this fabulous character as an African queen.

A great number of self-taught artists, particularly those who begin art-making late in life, express the conviction that their art is revealed to them in dreams or visions, and that they are essentially vehicles to bring forth revelations. These artists decline to assert themselves as creators, preferring to leave that honor to spiritual forces. Such is the case with Bessie Harvey, by whose hand was delivered *The Prophet* and *Prehistoric Bird*. *The Prophet* (page 162), like Bolden's *Scarecrow*, shares the African notion of aggregated power captured through the assemblage of many diverse materials, each of which has its own anima or spiritual force, for it is created from wood, wood putty, cowry shells, fabric, costume jewelry, paint, and artificial hair. Somewhat simpler is Harvey's *Prehistoric Bird*, a large work exploiting natural forms of wood articulated and given meaning by careful painting (page 122). Though Harvey denies any conscious knowledge of African artistic treatments, her art sings with African continuities, which are not countered by her own insistence that she is a spiritual medium for art coming to her in visions.

Exceedingly close in spirit and style to the work of Harvey is Ralph Griffin's *Medicine Man* (page 77). Like Harvey, he has allowed the form of the natural wood to deter-

Voodoo flag, Haiti. Mid-twentieth century.
Sequins on satin, 30 x 30" (76.3 x 76.3 cm).
Museum of the National Center of Afro-
American Artists

THORNTON DIAL JR. *King of Africa.*
1989. Enamel, carpet, and industrial
sealing compound on wood,
48 x 60" (122 x 152.4 cm). Ronald
and June Shelp Collection, New York

RALPH GRIFFIN. *Medicine Man.*
1987. Paint, found wood, and nails,
51 x 16 x 20" (129.5 x 40.7 x 50.8 cm).
Ronald and June Shelp Collection,
New York

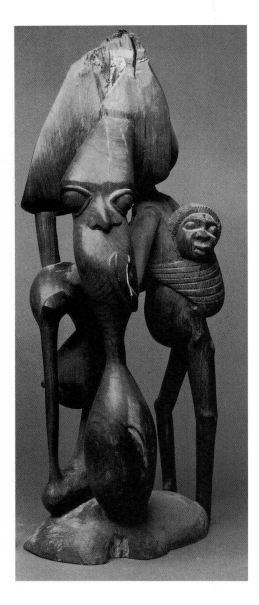

Figures, Makonde. Mid-twentieth
century. Wood, 26" high (66 cm high).
Museum of the National Center of
Afro-American Artists

mine the overall shape and organization of the sculpture. Using suggestions of form intrinsic to his material, he employs paint and nails to bring forward an upper face surmounted by a crested superstructure in red, and a lower one half hidden in the belly and facing in the opposite direction. These multiple faces, a common feature of Harvey's work as well, conjure recollections of Makonde art from East Africa (left). Interestingly, Harvey and Griffin show a clear preference for a shiny black paint as the base surface for their art. This choice gives their figures a great deal of sheen as well as offering excellent contrast for the frequent use of white materials or paint to define eyes and teeth. Typically, the faces are somewhat pinched and attenuated, with distant memories of the polychromed, grimacing faces of Congo-Angolan *minkisi* and their dental and eye inserts.

Sometimes cultural and artistic memories are not so distant. In Thornton Dial Sr.'s *Long Faced Lady in New York City* (page 81), an elongated woman's face, like one of the great stone heads of Ranu Raraku on Easter Island, rises the full height of the painting. Adjacent to it are drawings of the skyscrapers of New York with figures in the windows, partially obscured by strong washes of blue and red. The lady is long-faced and blue both literally and figuratively: she is estranged in the city, like so many generations of African Americans whose travels north in search of work have amounted to another diaspora.

More dramatically, the social history of black America has generated heroes and heroines who, in part through their deaths, have become part of a public iconography replicated in countless murals, paintings on velvet, T-shirts, and caps, as well as easel paintings and prints. Four such figures appear in *Assassinations* by Leroy Almon (page 95). The episodes depicted are the assassination of President Abraham Lincoln at Ford's Theater in Washington, D.C., just after the end of the Civil War; the murder of Malcolm X in the Audubon Ballroom in Harlem in 1965; the assassination of Dr. Martin Luther King Jr. on the balcony of the Lorraine Motel in Memphis, Tennessee; and the gunning down of President John F. Kennedy near the Texas Book Depository in Dallas. Each scene spins off the word ASSASSINATION, which is painted in green letters at the center of the work. Each representation shows the moment just before the fatal shots were fired. Altogether, this picture summarizes important passages in American and African-American history by focusing on the personalities who ended slavery, transformed black consciousness with respect to manliness, shaped the Civil Rights movement, and offered sympathetic, progressive support for blacks from the White House. Interestingly, two are black figures and two are white. Each mini-tableau—reminiscent of an Dahomean appliqué—is internally complete, and altogether they balance well compositionally. But the real strength of *Assassinations* is the direct and powerful narrative it offers in support of freedom and independence as black American possibilities.

Although the tradition of bearing witness always involves direct, personal testimony about compelling encounters with truth, it does not always include a deliberate portrait of the witness himself. It is therefore a pleasant surprise to encounter self-portraits by Mose Tolliver and Jimmy Lee Sudduth (pages 146, 147). Such images counter the

EDMUND BARRY GAITHER

frequent suggestion that self-taught artists lack historic awareness. With their self-portraits, both artists assert themselves as unique, self-conscious personalities, for whom recognition is important. Offering striking expressions of personal subjectivity, Tolliver and Sudduth have ensured that their images will be as well known as their artworks.

As a whole, black Southern vernacular art draws its power from a sincere relationship to experienced social and spiritual realities. It is little concerned with philosophical speculations on beauty or deliberate transformations of art-historical theories, nor does it labor over challenging various conventions of representation. Instead, it seeks to find the most direct means of relaying a story, without loss of emotional power, to an audience accustomed to plain speech. It is largely free of pretense, artifice, and affectation. For this art, artistic power is allied to intuition and spiritual visions, to unfiltered feelings and emotions, rather than to sublimated, highly intellectualized modes of expression. It does not follow, however, that vernacular art lacks sophistication. Dial depicts women as playful Circes in his "Fishing for Love" series, for example (page 80), but his juxtaposition of them with animals in other works suggests their profound powers in nature and the cycle of life. As blues possesses a passion for double entendre, paintings by Dial and other artists included here possess a certain interest in manipulation and subtlety. Sometimes, this art "wears the mask," that is, it hides beneath its obvious narrative a more biting commentary on the South. Like black spirituals, vernacular art is sometimes coded. In the main, vernacular art lives by the force of explosive energy that it condenses into compact narratives or essential stories, and by its repertoire of functional images compressed and concentrated by repeated use. More akin to folk music—which, though distilled over the years, will accommodate new verses—than to carefully composed melodies where original artistic intent precludes alterations, vernacular art retains a readiness to be honest and a willingness to respond quickly to the heart. Though it has much in common with traditional definitions of folk or naïve art, its self-awareness makes it a little too modern to live in the confines of those calcified categories, for its relationship to the realities of its own moment is more immediate, and its consciousness of itself is more profound. *Testimony: Vernacular Art of the African-American South* offers an introduction to an extraordinary world of lively visual images rooted in black popular culture and endowed with bristling energy, rough-hewn beauty, and emotional power.

THORNTON DIAL SR. *Fishing for Love.* 1991. Pencil and watercolor on paper, 30 x 22" (76.3 x 56 cm). Ronald and June Shelp Collection, New York

THORNTON DIAL SR. *Fishing for Business.* 1991. Watercolor and graphite on paper, 22⅛ x 30" (56.5 x 76.1 cm). Philadelphia Museum of Art, gift of June and Ron Shelp

Opposite: **THORNTON DIAL SR.** *Long Faced Lady in New York City.* 1991. Mixed media on paper, 29¾ x 22¼" (75.6 x 56.6 cm). Ronald and June Shelp Collection, New York

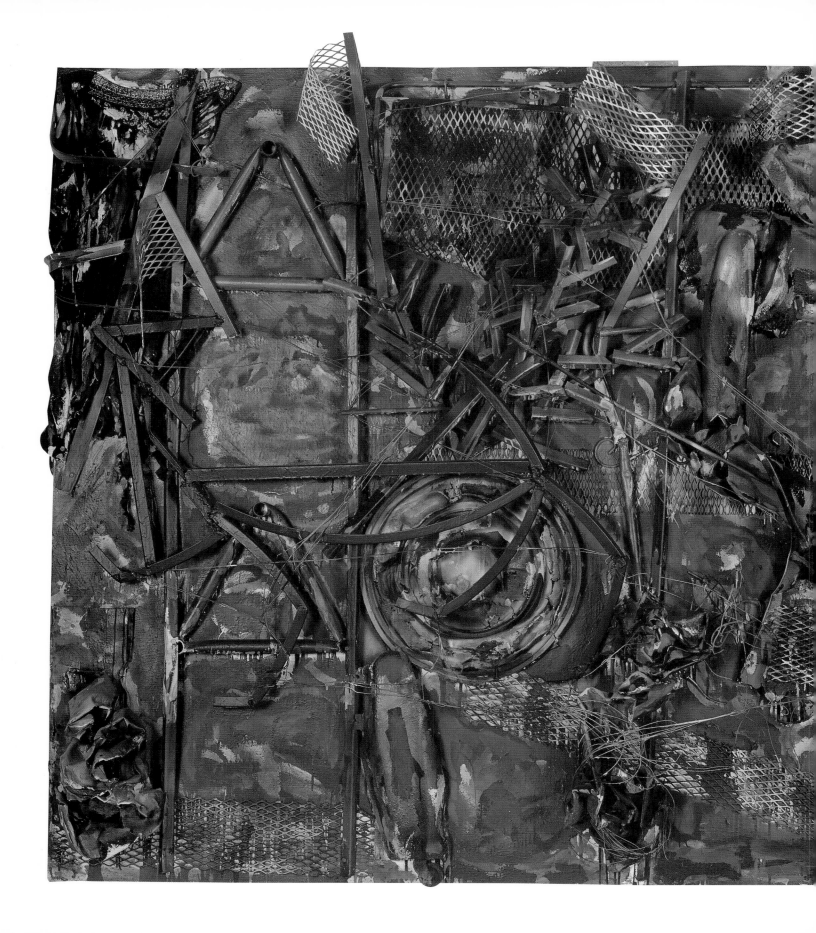

The Art and the Artists

The richly diverse works in the Ronald and June Shelp Collection are grouped here according to six themes, reflecting the artists' primary expressive and aesthetic interests: their work as witness to history, reflecting their responses to historic events and socioeconomic conditions affecting African Americans; their representation of allegorical animals, religious scenes, and iconic human figures; their spiritual and protective messages; and their direct observation.

Biographical profiles of each of the twenty-seven artists of *Testimony* appear under the theme that seems to dominate that artist's work, although a number of them pursue several subjects. The profiles have been compiled from the most recent published sources, as listed in the selected bibliography, and edited by Judith McWillie. The longest quotations are drawn from some thirty hours of interviews that she conducted with the artists in 1986–88, with the support of a grant from the University of Georgia. Many have not been published before. This material is presented as an extension of this book's overall purpose—to challenge the association of this art with Outsider and folk expression. *Testimony's* painters and sculptors are presented here with the analytical techniques used for studies of other prominent artists working today.

THORNTON DIAL SR. *Support for the Works*. 1998. Found metal, clothing, wire, nails, oil enamel, industrial sealing compound on canvas mounted on wood, 68 x 91" (172.7 x 231.1 cm)

Witness to History

The artists of *Testimony* all lived through the era of segregation in the South, the Civil Rights movement of the 1950s and '60s, the political activism and struggle for African-American identity and pride of the late 1960s and '70s, and the sobering aftermath of these turbulent decades. Living and working primarily in Alabama, Georgia, Mississippi, and Tennessee, they witnessed some of the racial crises that electrified the world and finally forced federal intervention and legislation. In Alabama in 1955, blacks led by the Reverend Martin Luther King Jr. boycotted Montgomery's segregated public transportation; in 1956 the University of Alabama was ordered by the federal government to accept its first black student. In 1962 federal marshals were sent in to force the University of Mississippi to admit the black veteran James Meredith. In Alabama the following spring, Birmingham police suppressed African-American protesters with dogs and fire hoses, and Governor George Wallace prevented two black students from enrolling at the state university. In 1965 hundreds marched from Selma to Montgomery to win support for new voting-rights laws. But the enactment of these and other laws, and the achievements of President Lyndon Johnson's Great Society programs, did not quiet political activity. The Black Panther party, founded in 1966, mobilized a highly visible group of African Americans; and the 1968 assassination of the Reverend Dr. King in Memphis, Tennessee, and the black rioting that followed in many cities deepened the chasm between liberal and militant black activists. The ideals of the Great Society collided with the realities of the escalating war in Vietnam, and ultimately with the skepticism about big government engendered by the Watergate scandal of 1972–74. For African Americans, this legacy was mixed, and it was bitter for some who, in their twenties, bore much of the brunt of the undeclared war. Yet these years generated a broad sense of empowerment, as well as African and African-American scholarship and protest-art movements. These activities helped to motivate the expression of the younger artists included here.

RONALD LOCKETT. *Smoke-Filled Sky.*
1989. Enamel, charred wood, twigs,
and nails on plywood, 46½ x 47½ x 3"
(118.1 x 120.7 x 7.8 cm)

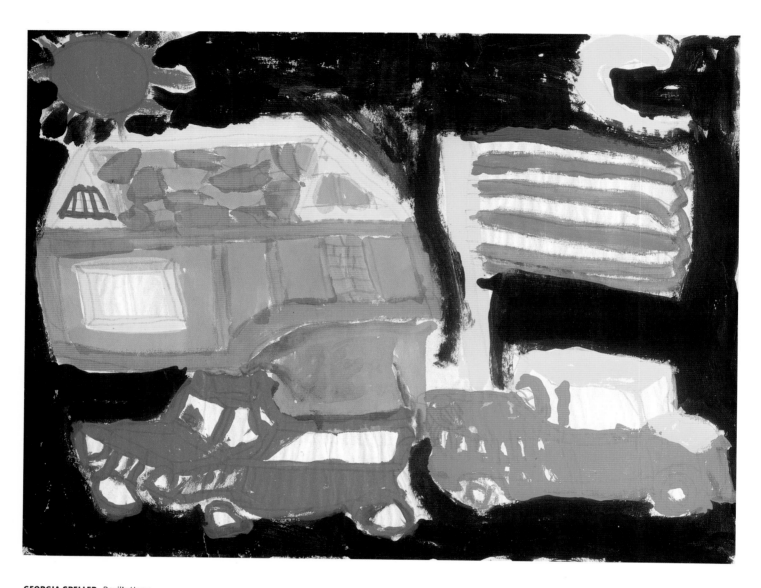

GEORGIA SPELLER. *Devil's Home in the United States*. 1986. Acrylic, tempera, and pencil on paper, 17⅞ x 23⅜" (45.2 x 59.4 cm)

THORNTON DIAL SR. *Sitting and Waiting—The Man Needs*. 1993. Enamel, oil, spray paint, found metal, and wood on canvas on wood, 60 x 48 x 7½" (152.5 x 122 x 19.1 cm)

THE ART AND THE ARTISTS

Top: **THORNTON DIAL SR.** *Rolling Mill: Steel is the Master, Lady is the Power.* 1992. Enamel, garden hoses, rope, steel springs and other found metal objects, and industrial sealing compound on canvas on wood, 71 x 72½ x 3½" (180.4 x 184.2 x 9 cm)

Left: **THORNTON DIAL SR.** *I Had a Dream, a Dream about Heavy Burdens.* 1991. Oil on canvas, 78 x 78" (198.2 x 198.2 cm)

Opposite: **THORNTON DIAL SR.** *The Big Black Bowl of Life.* 1993. Oil and enamel on canvas mounted on wood, 65 x 65" (165.1 x 165.1 cm)

THORNTON DIAL SR. *You Can See It in the Street (Homeless People in New York)*. 1991. Pencil and watercolor on paper, 30 x 22" (76.2 x 55.9 cm)

RONALD LOCKETT. *Homeless People.*
1989. Enamel and wire on plywood,
48 x 48¼" (122 x 122.6 cm)

ARCHIE BYRON. *Homeless.*
c. 1987. Elmer's glue, sawdust,
and pigment on plywood, 48 x
43¼" (122 x 109.9 cm)

LONNIE HOLLEY. *Cutting Medication Short.* 1997. Wood, wire, plastic, medicine bottles, fabrics, 47 x 15 x 17" (119.4 x 38.1 x 43.2 cm)

Leroy Almon, c. 1980s

Leroy Almon

b. 1938, Tallapoosa, Ga.,
d. 1997, Tallapoosa

Leroy Almon learned the tools of his art in the 1970s from the now-celebrated self-taught woodcarver Elijah Pierce (1892–1984) in Columbus, Ohio. He and Pierce both worshiped at the Gay Tabernacle Baptist Church, and when Almon lost his job at the Coca-Cola Company in 1979, Pierce took him on as an apprentice and as the "curator" of the gallery he had made in his barbershop. At first they collaborated on Pierce's narrative reliefs of religious inspiration. Then Almon began to carve independently with a pocketknife and chisel, translating his preliminary sketches into softwood panels centered on figures and figural groups with dramatic Christian, historical, and political themes of conflict. *Assassinations* (1985; opposite), for example, has a four-part composition showing Abraham Lincoln at Ford's

Theater in 1865, John F. Kennedy in Dallas in 1963, Malcolm X in Harlem in 1965, and Martin Luther King in Memphis in 1968—each at the moment before he is slain. Like Christian narrative paintings and story quilts as well as cartoons, the climactic scenes are each self-sufficient, but they cohere as one composition in form and drama. Each compartment contains a real small-caliber shell.

In 1982 Almon returned to his birthplace of Tallapoosa, where he became an ordained minister and a nondenominational evangelist. To support himself and his wife, Mary Alice, and their children, he worked as a police dispatcher. He restored his boyhood home, turning the basement into a gallery and workshop where he continued to make brightly painted reliefs.

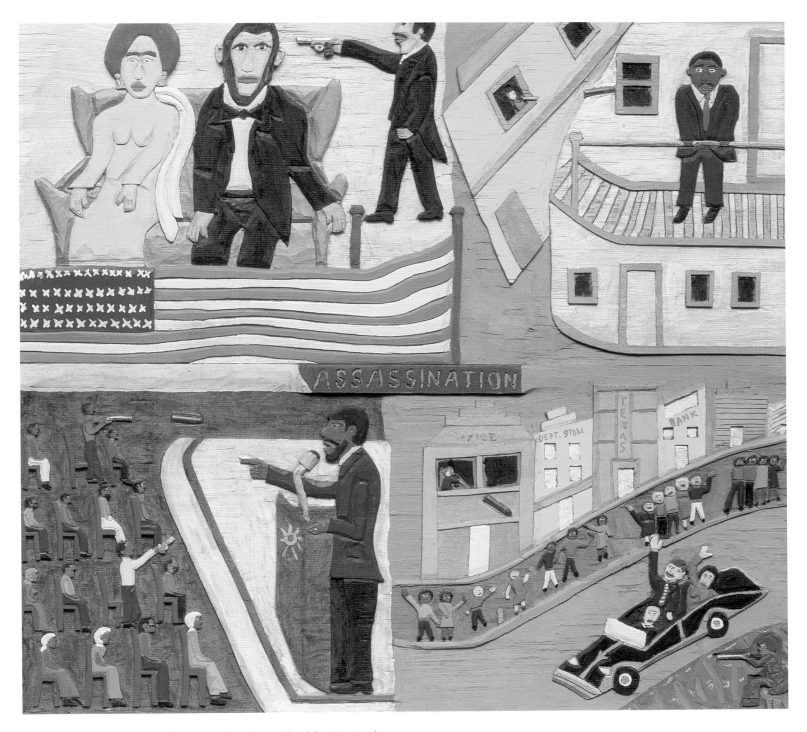

LEROY ALMON. *Assassinations*. 1985. Paint on carved wood, 24 x 25⅞ x 1⅛" (61 x 64 x 2.7 cm)

Joe Minter with Shelp collection assemblage at Morris Brown College gallery, Atlanta University, 1999. Wrought iron, tire rim, chain, metal light fixture, glass, 67½ x 53 x 17" (171.5 x 134.6 x 43.2 cm)

Joe Minter

b. 1943, Birmingham, Ala.,
lives in Birmingham

"The way you make an African a slave, you make him invisible," says the sculptor Joe Minter. "I'm making the African visible."[1] Minter's yard in Birmingham is filled with his assemblages, one side of it containing individual works in changing numbers, the other devoted to his "African Village in America," interpreting the four-hundred-year history of blacks in the United States (right). The works' ironic titles and juxtapositions of found objects dramatize the distance between the promises of the Founding Fathers and the Great Society and the realities for contemporary blacks. In *With Liberty and Justice for All*, for example, chains and handcuffs play off American flags and pictures of Martin Luther King, Malcolm X, and Nelson Mandela; another sculpture is called *Living in Public Housing and Working to Be Poor*. Minter builds on the Southern tradition of yard display, but uses it as an urban political activist to preach against injustice.

Minter began his assemblages in the late 1980s when he was laid off from work, disabled by years of exposure to chemicals in an automobile body shop. "When you pass on out, you want to leave something. . . . My goal is communication. Africa gave the world the drum. There were free people there in 4 million B.C., and in a book I saw rock paintings in South Africa, four thousand years old. It's not a third world, it's the First World."

Recent memorials to the Civil Rights movement also helped motivate Minter's "African Village," as well as his service during the Vietnam conflict. He wanted to tell what he considered the untold story of African-American workers. He has held various jobs himself since his high-school graduation, primarily in metalwork and machinery factories, as he supported his wife and two sons. During his Army duty of 1964–67 he specialized in heavy equipment manufacture and maintenance, and "The Unknown African Soldier" is one of his "Village" subjects. His determination to correct history drives him more than religion, but he is reverent. "There's a spirit in something that somebody used," he says of his found objects, which he does not paint. "You keep what's left from wind and water. God finishes it off with his hand."

The sculptor Lonnie Holley learned of Minter's work in the mid-1990s and alerted the collector William Arnett. Arnett's son Matthew included it in the 1999 exhibition he curated for Morris Brown College at Atlanta University, "Ogun Meets Vulcan: Iron Men of Jefferson County." Under this title, associating the Yoruba and Greek gods of metalwork, Arnett united assemblages by Minter, Holley, Ronald Lockett, Charlie Lucas, Thornton Dial Sr., Thornton Dial Jr., and Richard Dial.

View of Joe Minter's yard art, 1998

JOE MINTER. *Shipyard.*
Mid-1990s. Found metal, wire,
chains, 47½ x 50 x 28" (120.7 x
127.1 x 71.2 cm)

Purvis Young, 1980s

Purvis Young

b. 1943, Miami, Fla.,
lives in Miami

One of eight siblings, Purvis Young drew and painted as a child, and attended school until the ninth grade. He resumed art-making when he was jailed between ages eighteen and twenty-one for armed robbery. In 1973 he caught Miami's attention with a display of hundreds of his paintings on the walls of Goodbread Alley in the Overtown ghetto. A regular viewer of art books at the library, he had been inspired by a book about the late 1960s protest murals of Detroit. When Miami-Dade Public Library staff found him drawing in their texts, they gave him volumes that were about to be discarded, and he turned them into scrap- and sketchbooks of

ideas for his larger works. This support and his early exposure to an expressionist art of social engagement reinforced Young's drive to communicate, as well as his sense of style. He has continued to represent the characters and icons of Miami's streets on what he finds there—weathered boards, plastic, glass, and plaster.

Understanding his native city as a multiethnic crossroads of migrant workers and Latin immigrants, Young depicts trucks as emblems of freedom (opposite). "They bring food to the peoples of Miami," he says. "Angels bring the trucks, and trucks bring jobs, pick people up, and take them to jobs for a day. Jobs give you money to be free."[2] Like the trucks, wild dark horses embody freedom too, and he portrays them in squiggled shorthand, contrasting with white horses, and shown in sophisticated foreshortening, as in *Wild Horses* on page 124. Humans reach upward, as in *Stick Figures at Goodbread Alley* (1970s; page 150), because "they struggling still. The struggle, it come and go," because "there could be a better way for a better life." Young adds, "sometimes I paint Purvis in there!"[3]

Young calls his subjects "peoples who aren't happy, the homeless, and people who are knocking each other trying to get over the blue eye" (the white power structure).[4] Rembrandt, Van Gogh, and El Greco are his favorite artists, and he admires Abstract Expressionism and Japanese woodcuts, knowing them from reproductions. Despite his growing aesthetic awareness, however, Young's paintings of the 1990s are simpler than those of the '70s. His earlier works feature frames with detailed decoration and scenes in which jumps of scale between crowds of tiny figures and a few looming personages create an otherworldly space. One of his representatives explains that now pieces are removed by eager dealers before Young can work them over as before.[5]

PURVIS YOUNG. *Collage with Trucks*. Late 1970s.
Paint on paper on wood, 48 x 43" (122 x 109.3 cm)

Thornton Dial Jr., 1989

Thornton Dial Jr.

b. 1953, Bessemer, Ala.,
lives in Bessemer

The flaming house in Thornton Dial Jr.'s *Mississippi Burning* (1989; opposite) is instantly legible. The title is that of an Alan Parker film of 1988 about the murder in 1964 of four young Civil Rights volunteers in Philadelphia, Mississippi. Dial Jr. was eleven at the time of the incident, and his memory may have been reawakened not only by the film but by the white supremacist torching of several Southern churches around 1989. The flames in his picture are of cutout tin; the house is a silhouette of plywood with cutout windows and door. With a startling directness, this enamel-on-plywood relief brings home the savagery of racial persecution, setting its fire against a black sky.

Dial Jr.'s *Crucifixion* (1989; page 127) illustrates another aspect of his artistic expression, and one typical of the continued vitality of religious art among self-taught African Americans. The reality of Christ's suffering as a man (note the barbed wire crown of thorns) and the promise of salvation in his sacrifice are resonant themes for Dial Jr. and older black artists, as they are for the faithful in their communities. In portraying such subjects—notably absent from all but Expressionism and its revivals in post-war art—Dial Jr. and his colleagues respond to traditions of special meaning in their African-American experience and inheritance.

Dial first learned his art in the oldest form of artistic transmission—from his father. Both Dials use animals as resonant alter egos in their work, and both are particularly creative with a wide range of found materials, tactile ingredients that add expressive force to their depictions of allegorical beasts and topical events. Compare Dial Jr.'s *King of Africa* relief (1989; page 76) with his father's *Alone in the Jungle: One Man Sees the Tiger Cat* (1988; pages 108–9). Both men evoke Africa's king of the beasts and the emblem of royalty, and they draw associations from world art as seen in reproductions, from ancient Assyrian reliefs to Disney's *The Lion King*. Both Dials use rugs to form their big cats—Dial Jr. a tufted carpet that he left long for the mane of his lion and clipped for the body, and Dial Sr. a rag rug. Thus Dial Jr.'s *King of Africa* conveys the excitement of transformed materials found in the elder Dial's work, as well as its commanding scale. But characteristic of Dial Jr.'s reliefs and paintings is this piece's immediately readable motif and taste for patterning. His lion displays himself in simple profile, without foreshortening, and his habitat is filled with huge daisylike flowers framing two gorilla heads.

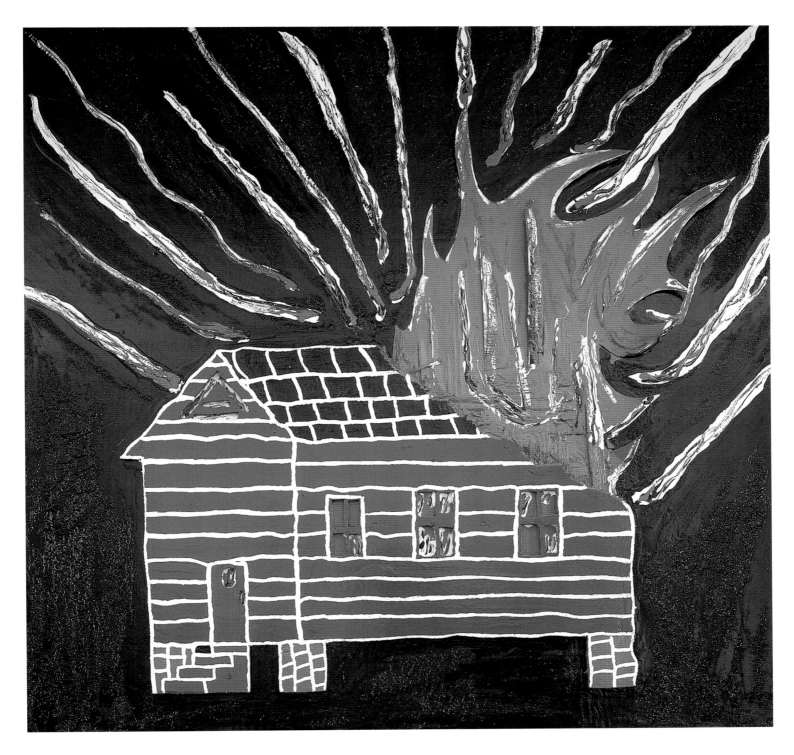

THORNTON DIAL JR. *Mississippi Burning.*
1989. Tin and enamel on plywood, 48 x 50"
(122 x 127 cm)

Charlie Lucas, 1980s

Charlie Lucas

b. 1951, Birmingham, Ala.,
lives in Pink Lilly, near Prattville, Ala.

Like many self-taught artists, Charlie Lucas describes his talent as God-given and says that he received a sign to exercise it at a time of personal need. "When I got down real sick and I couldn't care for my kids, I went to God," he remembered. "I asked him to give me a talent that no one else had, and I told him I would be honest with it, I would be disciplined in it, I would go as far as I could go with it. . . . This was the gift of God to me."[6] From then on he called himself "The Tin Man" and began to populate his yard with welded-metal dinosaurs, life-

size horses, cows, and human figures.

Lucas's maternal grandfather and great-grandfather were blacksmiths. His great-grandfather King Jackson made metal sculpture with leftovers from his work. Lucas "studied" with him, he recalled, and later acquired skills as a mechanic, which also translated readily into his art. Found materials attracted him too, and even though he could afford to buy new components by the early 1980s, he continued to search for pieces of used tin, wire, and wood. "I like anything that the man has thrown away that talks to me," he said, "I think to put something back into society." For Lucas, artistic transformation parallels personal redemption. "I'm trying to show I can recycle myself." The discards Lucas assembles are not ironic; they do not mock art-world preciousness, as in Dada, or reflect the cacaphonous urban scene, as do Robert Rauschenberg's "Combines." Rather, the materials of sculptures such as *Children of the World Reaching Out* (1989; opposite) reinforce their subjects, underlining Lucas's identification with the needy at society's lower edge. His consciousness of himself as an artist is sharpened by his family's history of creativity. They were basket weavers, jewelry and quilt makers, and repairmen of guns and wheels. His mother and grandmother—both quilters—"don't see me as an art person," he told Judith McWillie in 1987. Nevertheless, he remarks, "I like art; there's no limit on it. This is my life."

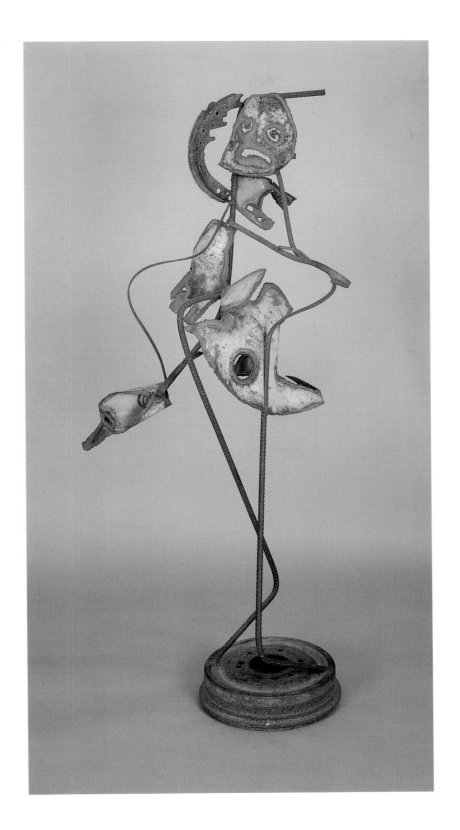

CHARLIE LUCAS. *Children of the World Reaching Out.* 1989. Welded found metal, 55 x 27 x 20" (139.3 x 68.6 x 50.8 cm)

THORNTON DIAL SR. *Clinton Blows His Horn.* 1993. Watercolor and graphite on paper, 30 x 22" (76.3 x 56 cm)

RONALD LOCKETT. *Remembrance of a Princess.* 1997. Paint, metal, nails, pencil, 48 x 48" (122 x 122 cm)

Allegorical Animals

The animal kingdom—from the dogs, squirrels, and cows of rural life to the great beasts of Africa—provides artists with symbolic identities while they make veiled sociopolitical commentaries. In the older Southern storytelling tradition of animal fables, popularized as Uncle Remus tales, such images communicate to both African-American and white audiences, though often in opposite ways. The artist can wear an aesthetically charming mask while making an otherwise discomfiting point. The narrative history of animal protagonists and self-identification with heraldic animals descends from African cultures, as well as from Western bestiaries and Aesop's fables, and can be seen in African-American quilt motifs and spirituals from the nineteenth century on. Some of the painted or modeled animals illustrated here may be simply decorative; however, the possibilities of local folkloric or private meanings cannot be ruled out.

In *Testimony*, Thornton Dial Sr.'s paintings of animal surrogates present what may be the most complex reflections on human relations. The tiger is his alter ego, but it also stands for African Americans struggling in their new jungle, with captors, one another, and other creatures (such as the monkey, which Dial sees as government on the animals' backs). Will the tigers be crushed or domesticated, or will they triumph on their own terms? About one of his pictures of a proud feline, he remarked, "If the tiger had knew he would be the star of the circus, he wouldn't have hid so long in the jungle."[7]

THORNTON DIAL SR. *The Beavers Dam the River and the Tigers Go Across.* 1990. Oil on canvas, 59½ x 60¼" (151.2 x 153.1 cm)

THORNTON DIAL SR. *Alone in the Jungle: One Man Sees the
Tiger Cat*. 1988. Enamel, rope carpet, and industrial sealing
compound on wood, 48 x 96" (122 x 243.9 cm)

Allegorical Animals

Thornton Dial Sr., 1997

Thornton Dial Sr.

b. 1928, Emelle, Ala.,
lives in McCalla, Ala.

Of all the artists represented here, Thornton Dial Sr. is probably the best known. The subject of a monograph with essays by Amiri Baraka (Leroi Jones) and Thomas McEvilley (1993), as well as countless writings, and represented in numerous American museums, Dial Sr. has earned a living through his art since the early 1990s. As the creative center of an art-making family,[8] he now enjoys a comfortable life not far from Bessemer, Alabama, where he spent over thirty years as a steel worker.

Dial Sr.'s success reflects on mainstream valuation of American art as well as African-American expression. The painter-sculptor stresses his determination, versatility, and persistence against the inevitable odds facing black workers as he recounts his experiences. He was employed by the Pullman Standard Company in Bessemer from 1952 to 1980, and part-time at the Bessemer Waterworks for some thirteen years.

"I used to go from job to job," he told Judith McWillie in 1988. "I worked with construction; I worked with highways; I was a cement worker when I was fourteen years old. I have worked some of everywhere. . . . When I would get out of a job, I'd pull corn. I did everything. I worked for a dollar a day, when the children were small, just helping somebody." Dial and the sculptors Charles Lucas and David Smith were all grandsons of blacksmiths, and proud of this descent. In the mythology of American art, such genealogies validate family, self-sufficiency, hard work, and manual dexterity.

Dial's sculptures of found metal parts, which he began in the mid-1980s, draw on his welding skills and transformative vision. In his paintings, in which the tiger is his personal emblem, he responds to current events, social and political circumstances, especially for African Americans, and happenings affecting family and friends. His surfaces writhe with built-up impasto, sometimes thickened with car-body compound and found materials, and his colors are often electric. Yet he channels his strong emotions and pungent observations indirectly, through animal and human allegories, like a traditional African-American folktale teller or fabulist. These alter egos let him comment on the harsh realities of human relationships—racial or otherwise—while he engages his viewers imaginatively and aesthetically.

A continuing subject for Dial is the struggle to succeed in the jungle, against odds, in a hierarchy of social players, as in *The Beavers Dam the River and the Tigers Go Across* (1990; page 107). Another title comments wryly on sexual conflicts: *If the Ladies Had Knew the Snakes Wouldn't Bite Them They Wouldn't Have Hurt the Snakes; If the Snakes Had Knew the Ladies Wouldn't Hurt Them They Wouldn't Have Bit the Ladies* (1989). Women are mythic enchantresses (page 80), mothers, bearers of wisdom, instigators of social change, and also society's victims (pages 31, 34). Images crowded in shallow space may signify physical and psychological oppression (page 10), while objects and materials embedded in reliefs or configured in assemblages unite past and present in multilayered allusions—to their original owners, to the history of their use, to their new public identity, or to other artists who use readymades (page 23). Improvisatory and technically daring with diverse ingredients, Dial's work is intended to provoke thought. "If my art don't rub off on somebody, it ain't art."[9]

Dial was born in a rural area of Alabama, near the Mississippi border, and had to leave school after the fourth grade to help farm with his family during the Depression. He moved to Bessemer as a youth to live with his great-aunt Sarah Lockett, who also helped rear Ronald Lockett and Lockett's father. Marrying in 1951, Dial and his wife, Clara Mae Murrow, had three daughters and two sons together. After the closing of Pullman Standard in 1980, Dial and his sons started manufacturing lawn furniture and selling it from their workshop on the family property. In 1987 he began to create art full-time. In 1993 his work was shown simultaneously in two solo exhibitions in New York, at the Museum of American Folk Art and the New Museum of Contemporary Art. His work was included in the Whitney Museum's Biennial 2000, as described in Arthur Danto's essay here.

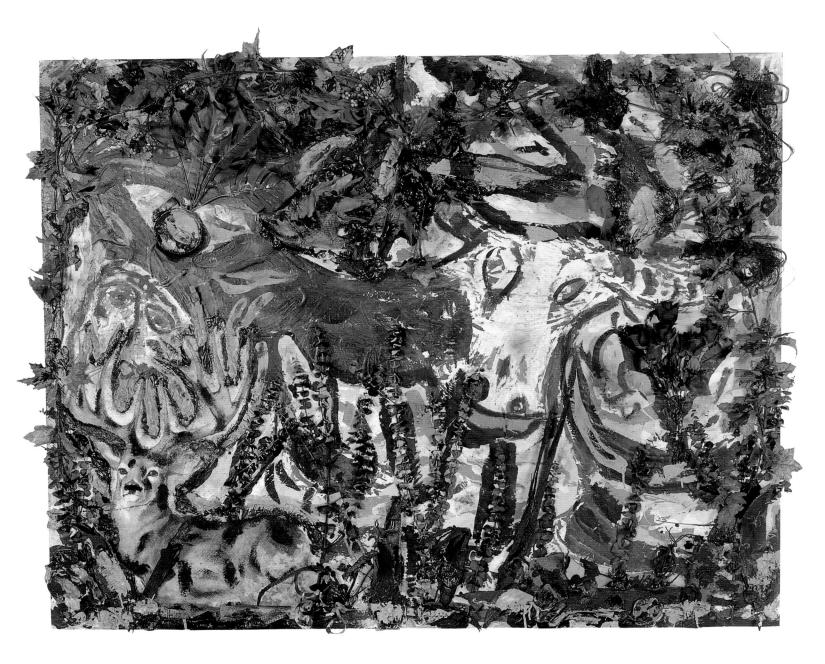

THORNTON DIAL SR. *Proud Family.* 1997.
Artificial flowers, printed fabric, wire, rope,
rubber, plastic, oil paint, clothing, glove,
metal, and enamel, 48 x 60" (122 x 152.5 cm)

THORNTON DIAL SR. *Lady Wondering about the Long Neck Goose*. 1991. Pencil and watercolor on paper, 30 x 22" (76.3 x 56 cm)

THORNTON DIAL SR. *Freedom Bird in the United States*. 1995. Pencil and watercolor on paper, 30 x 45" (76.2 x 114.3 cm)

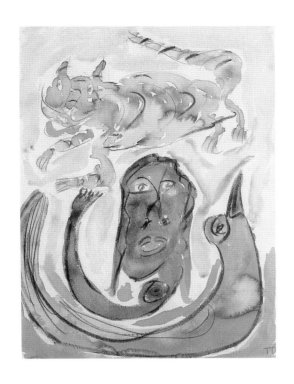

THORNTON DIAL SR. *Tiger on Top.* 1991. Pencil and watercolor on paper 30 x 24¼ " (76.3 x 56.6 cm). The Studio Museum, gift of Ronald and June Shelp

THORNTON DIAL SR. *Lady Holds the Bird.* 1991. Watercolor, charcoal, and crayon on paper, 22¼ x 30" (56.6 x 76.3 cm). Museum of American Folk Art, gift of Ronald and June Shelp

Ronald Lockett

b. 1965, Bessemer, Ala.,
d. 1998, Bessemer

Ronald Lockett, 1990

Of the artists in *Testimony*, Ronald Lockett was one of the most sophisticated about painting. Themes of opposition run through his life and work. A cousin of the Dial family, he was reared by his grandmother, who also reared his father and Thornton Dial Sr., the patriarch of the family of Alabama artists. Lockett's grandmother supported his art-making, as she had Thornton's, but Ronald's mother was negative, though he had drawn since the age of five and wanted to be an artist from the fourth grade. "I wouldn't allow her to stop me," he recalled. "So sometimes discouragement can encourage, too."[10]

After finishing high school, where art was his favorite class, Lockett drifted, briefly working in the Dials' metal furniture-making business. Thornton Dial's ingenious transmutations of found materials impressed him, and in his work Lockett sometimes made his points, like his uncle, through allegorical animals. In *Traps* (1988; page 116), for example, beasts and birds struggle behind real wire mesh. More often, however, Lockett used mixed media and fluidly painted images for more overt commentary on current social issues. In *Homeless People* (1989; page 91), black silhouettes seem threatened by their environment of brushstrokes in white enamel. Ku Klux Klan house-burnings (which he depicted in *Smoke-Filled Sky* on page 85), the Kennedy and Martin Luther King assassinations, environmental destruction, and disease are also among his themes. "In my work, I'm expressing an idea of what I really think is wrong with society," he said. "Mostly,

though, my work is connected to me. It's personal. Like one piece I did with strips of metal of a ghostlike cowboy on a horse, wandering around in eternal unrest, never at peace."[11]

When he was around age twenty-two, Lockett's art was noticed by William and Judy Arnett, the collectors and champions of African-American vernacular art of the South, and he began devoting himself to making art full-time. At thirty-two he died of AIDS.

RONALD LOCKETT. *Undiscovered.* 1993. Rusted tin and colored pencil on wood, 47 x 45" (119.4 x 114.3 cm)

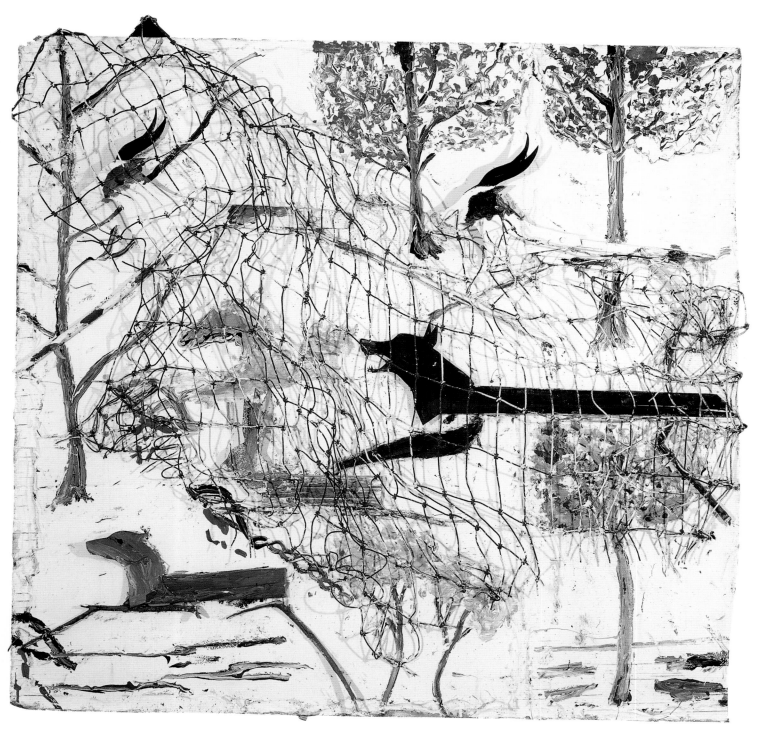

RONALD LOCKETT. *Traps*. 1988.
Enamel, tin, and wire mesh on ply-
wood, 48 x 50" (121.9 x 127 cm)

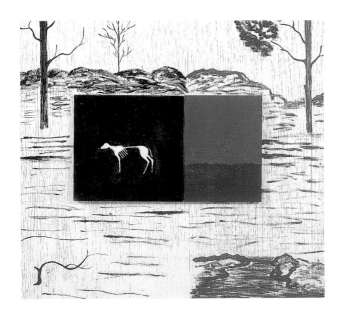

Left: **RONALD LOCKETT.** *The Deer Can See Everything.* 1993. Oil on canvas, 36 x 48" (91.5 x 122 cm). The Newark Museum, gift of Ronald and June Shelp

Below: **RONALD LOCKETT.** *Untitled.* c. 1988. Paint and wire mesh on plywood, 43 x 42½" (109.2 x 108 cm)

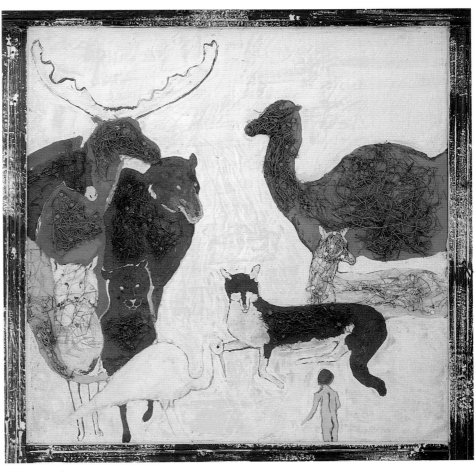

Mose Tolliver, 1980s

Mose Tolliver

b. c. 1919, near Montgomery, Ala.,
lives near Montgomery

Seen from above and painted with a
brushy, wet-on-wet technique, the avian
pairs in *Two Quail Birds, Two French
Birds, Two Love Birds with a Feed Basket*
(1988; opposite) resemble fabric pat-
terns in their decorative quality. But
Mose Tolliver's choices of delicacies,
pets, and song birds may intentionally
point to the luxuries of the white South.
Does *Deep Sea Water Turtle* (1987;
page 181) represent good catch, a lucky
charm, the maxim that slow and steady
wins the race, and/or a connection to
the natural world of Tolliver's boyhood
on a tenant farm in rural Alabama? The
artist's engaging and prolific work—full
of silhouetted fauna, flora, and some-

times sexually explicit figures—allows
multiple interpretations.

Although Tolliver is not a musician,
writers have associated his turtle paint-
ings with blues and jazz and "the musical
components of variation, improvisation,
strong rhythm, syncopation, percussive-
ness, chromatic harmony, and alternat-
ing stasis and movement."[12] Further,
Tolliver's subjects seem to evidence
"knowledge of Southern African-Ameri-
can tales, folk beliefs, and superstitions,
some of which deal with metamorpho-
sis, animism, conjuration, and magic,
including the belief that humans could be
transformed into nonhuman forms. . . ."[13]
The broad-brush dotting, which repre-
sents the turtle's shell in *Deep Sea Water
Turtle*, resembles "African and African-
American embellishments on sculpture,
wall painting, house facades, shrines,
and body decoration," and it also
appears in paintings by Nellie Mae Rowe
and Mary T. Smith.[14] Yet Tolliver is report-
edly unaware of African culture. Never-
theless, his work has affinities with that
of other African-American vernacular
artists of the South. This shifts the ques-
tion of conscious references by one artist
to "the possibility of a common cultural
source"[15] for this art.

As a teenager, Tolliver had decorated
stumps ("paint on a root, it brings life to
it"[16]), painted over reproductions and on
glass (for example, landscapes on dis-
carded TV screens), and copied popular
images. When an accident at work in the
late 1960s left him unable to walk with-
out canes (page 146, right), he resumed
painting, using found boards, paints,
and books to copy that friends brought
to him. The man he had worked for used
to paint, he recalled to Judith McWillie in
1986, "and I got all the lessons I want
watching him. . . . It took me a long
time. I didn't know if it was right or
wrong. Someone told me it was right."

He was included in the Corcoran
Gallery's influential survey of 1982,
"Black Folk Art in America 1930–1980,"
traveling to the capital for the opening,
and since that year Tolliver's family
members (he fathered thirteen children)
have collaborated on many of his paint-
ings. Between 1986 and 1989 he was
closely associated with the collectors
William and Judy Arnett, painting many
autobiographical figures and narratives
that entered the Arnetts' collection. Earli-
er, the dealer Anton Haardt of Mont-
gomery, Alabama, had purchased his
work, and Robert Bishop, then director
of the Museum of American Folk Art,
"bought every picture I had."[17] Tolliver's
exposure to these art-world figures
helped determine his career.

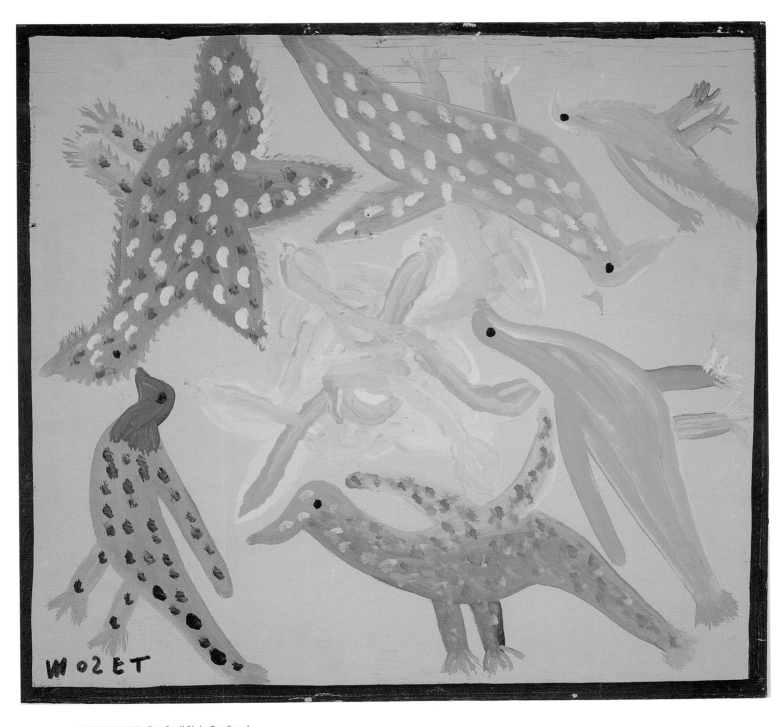

MOSE TOLLIVER. *Two Quail Birds, Two French Birds, Two Love Birds with a Feed Basket.* 1988. House paint on plywood, 24 x 25¼" (61 x 65.4 cm)

Joe Light, 1980s

Joe Light

b. 1934, Dyersburg, Tenn.,
lives in Memphis, Tenn.

Joe Light's art is most often public and made with a sense of mission. Outside his house, his hand-lettered signs comment on social concerns and preach righteous living, in the tradition of some evangelical churches. His sculptures made of found objects, from driftwood to junked TV sets, are placed inside and out, as in the yard art of Bessie Harvey, Ralph Griffin, and Lonnie Holley. His paintings, which he started in the mid-1980s, ornament his home and serve as a complex communication system with family members (he and his wife, Rosie Lee, have ten children). The cartoonlike animals and flowers he paints in enamel on wood are intended as both decorative and hieroglyphic, transforming what he

sees as humble objects and settings into things of beauty and personal meaning. *Best Mountain* (1989; opposite), on a four-by-eight-foot piece of plywood, shows a delicate color sense, and its shorthand language for topography contrasts with the literalness of its cutout metal relief of a duck in flight from a fish in the clouds.

Light says he was a delinquent adolescent, and in his twenties he served two prison terms. During the second, he converted to a private form of Judaism, and on his release he moved to Memphis, Tennessee, where he painted sidewalks and highway bridges with redemptive messages. "I had some experiences that taught me things," he told Judith McWillie in 1987. "I found out a lot of things I thought were wrong were right and a lot of things I thought were right were wrong." Supporting himself selling second-hand goods at flea markets, he married and around 1975 began making freestanding signs and sculptures. "I think I have the answers to a lot of things from my experience. I work at trying now to just better my life. . . . Everything is to the light." Despite the hostility of some of his neighbors to his yard art, where he is "speaking about God" and about how African Americans can improve themselves, he persists in this didactic work (below), commenting, "It's not about making people mad. It's about sharing what I know."

View of Joe Light's home, 1980s

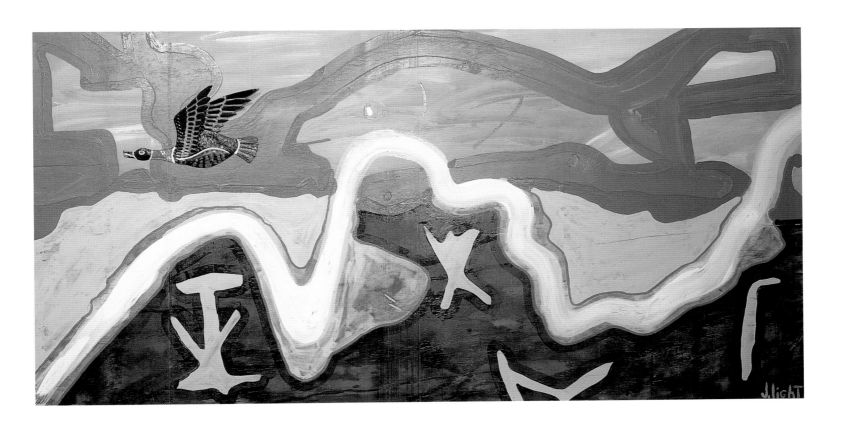

JOE LIGHT. *Best Mountain*. 1989.
Enamel and metal on wood,
48 x 96" (122 x 243.8 cm)

Top: **BESSIE HARVEY.** *Prehistoric Bird*. 1988. Paint on wood, 29⅜ x 44 x 19½" (74.6 x 111.8 x 49.6 cm); base of sculpture 14 x 38" (35.6 x 96.5 cm)

Right: **THORNTON DIAL SR.** *Julio*. 1995. Roots, goat carcass, wooden palette, enamel, and industrial sealing compound, 57½ x 53 x 48" (146 x 134.6 x 122 cm)

Opposite: **RALPH GRIFFIN.** *Untitled*. c. 1989. Acrylic paint on wood, 13½ x 32¾ x 5" (34.4 x 83.2 x 12.6 cm)

PURVIS YOUNG. *Wild Horses.*
1978. Paint on cardboard,
25¼ x 19¼" (64.1 x 49 cm)

THORNTON DIAL JR. *Cat.* 1989.
Enamel on carved plywood, 48 x
70⅝" (122 x 179.4 cm)

Biblical Scenes

In their renderings of scenes from the Old and New Testaments, the artists in this group respond most closely to the inheritance of Western art history. Yet their interpretations of the images they have received—filtered through centuries of Catholic commissions and transmitted via Protestant illustrations in bibles and hymnals and the evangelical practices of the South—remain personal. Adam and Eve in the Garden, the Holy Family, the miracles and parables of Jesus, and the Crucifixion are among the subjects inspiring their self-identification, sense of moral mission, and artistic invention. Edens set in Africa, narratives of heated emotion and ethical and physical combat, and Christ's suffering and his promise of justice and salvation are projections from intensely felt experience.

Many of these artists are motivated to preach through their visual expression, whether they paint edifying scenes or verbal homilies. Some grapple in public with the commandments of their faith, like Mary Proctor, who paints monumental panels with her didactic messages and biblical figures, and Joe Light, who has posted his moral sayings on his porch and around his property. Both were motivated by personal crises that gave them a sense of mission and led them to "the light"; both passionately exhort their viewers to mend their ways and live godly lives. Community reactions were not always positive: "I was speaking of the Old Testament in ignorance of the problems I would cause myself," recalled Joe Light. "I was speaking about God and I figured people would like to hear things about God. You know, I never would have thought they didn't. It was a long time before I learned how serious religion was in this world."[18] But he, Proctor, and others persist as self-selected missionaries. "I got the message from the Lord," says Proctor about her art-making, "and I've been following His directions ever since."[19]

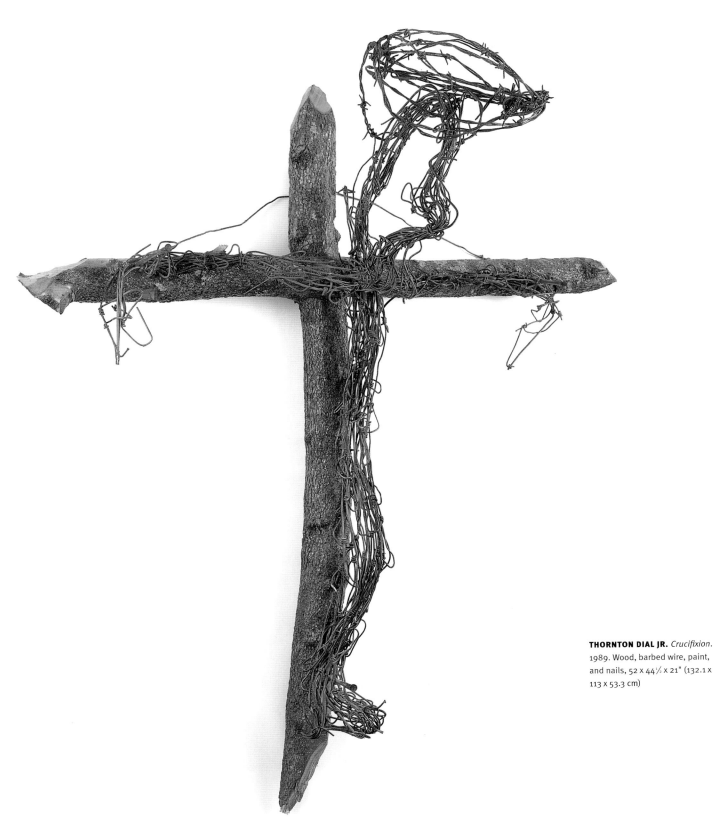

THORNTON DIAL JR. *Crucifixion*.
1989. Wood, barbed wire, paint,
and nails, 52 x 44½ x 21" (132.1 x
113 x 53.3 cm)

Mary Proctor, 2000

Mary Proctor

b. 1960, Monticello, Fla.,
lives in Tallahassee, Fla.

When Mary Proctor's grandmother, who had reared her, and her aunt and uncle died in a trailer fire in 1994, she was immobilized by grief for a year. She decided to fast and retreat to her backyard to read her Bible. On the thirtieth day, she reports, she saw a blinding light and heard a voice commanding her to find a door and paint a lady on it. "The Lord gave me a vision to paint doors, and I'd never painted anything before."[20] Her relatives may have perished because they were unable to open a door. The Bible spoke to her too: the door to salvation is Jesus, Proctor says, quoting the Gospel of St. John. The vision was a conversion experience that gave her an evangelical mission and a medium, as she saw it: she began painting full-time, often signing her tall panels "Missionary Mary Proctor."

Before 1995 Proctor had run "The Noah's Ark Flea Market" from her home and yard, selling old dolls, watches, costume jewelry, textiles, mirrors, and other bric-a-brac, as well as used furniture. These ingredients—small, colorful, reflective, often fragmentary—have entered her paintings, where they ornament the flattened human figures and set off her moralizing inscriptions. Against freely brushed backgrounds, Proctor silhouettes one or two iconic personages. Her inscriptions, preaching godly, moderate, charitable living, come from the Bible—such as Proverbs 22:6: "Train up a child the way he should go and when he is old he will not depart"— and from popular sayings and personal anecdotes. Some inscriptions convey folk wisdom, historical information about black leaders (such as Frederick Douglass and Harriet Tubman), or feminist statements, sometimes humorous ones ("Wow! If God made anything better than a woman, He kept it for himself"). The panels instruct with such messages, while they charm with their graphic patterns and cheerful hues.

Blue Willow Plate (opposite) poignantly honors her grandmother, telling how she forgave Proctor's breaking her "favorite old blue willow plate." The inscription goes on: "I forgive you child cause just yesterday God forgave me. And he said 'to get forgiven one must forgive.'" To collector William Arnett, the shards of blue china glued to the figures recall the African-American funerary practice of placing broken crockery on a grave, and also the grave ornament called a "memory jug," which contains small possessions of the deceased, often including broken pottery.[21]

In addition to her door paintings, Proctor's recent work includes wooden sculptures she roughs out with a chain saw and finishes with a jigsaw, and carvings of seven-foot wooden poles. Her "diary" is now more than two hundred pages long and consists of nine-by-twelve-inch sheets of tin, which she has inscribed with events from her life and collaged with her usual bright ingredients. Her work is represented in the collection of the American Visionary Art Museum in Baltimore, Maryland, and has been given several solo exhibitions.

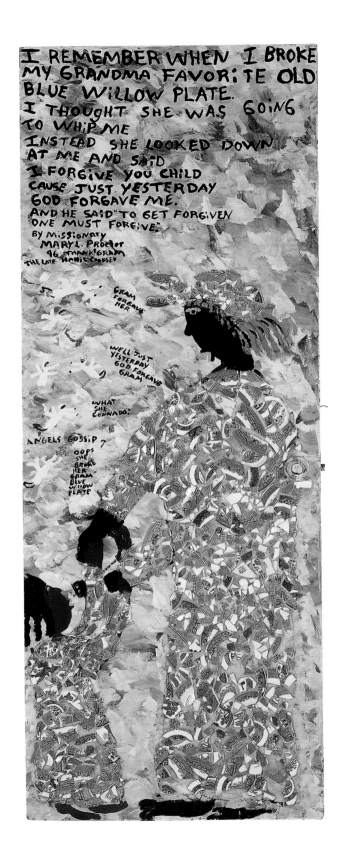

MARY PROCTOR. *Blue Willow Plate*. 1996. Wood door, paint, broken pottery, and glue, 80 x 30" (203.3 x 76.2 cm)

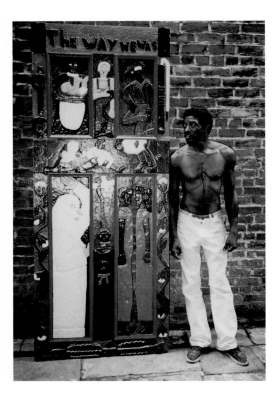

Herbert Singleton Jr.

Herbert Singleton Jr.

b. 1945, New Orleans, La.,
lives in New Orleans

Bible stories, chain gangs, and New Orleans jazz funerals are all subjects of Herbert Singleton Jr.'s relief carvings. Whether about joy, pain, or spiritual and moral confusion, these dramatic, action-filled narratives by the New Orleans–born artist are observations or projections from his life in the often violent inner city.

The oldest of eight children, Singleton completed sixth grade and in his youth worked in a steel factory and as a bridge painter. His first artworks were clay snakes he modeled in the 1970s for the old Voodoo Museum in New Orleans and then wooden totem poles and crucifixes, nailed with chicken claws, that he carved for the tourist boats. "The person running the shop would tell me what to do," he recalled.[22] "When the river was low, I would find a plank of wood to carve. I would look at it and wonder if someone's house and life fell apart."[23] Singleton also carved and painted "killer sticks" for neighborhood toughs to pay for his hard drugs. During the jail terms he served—almost fourteen years on three sentences—he became familiar with the Bible, and his

art grew more elaborate. Around 1989 he began the bas-reliefs for which he is best known, carving found wooden doors and panels and enameling them with emphatically patterned crowd scenes. In *The Miracle of Jesus* (opposite), for example, he uses the door panels to depict events such as Christ calming the waters and healing the sick. In the door frame are an elongated loaf and fish, and, beneath the Crucifixion, the words "I Promise Everybody Is Gonna Eat." In contemporary stories, Singleton portrays the self-destruction of the ghetto and the conflicts of the larger society, from a Ku Klux Klan lynching to what he calls the "blood for oil" of the Gulf War. He terms these his "struggle pieces."[24]

Since the early 1990s, Singleton has been able to support himself with his art, and he continues to castigate as well as attract with his range of themes. Depictions of one teen killing another for his gold-plated Malcolm X medallion and a black businessman hanging a black man in rags counter images of a black Moses, Fats Domino, and voodoo skulls and snake-men. All these works, boldly colored reliefs or carved stumps, combine contrasting syncopated forms in shallow space, sometimes with inscriptions. The reliefs exploit the symmetrical, paneled structures of the found doors. Singleton points out the moral of his didactic carvings: "I don't believe in no spirits. All those potions, palm reading, witch-doctor rituals give you confidence by proxy. The only way you can solve your problems is by yourself."[25]

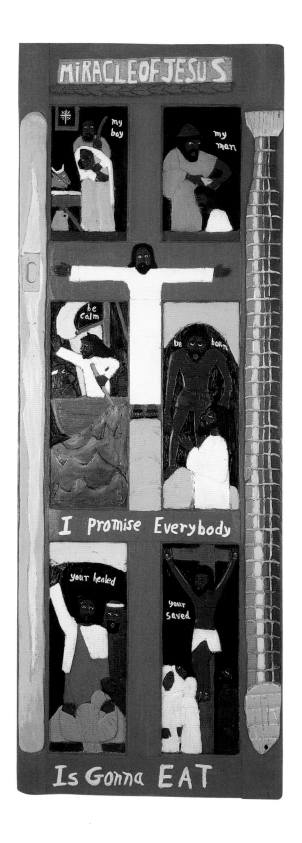

HERBERT SINGLETON JR. *The Miracle of Jesus.* 1998. Enamel on cypress wood, 108 x 36" (274.4 x 91.5 cm)

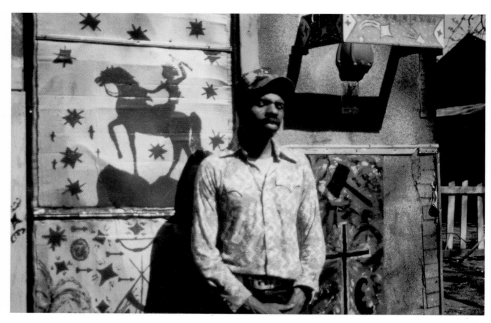

Felix Virgous, 1988

Felix "Harry" Virgous

b. 1948, Woodstock, Tenn.,
lives in South Memphis, Tenn.

Virgous began painting in childhood, around the time that an accident left him incapable of strenuous labor. As a result of the injury, he was unable to attend school, and he lived with his parents until his marriage at forty, supporting himself doing odd jobs in the neighborhood. The yard art and signs by Joe Light across the street in Memphis encouraged him to resume painting, and his parents let him decorate an outbuilding on their property. The "Harry Club" became his retreat, an environment-sized assemblage of magazine ads pasted to the walls, found objects, and his

own abstract and representational painting and carving. Themes of pop music, Native American heroes, threats to African-American youth such as drug use, and Old and New Testament narratives occupy him. The elephant, flamingo, and zebra in his *Adam and Eve* (1988; opposite) are probably based on magazine illustrations; they suggest that Eden, as Virgous sees it, was in Africa. In 1987 Lonnie Holley encountered his work while on a trip looking for other African-American artists. From then on, the colorful, gentle art of the shy Virgous began to reach a larger audience.

FELIX VIRGOUS. *Adam and Eve.*
1988. Tempera on wood,
12⅞ x 23⅜" (32.8 x 59.4 cm)

Arthur Dial

Arthur Dial

b. 1930, Emelle, Ala.,
lives in Bessemer, Ala.

Like many Southern vernacular artists, Arthur Dial creates pithy scenes of conflict from a variety of sources, from the Bible and recent Southern history to everyday life. Adam and Eve, cut from carpet backing, are tempted by a snake of tubing in a 1989 painting (page 65). Alabama governor George Wallace resists integration, and a farmer replaces his mule with a tractor.

On plywood sheets Dial paints or affixes cutout, emblematic figures in frontal or profile poses. Backgrounds are flat, patterns are brash, and colors are

meaningful. About *Welfare Office* (1989; page 72) he said, "The government know that some peoples can't take care of theirselves. The problem is that some of them that could work take advantage of the welfare. All colors [of people] go. There's all kinds need it. I made the inside of the welfare office a light color to symbolize comfort. Outside is dark. There ain't much out there for some peoples." About his New Testament scenes, he commented, "All they show us is a white Jesus, so I made him white. . . . The Bible says his hair was like lamb's wool, so I doubt he was white. Them thieves were Jews. Jews ain't white so I made them brown. The Romans that did the hanging of him were brown people, too. They were all brown back there, probably."[26]

Dial is a member of the extended family of Alabama artists and the half-brother of its patriarch, Thornton Dial Sr. As boys, the two were sent to Bessemer to live with their great-aunt, and as adults both worked locally at the Pullman Standard boxcar factory and at U.S. Pipe, where Arthur put in thirty-seven years doing various kinds of metalwork. Both Dials drew as children, and at the pipe shop Arthur assembled animals and figures from scrap steel and pipe. He started making art full-time when he retired at age sixty-two. He credits his art activity to the example of his family and their neighbors, but he works independently. "I got one or two ideas from the news, but most of it comes from what I see and the opinions I got inside me. My art is a record of what went by."[27]

ARTHUR DIAL. *Crucifixion.* c. 1989.
Enamel, foam, and industrial sealing
compound on plywood, 40¹⁄₂ x 79¹⁄₄"
(103 x 201.4 cm)

Lorenzo Scott

Lorenzo Scott

b. 1934, West Point, Ga.,
lives in Atlanta, Ga.

A devout Baptist, Lorenzo Scott made a visit with his church to New York in 1968; there he saw sidewalk artists at work and went to the Metropolitan Museum of Art. They were both revelations. He was earning his living as a house painter and sometime sign painter, and he had sketched, he says, from the age of five. The Renaissance and Baroque religious paintings at the Metropolitan led him to those at the High Museum in Atlanta, where his family had moved when he was an infant. Through patient copying of these paintings and art-book reproductions, he taught himself oil-glazing technique and Old Master composition and iconography. Motifs from artists as disparate as Giotto and Veronese meld in his serene and flattened figure compositions, generally portraying Christ (opposite). Scott

is unusual among vernacular artists in painting with oil on canvas; he gilds the frames he builds up with auto-body compound, in imitation of museum framing.

The distance of Scott's style (if not his religiosity) from the styles, for example, of John (J. B.) Murray and Thornton Dial Jr. demonstrates that these self-taught artists are not unified by their language of form or pool of artistic references. Indeed, Scott's art is unusual among the works in the Shelp collection because he attempts to replicate the anatomical drawing, modeling, and spatial illusionism of academic art. He lacks the decades of schooling often necessary for such mastery, but he may be as knowledgeable about art as many schooled artists—thanks to widely available reproductions, media coverage, and museum visits.

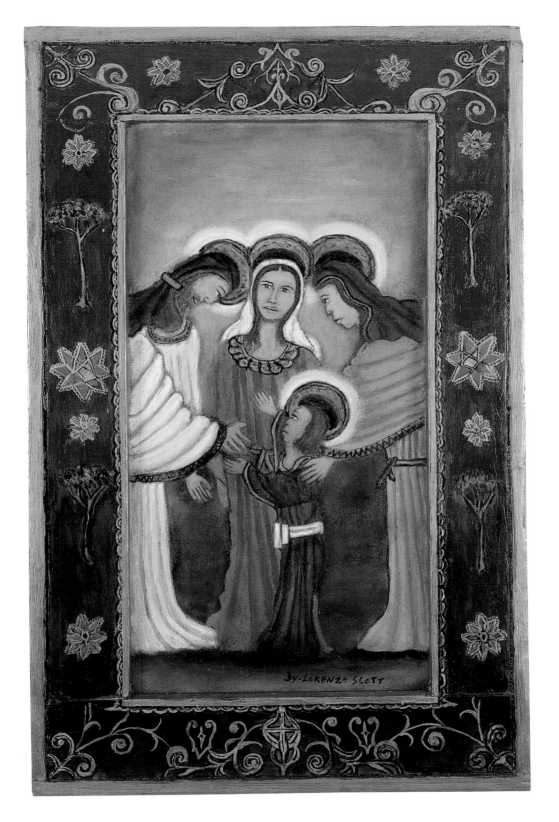

LORENZO SCOTT. *Jesus as a Child.*
c. 1980. Oil on canvas with
hand-painted wood frame, 33¼ x
21¼ x 3¼" (85.7 x 54 x 8.2 cm)

PURVIS YOUNG. *The Flying Angel.*
1979. Paint on wood, 96 x 48"
(244 x 122 cm)

THE BLACK MADONNA

LEROY ALMON. *The Black Madonna.*
1985. Paint on carved wood, 30 x 12"
(76.2 x 30.5 cm)

RONALD LOCKETT. *God Created Man in His Own Image.* 1988. Paint and metal on wood panel, 48 x 66 x 5" (122 x 167.6 x 12.7 cm)

JOE LIGHT. *Sheba.* 1989. Enamel on wood, 24 x 28½" (61 x 72.5 cm)

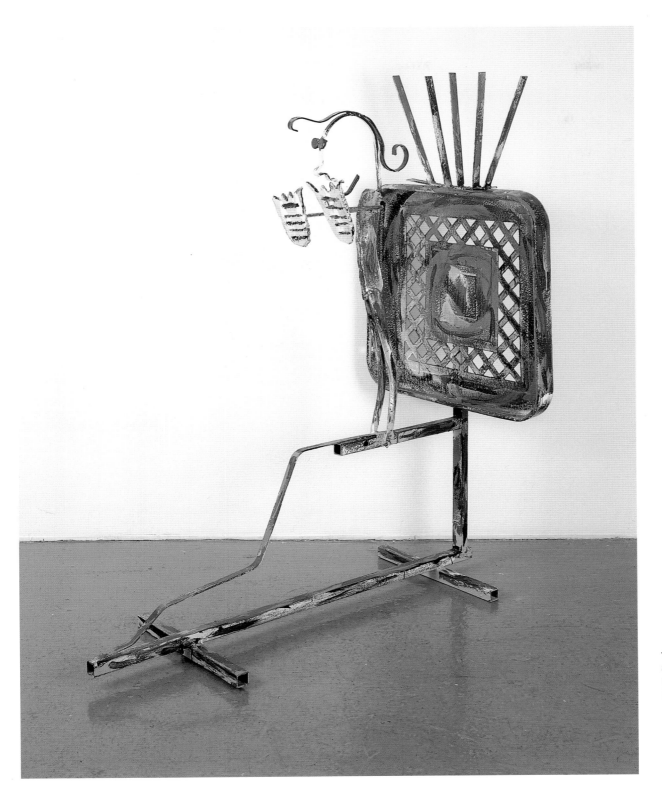

THORNTON DIAL JR. *Moses and the Ten Commandments.* 1988. Enamel on steel, 45 x 20½ x 37¾" (114.3 x 52.1 x 95.9 cm)

Iconic Human Figures

Overt self-portraits and icons of universal human conditions cohabit in this section, which suggests the kaleidoscopic visual possibilities of the human face and form. In single or paired figures, the artists see timeless themes such as parenthood through an African-American lens, interpreting them through concern for current socioeconomic conditions. Such works embody both the legacy of self-expression descending from Romantic art since the late eighteenth century and the encouragement to recognize and celebrate racial identity fostered by African-American political activity since the 1960s.

Self-portraits are directly self-assertive and descriptive. In Mary T. Smith's paintings of her family and church congregation, often displayed on the metal fence she erected on her property, she made her community permanent, as well as her place in it. Fellow artist Lonnie Holley admired her pictures: "She would take a hatchet and make all these praise images with their hands up in the air and all these simple faces of different people that she had been to church with, . . . these memories of her children and her grandchildren. . . . And this woman worked so hard, right beside the road, she got everybody's attention. They would stop and see her work. And she was really working for her Lord."[28]

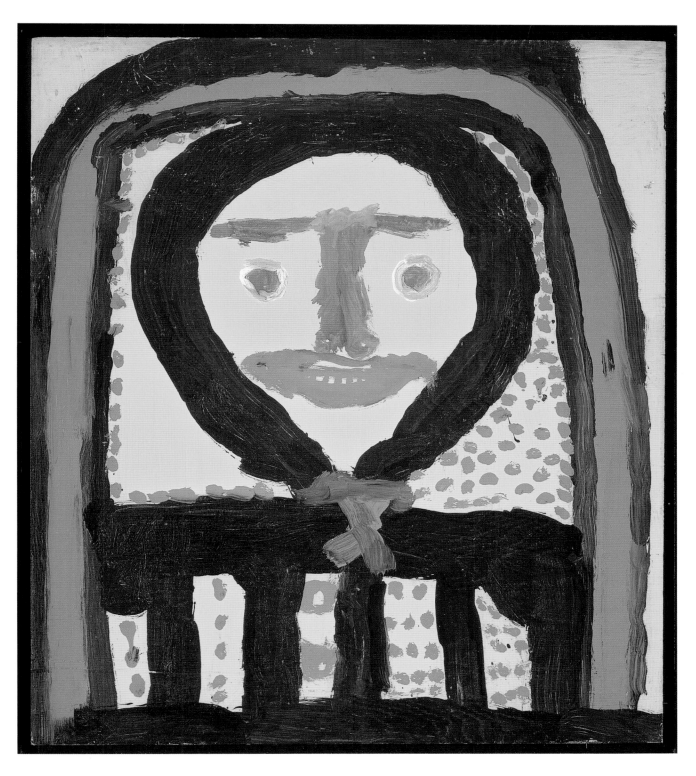

MARY T. SMITH. *Hello to Y'All.* 1988. Enamel
on plywood, 30 x 26½" (76.2 x 67.4 cm)

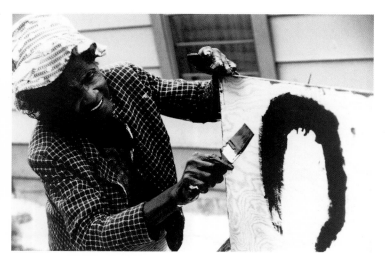

Mary T. Smith

Mary Tillman Smith

b. 1904, Brookhaven, Miss.,
d. 1995, Hazlehurst, Miss.

From around 1978, when she was seventy-four, Mary T. Smith painted brightly hued frontal figures and animals on scrap materials—discarded plywood, strips of tin, hubcaps, paint-can lids. She began, she said, "to pretty up my yard," in the tradition of the "yard shows" of sculptures, decorations, and signs found in the rural South and elsewhere. Eventually she filled her one-acre lot with her broadly brushed, expressionistic works, which she hung on a fence she had made of strips of shiny tin roofing. Because of a longtime hearing impairment, distinct speaking was impossible for her, but her images and her legends communicated directly, and most often joyously, to her neighbors: "I love God,

peoples. The Lord no me." "Here I am. Don't you see me." "Hello to Y'all" (page 143). "My name is someone. The Lord for me. He no." "I am for good, none for baid." "I love the name of the Lord." These were some of her yard signs and the titles of her paintings, as Judith McWillie noted them in 1986.

For most of her adult life, Smith earned a living as a tenant farmer and a cook not far from her birthplace in Copiah County, Mississippi. Pictures of cows, pigs, dogs, and so on are based on domestic animals she saw in her rural area. Certain paintings made from memory portray fellow parishioners and the children and grandchildren of her two marriages. Figures with their arms held

high may be worshipers (page 143), according to Southern tradition; those with hands on their hips suggest guardians (page 145). The word for this assertive gesture, arms *akimbo*, suggests a creolization of *bakimba*, the name of a Kongo protective society, according to the scholar Robert Farris Thompson. He sees the survival of such African sentinels in the yard art of Smith and others, although the artists were probably unaware of such sources.[29]

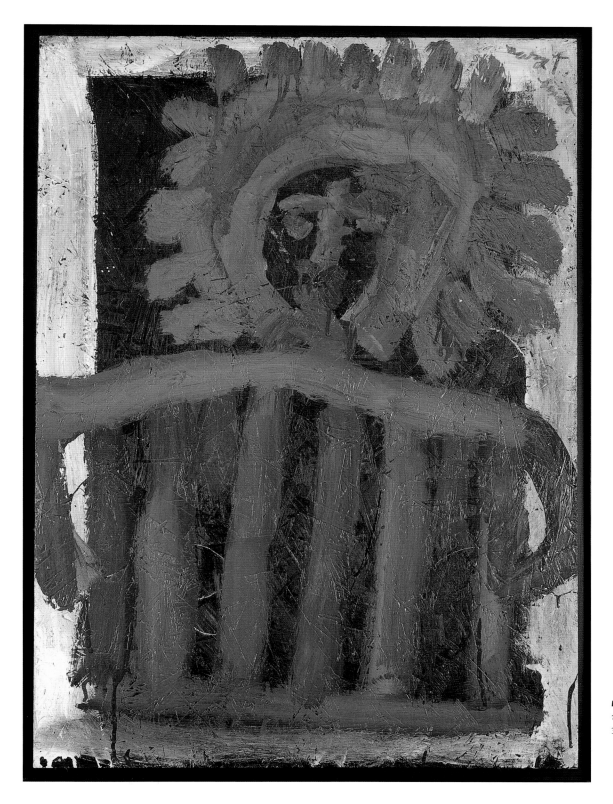

MARY T. SMITH. *Untitled.*
1987. Enamel on fiberboard,
33⅛ x 24¼" (85.5 x 61.6 cm)

LONNIE HOLLEY. *Big Mama.* 1986.
Painted sandstone, 24½ x 15½ x 8½"
(62.2 x 39.4 x 21.6 cm)

MOSE TOLLIVER. *Self-Portrait.* 1987.
House paint on plywood, 35 x 22¾"
(89 x 57.8 cm)

JIMMY LEE SUDDUTH. *Self-Portrait with Reindeer.* c. 1985. Natural home-made and commercial pigments on wood, 48 x 32" (121.9 x 81.3 cm)

THORNTON DIAL SR. *Spirit of Grand Central Station—*
The Man that Helped the Handicapped. 1990.
Enamel on braided rope carpet and industrial sealing
compound on canvas mounted on plywood, 60 x 83½"
(152.4 x 212.1 cm)

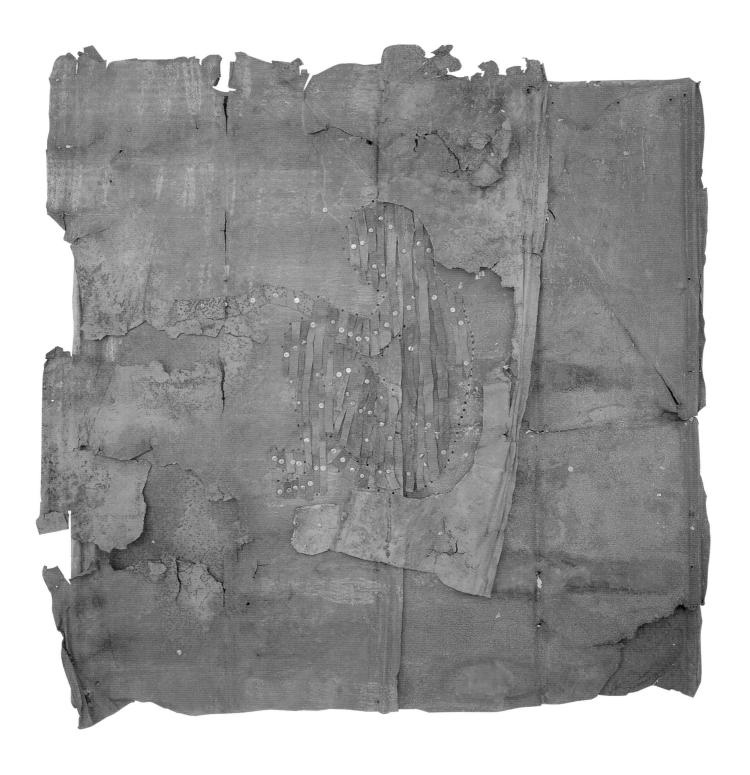

RONALD LOCKETT. *Pregnant Lady.*
c. 1993. Rusted tin collage on wood,
53 x 51 x 5½" (134.7 x 129.6 x 14 cm)

PURVIS YOUNG. *Untitled.* 1988.
Paint on wood, 48 x 27½ x 2"
(121.9 x 69.9 x 5.2 cm)

PURVIS YOUNG. *Stick Figures at
Goodbread Alley.* 1970s. Pencil, ink,
and crayon on paper and wood,
43½ x 44" (110.5 x 111.9 cm)

THORNTON DIAL SR. *Top of the Line*. 1992.
Mixed media, 65 x 80⅞ x 7⅞" (165.2 x 205.7
x 20.1 cm). National Museum of American
Art, Smithsonian Institution, gift of Ronald
and June Shelp, 1993

Archie Byron

Archie Byron

b. 1928, Atlanta, Ga.,
lives in Atlanta

In 1975 Archie Byron owned a gun shop and was working in law enforcement, when one night he found a tree root that reminded him of a gun.[30] He began searching out other root forms, painting and soon carving and adding materials to them. "I would see various life forms in the tree limbs, and I would complete what I saw." This was "tree limb art, or nature's art,"[31] he said, and it coincidentally resembled work by Bessie Harvey and Ralph Griffin, who had also recognized the powerful anthropomorphism of roots in the mid-1970s. In 1977, Byron

discovered the sculptural potential of sawdust as he was sweeping up the gun shop: "being old-fashioned, I didn't throw anything away much." Mixing the sawdust with Elmer's Glue and water, he created a doughy but durable mass that he painstakingly layered in bas-reliefs and hardened in molds he made of wood and metal for freestanding sculpture. The results range in subject from religious icons, human figures, political personalities (begun from photographs), landscapes, and plants to surreal combinations of body parts—the majority drawn from imagination. *Family Pain* (1988; opposite) is poignantly titled, for the couple shown, whose continuous silhouette encloses a baby and whose legs interlace, might seem happy at first glance. But the mother's eyes are closed, and her genital area shows the only touch of red in their bodies. The formal union of mother, father, and child reflects Byron's synoptic vision of the physical and psychic union that makes a family, with all its stresses.

This work was made while Byron was serving one of two terms as a city councilman, seeking to improve the representation of his district, one of Atlanta's poorest. "Part of my work is a reaction to what I see here on a daily basis," he told Judith McWillie at the time, in 1987. "I can see fear, anxiety, and need, and it is a daily problem. . . . I'm in a position now of being in a legislative body. We're making laws and you see people suffering under those same laws that are not being enforced. Then you meet the homeless people. . . . The average request . . . is . . . a kid needing food or a person needing shelter . . . a person needs a place that night."

Byron's art and his business and political careers seem inspired by a drive to empower himself and others and to improve conditions. Of African-

American, Native-American, and English ancestry, he was one of the nine children of a music instructor and a seamstress living in Atlanta's Buttermilk Bottom neighborhood. His musician father performed at the church of Martin Luther King's family, and Byron played with the young King as a boy. Byron attended parochial school ("I've noticed a lot of statues in my lifetime"), dropped out to join the Navy, and then returned to Atlanta in 1949 to finish high school, also attending trade school where he learned architectural drawing and bricklaying. Later he worked for the Fulton County sheriff's department, and in 1961 he started what he says was "the first black-owned detective agency in the United States."[32] By the 1970s he was running several small businesses from his home, where he and his wife, Joyce, reared their four children. It was then he began making sculpture. Since the early 1990s he has devoted himself to his art, recently making almost life-size painted figures, accompanied by his written explanations of their social and political content.

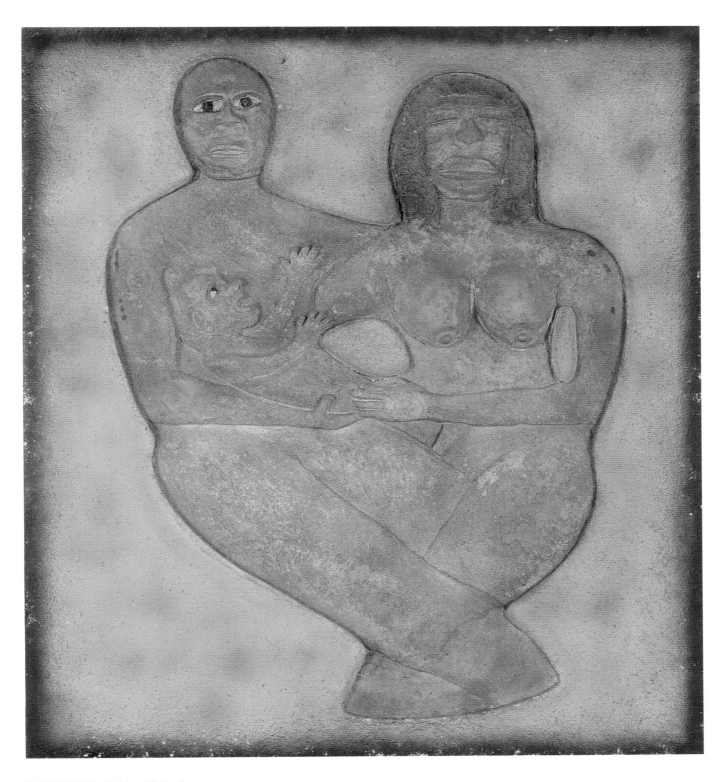

ARCHIE BYRON. *Family Pain.* 1988. Elmer's
glue, sawdust, and pigments on plywood,
48 x 43¼" (122 x 109.9 cm)

Spiritual and Protective Messages

From transcribing visionary messages to assembling protective devices, the artists gathered in this section rely on the magical potential of visual expression. Roots and branches, gnarled by time and water, are composed and adorned to become figures associated with healing or punitive power. Found objects, often of metal, and scraps of myriad materials are welded, nailed, wired, or glued together, and sometimes painted, to form humanoid figures and totemic compositions of accreted power. These root sculptures and assemblages have both evolved from the "yard shows" or "dressed yards" of the rural South and elsewhere, and distantly descend from Kongo protective devices and voodoo carvings. Most abstract of this group of expressions, and most transcendental, are the graphic works of J. B. Murray, which can be associated with Afro-Muslim "spirit writings." In 1986 Murray described why and how he began to work:

> When I started, I prayed and prayed. And the Lord sent a vision from the sun. Everything I see is from the sun. He showed me signs and seasons and He tells me. He turned around and gave me a question to ask Him and I asked him to see my mother. He brought her before me and two brothers. . . .
>
> See, Spirit will talk with Spirit. And when I left there [the hospital], the eagle crossed my eye—a Spiritual Eagle. The eagle can see farther than any bird in the world and that's why I can see things other people can't see. When I see between here and the sun is in a twinkle. It was then that I began to write these letters. Different writing represents different languages and folks. It's the Language of the Holy Spirit, direct from God.[33]

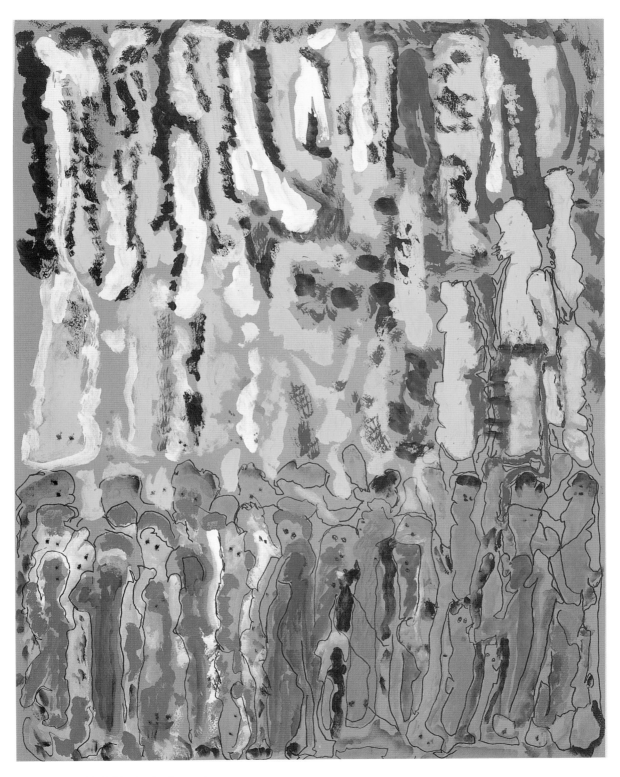

J. B. MURRAY. *Untitled.* Mid-1980s. Acrylic, gouache, and marker on paper, 25⅝ x 19⅝" (65.1 x 49.9 cm)

J. B. Murray

John (J. B.) Murray

b. 1908, Sandersville, Ga.,
d. 1988, Sandersville

Murray using a bottle of well water to "read" his painting.

John Murray's paintings of totemic figures, his brushy, abstract, all-over compositions of swarming cell-like forms, and his pages of indecipherable writing challenge critical categories.[34] He has been labeled an Outsider: uneducated, nonliterate, and unaware of museum art (at least until 1986).[35] How suitable is the term?

Murray was a tenant farmer in a remote area of Georgia all his life, and, during the last two decades of his life, he lived alone in a small shack. He first put stones and objects into shrinelike piles in his yard and then turned to painting on car headlights, TV picture tubes, and windshields, which became glistening protective devices for his house. Inspired by a vision in 1978, he began writing in a private script on paper scraps, such as adding-machine tapes, and passing

them out to townspeople on weekends. This led to his brief institutionalization in the late 1970s and may have encouraged the incantatory art making he had already begun.

Murray would "read" his script ceremonially while holding a bottle of his well water (below left). He believed that this writing could bless and protect others and warn them away from misspent lives. Though he denied any connection to local "hoo doo," his water divination ceremony was a Christianized expression that shared elements of local spiritualist practice—which may explain why his minister asked him to stop giving the scripts to parishioners. In the early 1980s, the doctor Murray was seeing regularly for cancer treatment gave him larger sheets of paper and paints. Murray's recurrent theme of the battle between good and evil and the color symbolism of his early work (red as evil, blue as good, yellow as sunlike, divine) became more pertinent: he had prostate cancer and would die of it.

Because of his apparent abstraction and reported aspects of his life, Murray's work is most often identified with Art Brut—the "raw, untutored" art named and collected by the French painter Jean Dubuffet. In form and culture, however,

Murray's art connects less with drawings by the insane than with certain African-American visual traditions in the South. Assemblages guarding yard perimeters were made by Ralph Griffin and others, and Murray's "spirit writings" resemble some African protective scripts and charms. (He saw them similarly, as having medicinal power.) For Judith McWillie, his paintings and drawings are the "visual equivalent of speaking in tongues," and they may descend from the Afro-Muslim practice of "spirit writing," a tradition carried by slaves of Muslim descent to his region of central and coastal Georgia.[36] Murray's drawings look abstract and improvisational, but like the mytho-poetic paintings of the 1940s and '50s by some Abstract Expressionists, which they distantly recall, he intended them to represent personally meaningful figures, body processes, and themes of elemental combat. To William Arnett, Murray was "paranoid, delusional, and obsessive."[37] Yet his work is closer to the Jungian drawings and abstract paintings of Jackson Pollock, for example, than to psychotic art. The parallels with Surrealist automatism and psychoanalytic free association bear examination—while Murray's cultural references deserve exploration in their own right.

Murray's house

J. B. MURRAY. *Untitled.* c. 1982.
Paint on wood paneling, 24 x 25¾"
(61 x 65.5 cm)

Hawkins Bolden

b. 1914, Memphis, Tenn.,
lives in Memphis

Hawkins Bolden

Hawkins Bolden has been blind since age seven, but he has always made things. Until recently he supported himself cleaning yards, alleys, and vacant lots. From the discarded wood, metal scraps, old pans, and tubs he collected through these tasks, he assembles and wires sculptures together. He calls these sculptures "scarecrows," as he began making them to keep the birds out of his garden. Since the 1970s he has placed them throughout the backyard of his home in Memphis, which is bordered by a seven-story office building and asphalt parking lots. Notwithstanding the names given them, his sculptures evoke the farmer's figure less than the protective devices found on graves elsewhere in the American South, in the Caribbean, and in sub-Saharan Africa. Yard sculptures like his can be found across the United States, in rural areas and urban neighborhoods, and they are created by whites as well as African Americans.[38] Scholars argue for their descent from tree charms and ritual objects in the *nkisi* traditions of the Kongo, even though artists such as Bolden, Lonnie Holley, Nellie Mae Rowe, and others may pursue them— originally unaware of their history—for more personal and ornamental purposes.[39] Portable and protective, able to heal or hurt, the *mojo* or magic charm of contemporary blues and rock music is a distant descendant of *minkisi* (plural of *nkisi*). The scholar Robert Farris Thompson proposes that African-American yard art may be an expanded version of the *mojo*.[40]

More personally, Bolden's transformation of found objects into sculpture allowed him to gauge wind speed through the sound of metal objects striking each other. In the untitled long-snouted creature shown opposite, the teapot and pieces of hose and carpet evoke a human face, and it was once strategically placed on the fence bordering his property. "Those buckets: I make eyes on them," Bolden told Judith McWillie about other works on fence posts in 1987. "They have four eyes; some have three—a middle eye. I make them so they can see good: two eyes here, and one way up on top of the head. The third eye sees a whole lot, you know. And I have milk cans tied together. When the wind comes, it sounds like a bell." Putting sound to practical use, and winning "soul power" and protection against encroachment, may have originally motivated Bolden to make his figures.[41] Never married, he lives with his sister, Elizabeth. They persist in refusing to sell their two "shotgun" houses to developers, and are now surrounded by commercial buildings (pages 44, 45). He complains that urban sprawl is killing his garden: "I don't put too much back there anymore, because it'll die in a little while," he says, "because of the heat from that wall and the water that runs off the parking lot."

HAWKINS BOLDEN. *Untitled.* c. 1987. Found
objects: teakettle, garden hose, and carpet,
13 x 9½ x 10" (33.1 x 24.2 x 25.5 cm)

Ralph Griffin

b. Burke County, Ga.,
d. 1992, Girard, Ga.

Ralph Griffin

The son of a cotton farmer, Ralph Griffin was schooled through the ninth grade and remained working on the family farm until he was thirty. After extensive traveling, he settled in Girard, Georgia, in the mid-1960s, where he married and worked as a janitor at a cookie factory. Around 1980 he began making sculpture from gnarled roots and branches he found, and after his retirement in 1989 he was able to devote himself to this transformative art. "I go to the stream. I read the roots in the water, laying in clear water," he told Judith McWillie in 1987. "There's a miracle in that water, running across them logs since the flood of Noah. Them logs—they been there since Noah's time, when the flood got out all the water. This is the water from that time. And the logs look like 'Old Experience Ages.' I take a root from the water and have a thought about it, what it looks like, then I paint it red, black, and white, to put a bit of vision on the root."

Griffin's sense of magic powers inherent in his aged elements of nature is evident in titles such as *Medicine Man* (1987; page 77) and *The Wizard* (1988; opposite). His figures also include baseball players, animals based on folktales, and some abstractions; he arranged them in his yard, often in narrative situations. (Such protective placements may descend from Caribbean practices in which the dead are buried around their former homes, according to McWillie.) Compared to Bessie Harvey's related root sculptures (pages 162, 163), which have similar distant African origins, his work involves fewer additions, and it looks more intimidating than whimsical, in keeping with his sense of primordial time. "The first thing I do is get the eyes," he said. "When I get his eye, I can make him come out of the root. I can bring a man out of it, then make heads on heads. It seems like a dream until I get it made."

As a result of their art-making, both Griffin and Harvey were sought out by neighbors for advice, a distinction that aroused ambivalent feelings in the artists. Some found Griffin's yard art a sign of special powers, and asked him to foretell winning lottery numbers, which he refused to do. Harvey liked the supposition that she had healing abilities, but rejected being called a sorceress. Both insisted on their artistry and denied the association with witchcraft: it was not only false but too limiting.

Griffin remarked in 1987: "They called me the Root Man when I started this stuff, and I'm the only person in these parts doing things like this. People still come over and ask me to help them with their dreams and all, but I don't go that far. . . . I believe that the more I do this, I could maybe shake your hand and give you all the luck you want. I'm for real about that, but I don't go that far. I feel just like the astronauts exploring up there: I just want to see what I can find in these roots and things. I'm going to work in stone now too. That'll give me some deep ideas."[42]

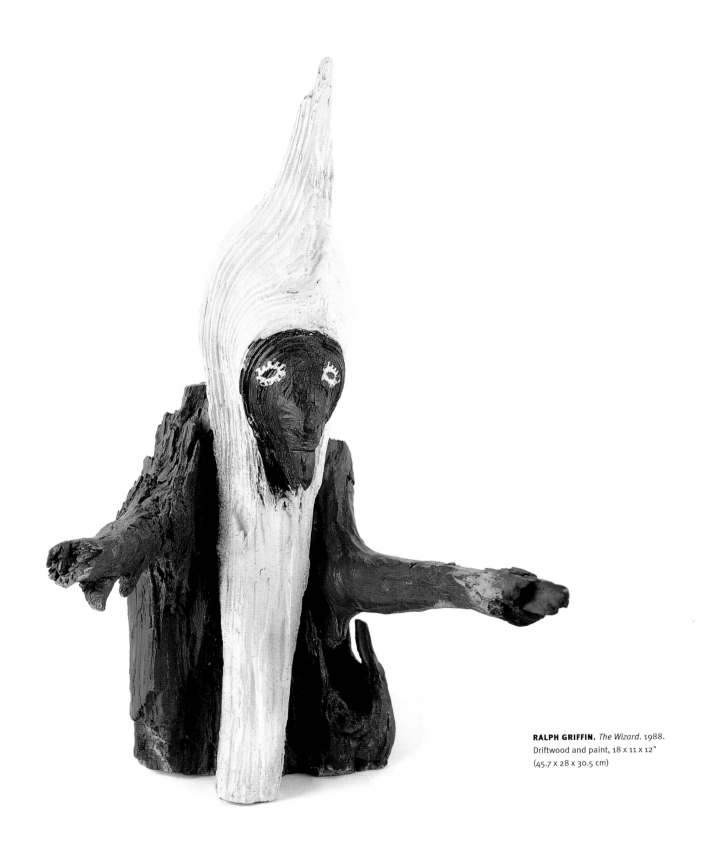

RALPH GRIFFIN. *The Wizard.* 1988.
Driftwood and paint, 18 x 11 x 12"
(45.7 x 28 x 30.5 cm)

Bessie Harvey

was upset and burned a number of the anthropomorphic pieces. A devout Christian, she had made them as private comforts during a time of anxiety caused by her teenage sons' involvement in drugs and petty crime, and she saw her skill as visionary. "I was afraid, but the Lord began to show me faces in the wall to soothe me, and I began to talk to the trees and to the grass. And I discovered they're alive, just like we are. . . . And the Lord showed me how to bring these faces out of these pieces of wood, so I could have somebody to talk to, so I wouldn't be afraid."[44]

Harvey believed that she had overcome the amoral power of voodoo as found in roots and had given it a Christian force. And when the root sculptures were praised in an employees' art exhibition where she worked and then shown in New York beginning in 1983, she felt a kind of exoneration. Critics identified conceptual and formal parallels between traditional African carvings and her wood sculptures, which she animated with paint, cowry shells, hair, costume jewelry, and other found objects, as in *The Prophet* (1987: right), and between African charms and her small yet hypnotic clay heads and figurines. This in turn led Harvey to study African art and rituals and inspired some of the content and titles of her later work, as well as her masks based on ceremonial examples. The latter show her growing pride in her African heritage but also her awareness of racism. "The black man is about the weakest man on earth according to what God said for man to be like," she observed. "But he's not really like that. He's always had to wear a disguise. He has never been free to really be himself. Even in Africa. . . . Everything has been taken away from them that God blessed them with. And the Indian, too. So these masks represent the men that has had to wear disguises all their lives."[45]

Born in Dallas, Georgia, Harvey was one of ten children and eventually had eleven of her own, as well as twenty-eight grandchildren. She attended school through the fourth grade, married at age fourteen, and left her husband when she was twenty, moving to Alcoa, Tennessee, near Knoxville. She worked as a domestic through the late 1970s and as a housekeeper's aide in a hospital until her retirement in 1983. Her work was included in the 1995 Biennial of the Whitney Museum of American Art, a year after her death.

Bessie Harvey

b. 1929, Dallas, Ga.,
d. 1994, Alcoa, near Knoxville,
Tenn.

Bessie Harvey recalled that her art-making began when she was digging up a flowerbed and saw a root with a little face—"an Egyptian face about the size of a nickel." Her mother told her to "'keep that thing because one of these days you're gonna find out what goes with it.' . . . I started making statues and I called them 'dolls.' . . . It's all the roots of trees—little creatures. To me, there are little creatures down under the earth. I'm giving all praise and thanks unto God. All through life I have thought that the trees was praising God. I talk to the trees."[43] But when some of Harvey's neighbors saw the figures she first made from roots and gnarled wood in 1972, they called her a "voodoo person." She

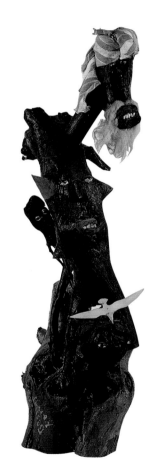

BESSIE HARVEY. *The Prophet.* 1987. Wood, wood putty, cowry shells, fabric, costume jewelry, paint, and artificial hair, 29 x 9½ x 17" (73.7 x 24.2 x 43.2 cm)

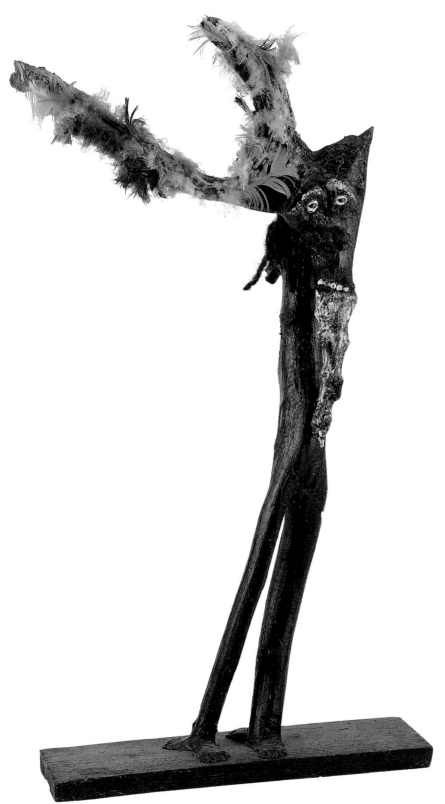

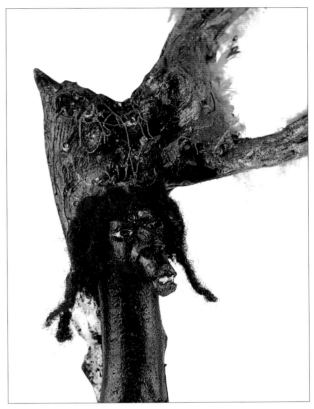

Left: **BESSIE HARVEY.** *Zuna and Zeb.*
1986. Wood, wood putty, feathers,
human hair, costume jewelry, glitter,
and paint, 37 x 19 x 7½" (94.1 x 48.3 x
19.1 cm)

Above: **BESSIE HARVEY.** *Zuna and
Zeb*, opposite side

Lonnie Holley

Lonnie Holley

b. 1950, Birmingham, Ala.,
lives in Birmingham

About the found objects he combines in his sculptures (opposite, bottom), Lonnie Holley told Judith McWillie in 1987: "I'm cultivating the roots of a new seed from an old source. I dig through what other people have thrown away to get the gold of it, to know that Grandmother had that skillet and stood over that heat preparing that meal, so when I come home with that skillet, I've got grandmother—'Grand,' someone who has authority and is capable." This sense of time and use-value enriches such castoffs for Holley and other sculptors described in these pages. By recycling materials once used by family and neighbors, they reaffirm collective and personal identity and insist that the material world can have a higher meaning.

"Grand," as in "grandparents," means much to Holley because he was one of twenty-seven children and his grandparents helped rear him. His grandfather was a leader in establishing the area's First Baptist Church and in building its major thoroughfare near the Birmingham airport.[46] Holley remembers helping elderly neighbors with chores and looking with his mother and grandmother for items to sell at flea markets. He gathered stories as well as objects: both were redolent of his community. He completed the seventh grade, lived in Louisiana, Ohio, and Florida, and took various jobs, including short-order cook at Walt Disney World. After he returned to Birmingham, his childhood sense of community was reawakened, and in 1977 when two young relatives died in a house fire, he channeled his grief into carving their tombstones. The soft sandstone, which he still uses, is a by-product of Birmingham's aging iron industry, where sand is used to pack cast-iron molds. Here too Holley was able to transform dross into "gold." He continues to create compact figures with African features in carvings that have an African stylistic aura (left). His local nickname, "The Sandman," refers to his medium and also to the dreams he can make it embody. His ability to create figures and narratives from found objects has also led some neighbors to see him as a kind of healer and prophet.[47]

Today what had been Holley's "square acre of art" in his yard is dispersed into private collections, and the airport's expansion has forced him to relocate. This has not changed his art-making or his self-image as a kind of preacher through his art. His recycling, as he sees it, is socially constructive, dramatizing global waste. Art that began with a personal loss has expanded philosophically and formally to address a growing social issue and the human condition, as he views them, across time.

Rear view of Lonnie Holley's truck

LONNIE HOLLEY. *Road to the Spirit.*
1989. Mixed media on panel,
29 x 59¼" (73.7 x 150.5 cm)

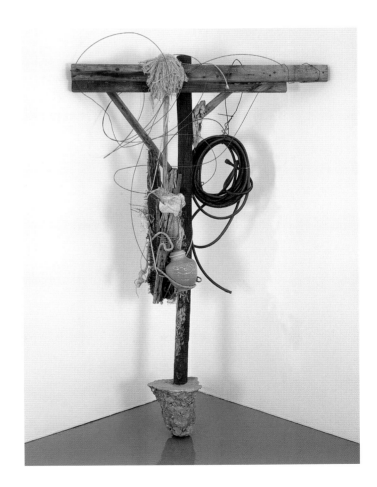

LONNIE HOLLEY. *Don't Go
Crossing My Fence.* 1994. Wood,
garden hose, mop, green-colored
lamp base, and other found
materials, 85 x 56 x 42" (215.9 x
142.3 x 106.7 cm)

Richard Dial

Richard Dial

b. 1955, Bessemer, Ala.,
lives in Bessemer

Like his brothers, Richard Dial learned his art first from his father, and his own success has mirrored Thornton Dial Sr.'s rise in reputation from local craftsman to nationally known artist. Richard's "Comfort Chairs" series is derived from the line of metal lawn and patio furniture that his father and he and other family members produced and sold from their home in the early 1980s. The "Shade Tree Comfort" collection, as the Dials called it, drew on the family's skills in welding and metalwork, skills that Richard and Dial Sr. fluently translated into artworks by the middle of the decade.

For their assemblages, father and son both exploit the humanoid aura intrinsic to a chair—its separation of parts into arms, legs, and body—by adding metal heads and hands to metal chair forms. Their sculptures reveal a critical awareness of social milieu, while Richard's approach has some of the irony of the generation that came of age in the late 1960s and '70s. His chairs are strong enough for seating, but he transmutes the brand name "Comfort" into the titles *The Comfort of Prayer* (1988; opposite, left) and *The Man Who Tried to Comfort Everybody* (1989; opposite, right). These titles and the chairs' welded additions shift the meaning of comfort from physical to psychological. Does the pedal added to *The Comfort of Prayer* suggest the foot-tapping of evangelical worship; does the handle refer to faith as something to hold onto? The artist moves easily from the utilitarian object to the cultural comment. Such vision is not that of some of the older generation of Southern animistic sculptures, who intuit spirits in evocatively shaped roots and tree trunks. Instead, Ralph Dial enjoys playing with the magic of wit in a machine-made world.

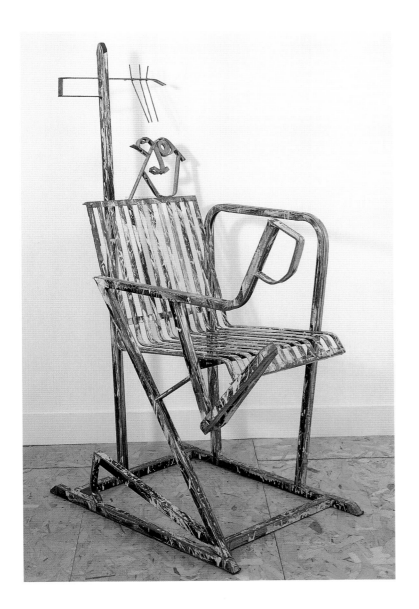

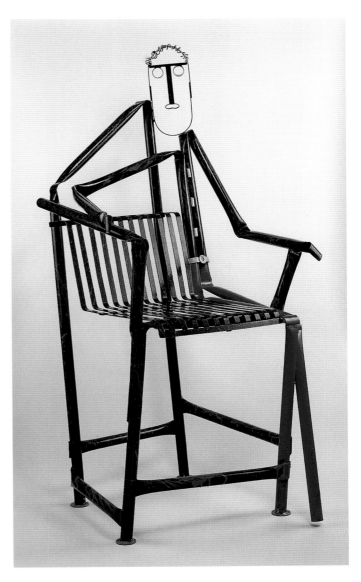

RICHARD DIAL. *The Comfort of Prayer.*
1988. Painted and welded chair of
found steel, 54½ x 20½ x 39" (138.5 x
52.1 x 99.1 cm)

RICHARD DIAL. *The Man Who Tried to
Comfort Everybody.* 1989. Painted and
welded chair of found steel, 64 x 28 x
32" (162.6 x 71.2 x 81.3 cm)

Richard Burnside

Richard Burnside

b. 1944, Baltimore, Md.,
lives in Pendleton, S.C.

As a boy Burnside moved from Baltimore to Greenville, South Carolina, where he attended high school. After his military service of 1974–78 he worked at various jobs, including chef and clerk. In 1983 he moved to Pendleton, an Army base. Twice married, he has four children. He finds the motifs of his paintings in other artworks and in everyday objects, from Army insignia to beer mugs and telephone poles, and he has invented personal symbols that he terms his "Roman alphabet." These symbols, including spiders, snakes, and other creatures, most often surround his depictions of flat, round, masklike faces, which he says he has seen in dreams and "coming out of the walls."[48] He titles his frontal, staring figures kings, queens, and priests. They speak of power. For some observers his work presents "an Africanized mythology [derived] from biblical stories, folktales, and even nursery rhymes."[49] For others, his emblematic, emphatically outlined forms such as those in *Swords and Shields and Odds and Ends* (1988; opposite) resemble appliqué and other needlework from Africa's central kingdoms, as well as images by CoBrA artists, the expressionist group of the 1950s from Cologne, Brussels, and Amsterdam. These diverse associations have attracted knowledgeable viewers to his work, while its graphic language suggests mysterious meanings in its own right. Burnside began painting around 1980; for over ten years he has supported himself by his art.

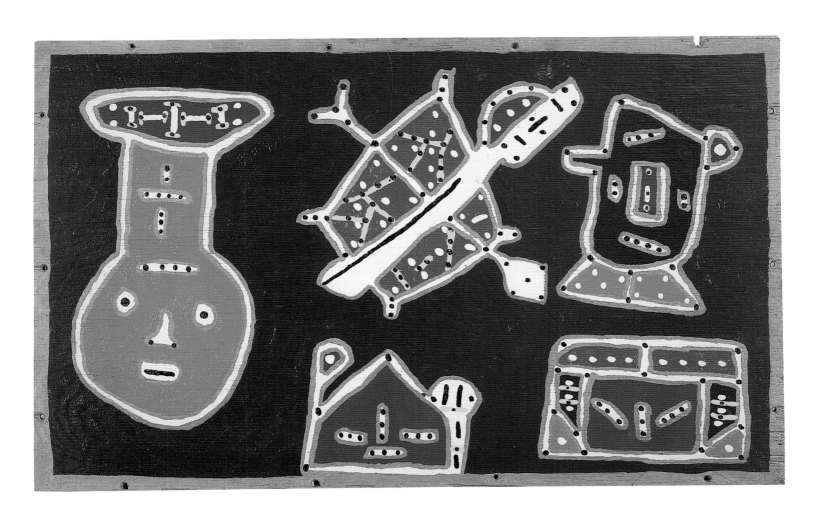

RICHARD BURNSIDE. *Swords and Shields and Odds and Ends.* 1988. Enamel on wood, 20 x 35" (50.9 x 88.9 cm)

Direct Observation

To beautify one's home and property are age-old goals, and the urge to possess an attractive portion of reality through representation has been strong in the West since the Renaissance. Lively everyday scenes, loved ones, neighbors, passersby, and animals populate the paintings and drawings presented here. Many were originally displayed in homes or executed on their walls, inside and out, and were given or sold to relatives and neighbors. They functioned as mediums of exchange and displayed their makers' artistic skills to the community. When artworks served the church and burial practices, embellished family gardens, or recorded communal experience and history, they were valued. Some of the artists in the Shelp collection repeatedly depict their spouses and themselves, copy illustrations, and take commissions for portraits, animal sculptures, and pictures of local landmarks and events.

Jimmy Lee Sudduth, for example, specializes in rendering the buildings and people of Fayette, Alabama, his home, in addition to animals, cars, and self-portraits, often painting himself strumming a banjo. From the late '60s he played his music at county fairs and also showed his art. In 1976 he performed and exhibited at the Smithsonian Institution's bicentennial Festival of American Folklife, and in 1980 he appeared on the *Today* show. "I didn't learn much in school—just learned to write my name—Jim," recalls the nonagenarian. "But I believe I'd rather be famous than rich or smart."[50] Such recognition has enabled Sudduth and other self-taught artists to paint full-time.

HENRY SPELLER. *Two Ladies Dressed Up.* 1986. Pencil, crayon, and marker on paper, 24 x 18" (61 x 45.8 cm)

James "Son" Thomas

James "Son" Thomas

b. 1926, Eden, Miss.,
d. 1993, Greenville, Miss.

singing and composing, led him from the jook joints of southern Mississippi to four albums and six tours of Europe.

As a child, Thomas had made clay skulls playfully, to frighten his grandfather; in adulthood a stint as a gravedigger revived his interest in the memento mori. He was not conventionally religious, but he did not dismiss voodoo or the spirit world. He liked the idea of scaring his viewers, and in his early art-making days he lit his skulls from within with red Christmas lights. His clay heads (opposite) have an uncanny vitality, enhanced by their paint and his frequent use of glass marble eyes, artificial hair, and teeth. Though the verisimilitude of all his sculptures came from observation and from pictures he saw, he asserted that the ideas for his art and his blues lyrics both originated in dreams. He worked from mental images rather than copying. "If you can't hold it in your head," he said, "you can't do it in your hand."[53] In the 1970s, the writer William Ferris introduced him to new materials and techniques, and by the early 1980s he was earning a living mainly through his art and music.[54]

Growing up in his grandparents' home in the Mississippi Delta, James "Son" Thomas was a prodigy in both art and music. From age eight, he learned to play the guitar and to model clay animals from his uncle; these skills eventually freed him from the cotton fields. Playing the blues connected him to "way back times," he later remembered, while his nickname, shortened from "Son Ford," came from the clay trucks he made as a boy.[51] When he sold a box of his clay horses for three dollars as a schoolboy, while his grandparents had to work a week for two dollars,[52] his career might have been determined. But the region wanted his blues. His bottleneck blues style, related to that of B. B. King, Elmore James, and Sonny Boy Williams (men he played with), and his

JAMES "SON" THOMAS. *Squirrel.* 1987. Unfired clay and spray paint, 5½ x 6½ x 3" (14 x 16.6 x 7.7 cm)

JAMES "SON" THOMAS. *Black Woman.*
c. 1986. Unfired clay with human hair, and
earrings, 8½ x 5½ x 6" (21.7 x 14 x 15.3 cm)

Henry Speller

b. 1900, Rolling Fork, Miss.,
d. 1997, Memphis, Tenn.

Henry Speller

The son of sharecroppers in the Missis-
sippi Delta, Henry Speller was taken
out of school to help farm cotton before
he learned to read or write. He drew
between chores and helped his mother
quilt, but he could not afford to pursue
art-making or music full-time—he played
the guitar and harmonica—until his mid-
sixties. At age eighteen he had left home,
and in 1939 he settled in Memphis, where
he worked as a garbage collector and a
landscaper for the city. In 1964 he mar-
ried Georgia Verges, his third wife, and
soon retired. He encouraged her draw-
ing, and the two supported each other's
art making until her death in 1987.

Similar in their themes and
approaches, both Spellers portrayed the
strutting, fancily dressed types of their
Beale Street neighborhood as it rose
from a local music center to a tourist
attraction. The singing group the
Supremes and the equally sexy stars of
television's *Dallas* also fascinated Henry,
whose best-known works feature toothy
women with breasts and sometimes
genitalia outlined on their richly pat-
terned dresses (page 171). Writers have
linked his vivid colors and profuse,
asymmetrical patterning with African-
American quilt-making[55] and also with
his improvisational but structured music
(he sometimes played with the blues
greats Muddy Waters and Howlin'
Wolf).[56] In all the media he used, Speller
observed and stylized already stylized
and sexualized realms, the urban parade
of mostly unattainable performers and
their noisy world of wheels—of hot cars,
trains, and motorcycles.

HENRY SPELLER. *Train*. 1987. Marker on paper, 18 x 24" (45.8 x 61 cm)

Georgia Speller

Georgia Speller

b. 1931, Aberdeen, Miss.,
d. 1987, Memphis, Tenn.

Frank themes of sexual attraction, pleasure, and power struggle pervade Georgia Speller's colorful figure compositions, which depict city streets and bedroom scenes of display and exuberant combat. Her drawing exaggerates social and gender differences and radiates energy (opposite): it is a freer version of the style of her husband, Henry Speller, whom she met and married in Memphis in 1964, a time of growing sexual emancipation across the United States. The two fostered one another's art making, especially after Henry's retirement from the city parks department in the mid-1960s. Georgia urged him to advertise his work, which he hung on the front of their house near Beale Street. He challenged her to draw the same subjects as he did, and they compared the results.[57] Her work sometimes concerns memories of her rural youth as the daughter of a blacksmith, but more often the couple observed the lively scene in the Memphis blues and jazz mecca, as it unfurled around their door.

Theirs is an urban art, in its representation of the anonymous actors of a city's fast-paced public life. Yet in turning their front porch into a gallery, the Spellers built on the old tradition of yard art. Yard art itself, from which much vernacular expression has evolved, is increasingly threatened by the bulldozers of civic expansions, while self-sufficient works on panel or paper, like those by the Spellers, have become more numerous.

GEORGIA SPELLER. *Music Man in the Country.* 1987. Acrylic and pencil on paper, 18 x 24" (45.8 x 61 cm)

Jimmy Lee Sudduth

Jimmy Lee Sudduth

b. 1910, Caines Ridge, Ala.,
lives in Fayette, Ala.

The son of a medicine woman in Fayette County, Alabama, Jimmy Lee Sudduth remembers that his mother gathered herbs and berries in the woods for healing. The painting materials for which he is best known are also natural: until the mid-1980s, he found colored clays near his home—as many as thirty-six different ones, he says—mixed them with sugar and water as a binder to make them permanent, and applied them to plywood or other flat supports with his fingers. To this ground he added hues he created—

red-purple from pokeberries (as in *Duck*, c. 1985, opposite, top), green from leaves and tree buds, black and brown from soot and coffee grounds—and then he detailed his subjects with lines drawn in carpenter's chalk or incised with a sharp tool. Proud that he did not need commercial pigments, Sudduth nevertheless adopted latex house paint some fifteen years ago, and admirers continue to bring him art supplies in hopes of assuring the permanence of his pictures. He still paints with his hands sometimes. "That brush don't wear out. When I die, the brush dies," he says.[58]

Sudduth works from observation, not recollection, and he paints his own image and the people and animals around him, and the buildings he has seen on his travels (sometimes using postcards) and that owners have commissioned him to depict. As in *People at Church* (c. 1987; opposite, bottom) and *Ferris Wheel* (1988; page 180), these structures fill the frame and gain monumentality by Sudduth's grasp of perspective and the tactile density of their relieflike surfaces. Animals move energetically, while humans solemnly face forward.

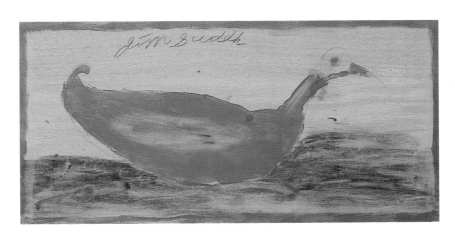

JIMMY LEE SUDDUTH. *Duck.*
c. 1985. Berry juice and earth on
wood, 12½ x 25" (31.8 x 63.5 cm)

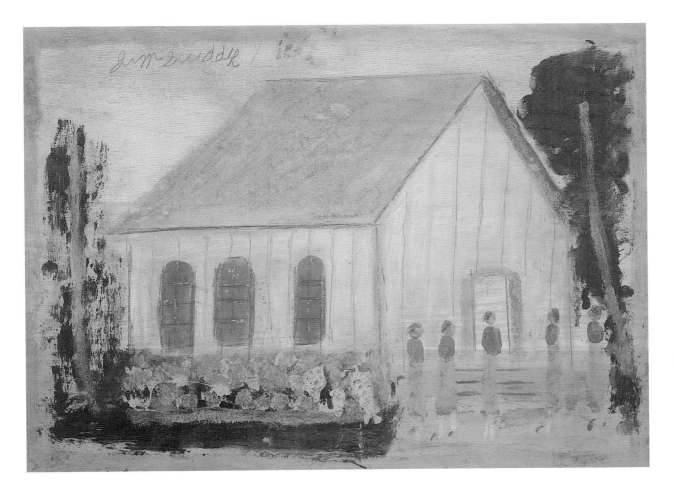

JIMMY LEE SUDDUTH.
People at Church. c. 1987.
Natural homemade pigments
and pencil on wood, 18½ x 25"
(47 x 63.5 cm)

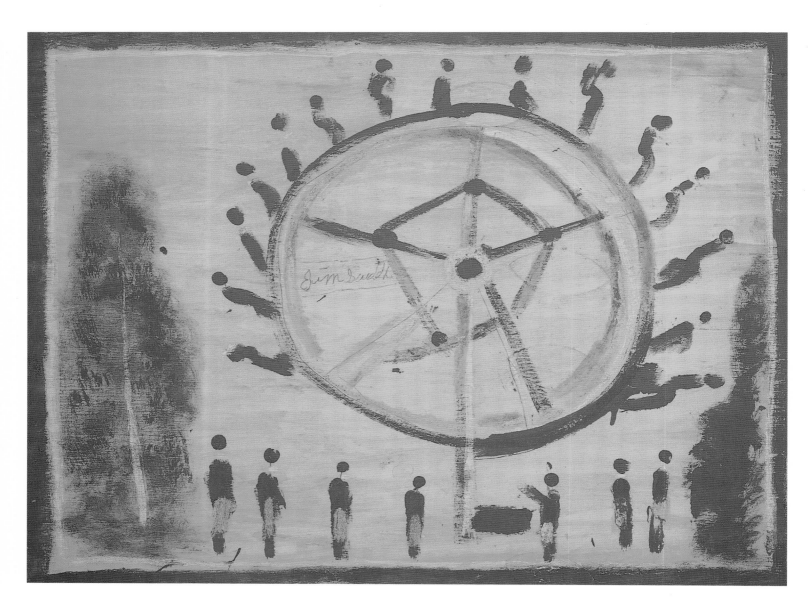

JIMMY LEE SUDDUTH. *Ferris Wheel.*
1988. Natural homemade pigments
and house paint on wood, 24 x 32"
(61 x 81.4 cm)

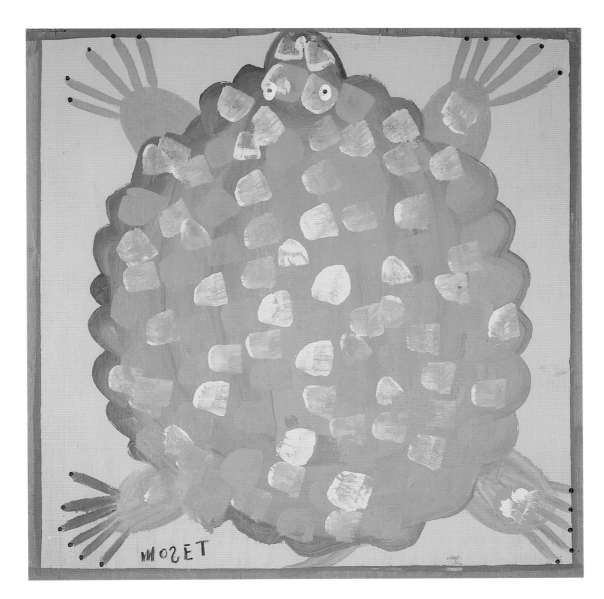

MOSE TOLLIVER. *Deep Sea Water Turtle.* 1987. House paint on plywood, 23½ x 24" (59.8 x 61 cm)

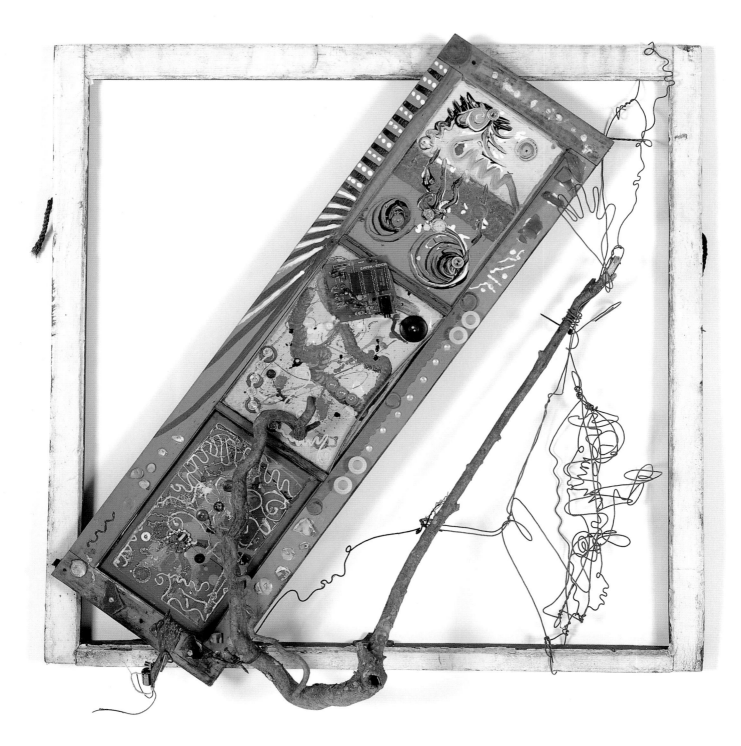

LONNIE HOLLEY. *Not as Much as Grandmother's Pain.* 1990. Window frame, wire, paint, buttons, broken pottery, plastic, wood, nails, glass, rope, 41 x 42" (104.2 x 106.7 cm)

List of Plates

Leroy Almon
Assassination 95
The Black Madonna 139

Hawkins Bolden
Scarecrow 46
Untitled 159

Richard Burnside
*Swords and Shields and Odds and
 Ends* 70, 169

Archie Byron
Family Pain 153
Homeless 92

Arthur Dial
Adam and Eve 65
Crucifixion 135
Welfare Office 72

Richard Dial
The Comfort of Prayer 167
The Man Who Tried to Comfort Everybody
 167

Thornton Dial Jr.
Cat 125
Crucifixion 127
King of Africa 76
Mississippi Burning 101
Moses and the Ten Commandments 141

Thornton Dial Sr.
*Alone in the Jungle: One Man Sees the Tiger
 Cat* 108–109
*The Beavers Dam the River and the Tigers Go
 Across* 107
The Big Black Bowl of Life 88
Clinton Blows His Horn 104
The Coal Mine 10
*Everybody Got a Right to the Tree
 of Life* 62–63
Fishing for Business 80
Fishing for Love 80
Freedom Bird in the United States 112
*I Had a Dream, a Dream about Heavy
 Burdens* 89
Julio 122
Lady Holds the Bird 113
*Lady Wondering about the Long Neck
 Goose* 112
Long-Faced Lady in New York City 81
The News 59

Proud Family 111
*Rolling Mill: Steel is the Master, Lady is the
 Power* 89
Sitting and Waiting—The Man Needs 87
*Spirit of Grand Central Station—The Man
 that Helped the Handicapped* 148
Support for the Works 82–83
*Taking Care of Old Things (Honoring Lonnie
 Holley)* 23
Tiger on Top 113
Top of the Line 151
The Top of the World 2 (frontispiece)
*You Can See It in the Street (Homeless People
 in New York)* 90

Ralph Griffin
Medicine Man 77
Untitled 123
The Wizard 161

Bessie Harvey
Prehistoric Bird 122
The Prophet 162
Zuna and Zeb 163

Lonnie Holley
Big Mama 146
Cutting Medication Short 93
Don't Go Crossing My Fence 165
Fighting at the Foundation of the Cross 26
Not as Much as Grandmother's Pain 182
Road to the Spirit 165
Untitled 51

Joe Light
Best Mountain 121
Sheba 140

Ronald Lockett
Adam and Eve 68
The Deer Can See Everything 117
Garden of Eden 69
God Created Man in His Own Image 140
Homeless People 91
Pregnant Lady 149
Remembrance of a Princess 105
Smoke-Filled Sky 85
Traps 116
Undiscovered 115
Untitled 117

Charlie Lucas
Children of the World Reaching Out 103

Joe Minter
Shipyard 97

John (J. B.) Murray
Untitled 15
Untitled 155
Untitled 157

Mary Proctor
Blue Willow Plate 129

Lorenzo Scott
Jesus as a Child 137

Herbert Singleton
The Miracle of Jesus 131

Mary Tillman Smith
Hello to Y'All 143
Untitled 22
Untitled 145

Georgia Speller
Devil's Home in the United States 86
Music Man in the Country 177

Henry Speller
Train 175
Two Ladies Dressed Up 171

Jimmy Lee Sudduth
Duck 179
Ferris Wheel 180
People at Church 179
Self-Portrait with Reindeer 147

James "Son" Thomas
Black Woman 173
Squirrel 172

Mose Tolliver
Deep Sea Water Turtle 181
Self-Portrait 146
*Two Quail Birds, Two French Birds, Two Love
 Birds with a Feed Basket* 119

Felix "Harry" Virgous
Adam and Eve 133

Purvis Young
Collage with Trucks 99
The Flying Angel 138
Stick Figures at Goodbread Alley 150
Untitled 27
Untitled 150
Wild Horses 124

Endnotes

CRITICAL VANTAGE POINTS

African-American Art and Contemporary Critical Practice

1. Richard J. Powell. *The Blues Aesthetic: Black Culture and Modernism* (Washington, D.C.: Washington Project for the Arts, 1989), 20.
2. Ibid., 21–31.
3. Jed Tully, "Outside, Inside, or Somewhere In-between," *ARTnews* (May 1996): 119.
4. Eugene W. Metcalf Jr. "From Domination to Desire: Insiders and Outsider Art," in *The Artist Outsider: Creativity and the Boundaries of Culture*, ed. Eugene W. Metcalf Jr. and Michael D. Hall (Washington, D.C.: Smithsonian Institution Press, 1994) 215.
5. Quoted in Tully, 120.
6. Ibid., 121.
7. Lucy Lippard, "Crossing Into Uncommon Grounds," in *The Artist Outsider*, 11.
8. Ibid.
9. Peter Schjeldahl, "On the Wild Side," *The Village Voice* 625, no. 6 (Feb. 11, 1997): 1.
10. Ibid.
11. The World Wide Web: http://web.nypl.org/research/sc/history. html. New York Public Library: Schomburg Center for Research in Black Culture. History and General Information.
12. Sandra Kraskin, *Wrestling with History: A Celebration of African American Self-Taught Artists from the Collection of Ronald and June Shelp*, exh. cat. (New York: Baruch College, The City University of New York, 1996), 7.
13. Metcalf, 215.
14. Ibid., 220.
15. Ibid., 221.
16. Simon Carr, "The Visionary Body," in *Portraits from the Outside: Figurative Expression in Outsider Art*, exh. cat. (New York: Parsons School of Design and Groegfeax Publishing, 1990), 48.
17. Videotaped interview with J. B. Murray by Judith M. McWillie, Glascock County, Ga., May 28, 1986, and May 31, 1986, VHS.
18. Konrad Tuchscherer, "The Lost Script of the Bagam," *African Affairs: The Journal of the Royal African Society* 98, no. 390 (Jan. 1999): 55–77; Grey Gundaker, *Signs of Diaspora; Diaspora of Signs* (Oxford: Oxford University Press, 1998); Robert Farris Thompson, *Flash of the Spirit: African and African American Art and Philosophy* (New York: Random House, 1983); Judith M. McWillie, "Writing in an Unknown Tongue," in *Cultural Perspectives on the American South* 5 (New York: Gordon and Breach, 1991), 103–17.
19. Arthur C. Danto, "Outsider Art," *The Nation* (Mar. 10, 1997): 36.
20. Schjeldahl, 2.
21. Ibid.
22. Lowery Stokes Sims, "The Self-Taught Among Us: William Edmondson and the Vanguardist Dilemma," in *The Art of William Edmondson*, ed. Rusty Freeman (Jackson: The University Press of Mississippi, 2000), 71–78.
23. Thomas McEvilley and Amiri Baraka, "Proud-Stepping Tiger: History as Struggle in the Work of Thornton Dial," in *Thornton Dial: Image of the Tiger* (New York: Harry N. Abrams, 1993).
24. Danto, "Outsider Art," 35.
25. Ibid., 34–35.
26. Ibid., 36.
27. Danto, *After the End of Art: Contemporary Art and the Pale of History* (Princeton: Princeton University Press, 1997), 135.
28. Danto, "Outsider Art," 35.
29. Danto, *After the End of Art*, 147.
30. Ibid., 135.
31. Danto, *ART/artifact* (New York: The Center for African Art, 1988), 20.
32. Danto, *After the End of Art*, 15.
33. Ibid., 17.
34. Sarah Wilson, "From the Asylum to the Museum: Marginal Art in Paris and New York 1938–68," in *Parallel Visions: Modern Artists and Outsider Art* (Princeton: Princeton University Press and Los Angeles: The Los Angeles County Museum of Art, 1992), 131.
35. Robert Storr, "Between a Rock and a Hard Place," *Paper No. 3* Aug. 15, 1994. The Andy Warhol Foundation, Pittsburgh, Pa. Posted on the World Wide Web at http://www.warholfoundation.org/article3.html. Storr notes that Milone's shoeshine stand was brought to Barr's attention by Louise Nevelson.
36. Ibid.
37. Videotaped interview with Lonnie Holley by Judith M. McWillie, Birmingham, Ala., Mar. 18, 1987, VHS.
38. Videotaped interview with Lonnie Holley by Judith M. McWillie. Birmingham, Ala., Dec. 11, 1991, Video 8.
39. Jonathan Fineberg, *Art Since 1940: Strategies of Being* (New York: Harry N. Abrams, 1995), 27–79. Fineberg associates the term *funk art* with the African-American-influenced counterculture active in San Francisco during the 1960s. In blues and jazz, *funk* describes a mode of sensuality related to "the blue notes or blue mood created in jazz, blues, and soul music generally" (*American Heritage Dictionary*). See Geneva Smitherman-Donaldson, *Talkin' and Testifying: The Language of Black America* (Detroit: Wayne State University, 1986).
40. Roger Lipsey, *An Art of Our Own: The Spiritual in Twentieth Century Art* (Boston: Shambhala Publications, 1988), 226. Lipsey suggests this kind of double reading in his discussion of the work of Constantin Brancusi.
41. Danto, *ART/artifact*, 18.
42. Ibid.

The End of the Outsider

1. *Whitney Biennial: 2000 Biennial Exhibition* (New York: Whitney Museum of American Art, 2000), 89. The text is unsigned. Contributors are listed as Maxwell L. Anderson, Michael Auping, Valerie Cassel, Hugh M. Davies, Jane Farver, Andrea Miller-Keller, and Lawrence R. Rinder.
2. Clement Greenberg, *The Collected Essays and Criticisms*, vol. 1, *Perceptions and Judgments, 1939–1944*, ed. John O'Brian (Chicago: University of Chicago Press, 1986), 33.
3. Greenberg, *The Collected Essays and Criticism*, vol. 4, *Modernism with a Vengeance, 1957–1969*, ed. John O'Brian (Chicago: University of Chicago Press, 1986), 108.
4. All references to Dial's work are on page 89 in the catalogue.
5. Donald Kuspit, *Interview with Eric Fischl* (New York: Vintage Books, 1989), 33.
6. Arthur C. Danto, "The Art of the Free and the Brave: Whitney Biennial 2000," *The Nation* (May 8, 2000): 45–49.
7. Ellen Simer, "Letter to the Editor," *The Nation* (Aug. 7/14, 2000): 2.
8. Susan Vogel, *African Aesthetics: The Carlo Monzino Collection* (New York: The Center for African Art, 1985).

Becoming Art: Life Spans, Biographies, and the Shelp Collection

1. Igor Kopytoff, "The Biography of an Object," in *The Social Life of Things*, ed. A. Appadurai (Chicago: University of Chicago Press, 1989).
2. See, for example, the introduction and other papers in Appadurai, ed., *Social Life*. Another classic is Pierre Bourdieu, *The Field of Cultural Production* (New York: Columbia University Press, 1993).
3. For example, Grey Gundaker, "Tradition and Innovation in African American Yards," *African Arts* 26, no. 2 (April 1993): 58–71, 94–96; G. Gundaker, ed., *Keep Your Head to the Sky: Interpreting African American Home Ground* (Charlottesville: University Press of Virginia, 1998).
4. I thank my colleague Alan Wallach for this information and insight; personal communication June 20, 2000.
5. This idea is developed by Dell Hymes in his *In Vain I Tried to Tell You* (Philadelphia, Pa.: University of Pennsylvania Press, 1981).
6. Sandra Kraskin, "Wrestling with History," in *Wrestling with History: A Celebration of African American Self-Taught Artists from the Collection of Ronald and June Shelp* (New York: Baruch College, City University of New York, 1996). 5–10.

7. Ibid., 5.

8. Ibid., 6.

9. Ibid., 7.

10. See Clifford Geertz, *Local Knowledge: Further Essays in Interpretive Anthropology* (New York: Basic Books, 1983), 94–120.

11. Kraskin, "Wrestling," 7.

12. Ibid., 7.

13. On the commodity fetish, see Karl Marx, *Capital: A Critique of Political Economy*, vol. 1. trans. Ben Foukes (New York: Vintage Books, 1976), 163–77. For a number of provocative discussions of the subject, see Patricia Spyer, ed., *Border Fetishisms: Material Objects in Unstable Spaces* (New York: Routledge, 1998).

14. Michael Kimmelman, "By Whatever Name, Easier to Like," *The New York Times*, February 14, 1997.

15. Pravina Shukula, review of "The Art of Nellie Mae Rowe: Ninety-Nine and a Half Won't Do," in *Journal of American Folklore* 113, no. 447 (Winter 2000): 90–92.

16. Consider how true this is of much art that is supposedly secondary and is classified as decorative, folk, visionary, or ethnographic: in their purified functionalism, Shaker works, for example, were intended as directives to a moral life. Their kind of beauty was didactic.

Feeling at Home with Vernacular African-American Art

1. Kinshasha Holman Conwill, "In Search of an 'Authentic' Vision: Decoding the Appeal of the Self-Taught African-American Artist," *American Art* (Fall 1991): 3–4.

2. Roger Brown, "Setting the Stage," in Ruth Ann Stewart and Roger Brown, *The Artworks of William Dawson* (Chicago: Chicago Public Library Cultural Center, 1990), 10. Brown's context is the "presumptuous manner" in which an arts and crafts teacher tried to change Dawson's expression of his intuitive vision. He further notes that the implicit hierarchy of voices is the same "that told us that Thomas Hart Benton is a Hayseed Modernist . . . and that folk art

ceased to exist after the nineteenth century."

3. Henry Louis Gates Jr., "'Jungle Fever' Charts Black Middle-Class Angst," *The New York Times*, 23 June 1991, H-20.

4. For a fuller discussion of these issues, see Judith McWillie's essay in this publication and Maurice Berger's essay, "Critical Fictions: Race, 'Outsiders,' and the Construction of Art History," in Museum of American Folk Art, *Self-Taught Artists of the 20th Century: An American Anthology* (San Francisco: Chronicle, 1998), 28–37.

5. The definitive study on Johnson is Richard Powell's *Homecoming: The Art of William H. Johnson* (New York: Rizzoli International Publications, 1991). Powell discusses Johnson's artistic development at length and the artist's "flirtation with images and forms that suggested naïveté." Powell also notes that, "Schooled and dedicated artists like Johnson must have felt a little envious of these self-taught artists such as [Horace] Pippin who, in only a matter of a few years, had several museum and gallery exhibitions to their credit" (p. 138).

6. Dr. Perry's writings include essays in Jane Livingston and John Beardsley, *Black Folk Art in America: 1930-1980* (Jackson: University Press of Mississippi and the Center for the Study of Southern Culture, 1982) and *Black Art—Ancestral Legacy: The African Impulse in African- American Art* (Dallas: Dallas Museum of Art and Harry N. Abrams, 1989).

7. Mary Schmidt Campbell, foreword, in David Driskell and Leslie King Hammond, *Ritual and Myth: A Survey of African American Art* (New York: The Studio Museum in Harlem, 1982), 4.

8. See the catalogue for the exhibition at the Southeastern Center for Contemporary Art, *Next Generation: Southern Black Aesthetic* (Winston-Salem: Southeastern Center for Contemporary Art, 1990).

9. Lizetta LeFalle-Collins, "Between

Traditions," *American Visions* 14 (Winter, 1989): 24–26.

10. Ibid., 24.

11. Dinitia Smith, "Bits, Pieces and a Drive to Turn Them into Art," *The New York Times*, February 5, 1997, C-9

12. For a larger discussion of African-American literary and vernacular visual culture, see Houston A. Baker Jr., *Blues, Ideology, and Afro-American Literature: A Vernacular Theory* (Chicago: University of Chicago Press, 1984), and Richard Powell, et al., *The Blues Aesthetic: Black Culture and Modernism* (Washington, D.C.: Washington Project for the Arts, 1989).

Witnessing: Layered Meanings in Vernacular Art

1. Isaac Watts (1674–1748) was a writer of Protestant hymns and psalms that were very popular across the South.

2. This expression is taken from the poem "We Wear the Mask" by the African-American poet Paul Laurence Dunbar (1872–1906), in which he explores the frequent need of African Americans to play roles for whites that belied their true feelings.

3. I am suggesting here that many Southern-born African Americans absorbed unconsciously, as an aspect of their socialization, African-derived attitudes about a variety of cultural practices including artmaking and uses of art.

4. Several scholars have shed light on African continuities by localizing them within the continual existence of black communities throughout the Americas. Roger Bastide, in *African Civilizations in the New World* (New York: Harper & Row, 1971); Sterling Stuckey in *Slave Culture: Nationalist Theory and the Foundations of Black America* (New York and Oxford: Oxford University Press, 1987); and Sidney W. Mintz and Richard Price in *The Birth of African-American Culture: An Anthropological Perspective* (Boston: Beacon Press, 1976) advance this viewpoint.

5. Marcus Garvey (1887–1940) was a Jamaican-born activist who organized and headed the Universal Negro Improvement Association, which created an African government "in exile," sought to arrange for African Americans to return to Africa, and promoted the idea that all black people were Africans and that Africa was their motherland. His movement was widely influential in the early twentieth century, and he is regarded as one of the fathers of black nationalism.

6. Edmund Barry Gaither, "Heritage Reclaimed: An Historical Perspective and Chronology," in *Black Art: Ancestral Legacy* (Dallas: Dallas Museum of Art, 1989), 17–34.

7. This catalogue, published in 1980 by the University of Mississippi and the Center of the Study of Southern Culture, accompanied an exhibition of the same name mounted by the Corcoran Gallery of Art in Washington, D.C. One of the first exhibitions of black folk art presented by a major American museum, the show featured the work of figures such as Elijah Pierce, Sam Doyle, Sister Gertrude Morgan, and Bill Traylor, all of whom are now recognized as masters in this genre of art.

8. A great deal of effort has been expended searching for an appropriate term to describe works by essentially self-taught artists. *Folk*, *intuitive*, *naïve*, and *primitive* have all been applied at one time or another. Currently, many apply the term *Outsider* art, as described in the essays here by Judith McWillie and Arthur C. Danto. *Vernacular*, which means "common" in the sense of everyday or ordinary usage, accommodates the idea of an untutored, nonacademic production without precluding influences that are modern and easily available through media and publications regardless of one's region or its population density.

9. A very useful discussion of this appears in A. Wyatt MacGaffey, *Astonishment and Power* (Washington, D.C.: Smithsonian Institution Press, 1993).

THE ART AND THE ARTISTS

Witness to History

1. All quotations here come from a conversation with Exhibitions International, August 21, 2000.
2. Purvis Young, quoted in Kathy Moses, *Outsider Art of the South* (Atglen, Pa.: Schiffer Publishing, 1999), 202.
3. Ibid.
4. Purvis Young, quoted in Wendy Steiner, "Purvis Young," in Museum pof American Folk Art, *Self-Taught Artists of the 20th Century* (San Francisco: Chronicle, 1998), 181.
5. Ibid.
6. Charlie Lucas, interviewed in the videotape, "Passionate Visions of the American South: Self-Taught Artists from 1940 to the Present," October 1993, directed by David M. Jones, for WYES-TV, New Orleans, accompanying an exhibition of the same name then at the New Orleans Museum of Art.

Allegorical Animals

7. Thornton Dial Sr., quoted in Amiri Baraka and Thomas McEvilley, *Thornton Dial: Image of the Tiger* (New York: Harry N. Abrams, 1993), 79.
8. Works by Dial's half-brother Arthur, his sons Richard and Thornton Jr., and his nephew Ronald Lockett are reproduced here.
9. Frank Ricco and Richard Maresca, "Thornton Dial," in *American Self-Taught: Paintings and Drawings by Outsider Artists* (New York: Alfred A. Knopf, 1993), 53.
10. Ronald Lockett, quoted in Moses, *Outsider Art of the South*, 169.
11. Ibid., 171.
12. Lee Kogan, "Mose Tolliver: Picture Maker," in Paul Arnett and William Arnett, eds., *Souls Grown Deep: African American Vernacular Art of the South*. Vol. 1: *The Tree Gave the Dove a Leaf* (Atlanta: Still Waters Press, 1999), 1: 330.
13. Ibid., 336.
14. Ibid., 335.
15. Ibid.
16. Mose Tolliver, "'Tree Roots, That's What I Started With,'" in Arnett and Arnett, eds, *Souls Grown Deep*, 1: 356.
17. Ibid.

Biblical Scenes

18. Joe Light, interviewed by Judith McWillie, June 3, 1987.
19. Mary Proctor, quoted in Steve Kistulentz, "Mary Proctor's Vision," *Raw Vision* 29 (December 1999): 34.
20. Ibid., 32. This essay is the fullest source of information on Proctor.
21. William Arnett, communication with Exhibitions International, September 5, 2000.
22. Herbert Singleton Jr., quoted in Moses, "Herbert Singleton, Jr.," in *Outsider Art of the South*, 67.
23. Herbert Singleton Jr., quoted in Andy P. Antippas, "Herbert Singleton: Secular and Sacred," in Arnett and Arnett, eds., *Souls Grown Deep*, 1:216.
24. Ibid., 1:214.
25. Singleton, quoted in Moses, in *Outsider Art of the South*, 69.
26. Arthur Dial, "'A Record of What Went By,'" in Arnett and Arnett, eds., *Souls Grown Deep*, I:374.
27. Ibid. This chapter, based on interviews by William Arnett in 1997, provides the fullest account of Dial's life.

Iconic Human Figures

28. Lonnie Holley, quoted in Museum of American Folk Art, *Self-Taught Artists of the 20th Century: An American Anthology* (San Francisco: Chronicle, 1998), 40–41.
29. Robert Farris Thompson, "The Circle and the Branch: Renascent Kongo-American Art," in *Another Face of the Diamond: Pathways through the Black Atlantic South*, exh. cat. (New York: INTAR Latin American Gallery, 1989), 27.
30. William Arnett, "Archie Byron: Anatomically Correct," in Arnett and Arnett, eds., *Souls Grown Deep*, I:78.
31. T. P. [Tom Patterson], "Archie Byron," in *Pictured in My Mind: Contemporary American Self-Taught Art from the Collection of Dr. Kurt Gitter and Alice Rae Yelen* (Birmingham: Birmingham Museum of Art, 1995), 36.
32. Ibid.

Spiritual and Protective Messages

33. J. B. Murray, interviewed by Judith McWillie, May 28 and 30, 1986.
34. The fullest biographies of Murray are by William Arnett, "John B. Murray: The Handwriting on the Wall," in Arnett and Arnett, eds., *Souls Grown Deep*, 1:465–79; and Mary Padgelek, *In the Hand of the Holy Spirit* (Macon, Ga.: Meneer University Press, 2000).
35. Judith McWillie reports that Murray came to Atlanta to see the exhibition "Outside the Mainstream: Folk Art in Our Time" at the High Museum of Art, 1988, in which he was included: conversation with Exhibitions International, February 20, 2000.
36. See Judith McWillie, *Cultural Perspectives on the American South* (New York: Gordon and Breach, 1991).
37. Arnett, "John B. Murray," in Arnett and Arnett, eds., *Souls Grown Deep*, 1: 479.
38. See Richard Westmacott, *African-American Gardens and Yards in the Rural South* (Knoxville: University of Tennessee Press, 1992); and Grey Gundaker, "Tradition and Innovation in African-American Yards," *African Arts* 26, no. 2 (April 1993): 58–71, 94–131.
39. See Maude Southwell Wahlman, "Africanisms in Afro-American Visionary Arts," in *Baking in the Sun: Visionary Images from the South: Selections from the Collection of Sylvia and Warren Lowe* (Lafayette: University of Southwestern Louisiana, University Art Museum, 1987), 28–43; and Robert Farris Thompson, "The Song that Named the Land: The Visionary Presence of African-American Art," in *Black Art— Ancestral Legacy: The African Impulse in African-American Art* (Dallas: Dallas Museum of Art, 1989), 123–35.
40. See Thompson, "Circle and Branch," 27.
41. Judith McWillie, conversation with Exhibitions International, July 28, 2000.
42. Ralph Griffin, quoted in Judith McWillie, *Even the Deep Things of God: A Quality of Mind in Afro-Atlantic Traditional Art*, exh. cat. (Pittsburgh: Pittsburgh Center for the Arts, 1990), 11.
43. Bessie Harvey, interviewed by Judith McWillie, June 5, 1987.
44. Bessie Harvey, quoted in T. P. [Tom Patterson], "Bessie Harvey," in *Pictured in My Mind*, 86.
45. Bessie Harvey, quoted in Moses, *Outsider Art of the South*, 89.
46. Teresa Parker, "Lonnie Holley," in *Self-Taught Artists of the 20th Century*, 186–89.
47. John Beardsley, *Gardens of Revelation: Environments by Visionary Artists* (New York: Abbeville Press, 1995), 181.
48. Chuck Rosenak and Jan Rosenak, *Museum of American Folk Art Encyclopedia of Twentieth-Century Folk Art and Artists* (New York: Abbeville Press, 1992), 63.
49. Katherine Bell Douglas, "Richard Burnside," in Arnett and Arnett, eds., *Souls Grown Deep*, I:442.

Direct Observation

50. Rosenak and Rosenak, *Museum of American Folk Art*, 295.
51. The most extensive biography of Thomas is William Ferris, "Inside the Jook Joint: Blues and Sculpture in the Life of James Thomas," in Arnett and Arnett, eds., *Souls Grown Deep*, I: 241–52.
52. Ibid., 243–44.
53. Jane Livingston and John Beardsley, *Black Folk Art in America 1930–1980* (Jackson: University Press of Mississippi and the Center for the Study of Southern Culture for The Corcoran Gallery of Art, 1982), 130.
54. Ibid.
55. "Henry Speller," in *Baking in the Sun*, 104.
56. William Arnett, "Henry Speller: Handy Man," in Arnett and Arnett, eds., *Souls Grown Deep*, I: 389.
57. William Arnett, "Henry Speller: Handy Man," in Arnett and Arnett, eds., *Souls Grown Deep*, I:385.
58. Jimmy Lee Sudduth, quoted in Karekin Goekjian and Robert Peacock, *Light of the Spirit: Portraits of Southern Outsider Artists* (Jackson: University Press of Mississippi, 1998), 108.

Selected Bibliography

Adele, Lynne. *Black History/Black Vision: The Visionary Image in Texas.* Austin, Tex.: Archer M. Huntington Art Gallery, University of Texas, 1989.

Alexander, Judith. *Nellie Mae Rowe, Visionary Artist: 1900–1982.* Atlanta: The Southern Arts Federation, 1983.

Another Face of the Diamond: Pathways through the Black Atlantic South. New York: INTAR Latin American Gallery, 1989.

Baker, Houston A., Jr. *Blues, Ideology, and Afro-American Literature: A Vernacular Theory.* Chicago: University of Chicago Press, 1984.

Baking in the Sun: Visionary Images from the South. Lafayette: University Art Museum, University of Southwestern Louisiana, 1987.

Baraka, Amiri [LeRoi Jones], and Thomas McEvilley. *Thornton Dial: Image of the Tiger.* New York: Harry N. Abrams, Inc., 1993.

Bearden, Romare, and Harry Henderson. *A History of African-American Artists.* New York: Pantheon Books, 1993.

Beardsley, John. *Gardens of Revelation: Environments by Visionary Artists.* New York: Abbeville Press, 1995.

Berger, Maurice. *How Art Becomes History: Essays on Art, Society and Culture in Post–New Deal America.* New York: Harper Collins, 1992.

_____. "The Delicate Quest: Paradox in Contemporary African-American Art." In *No Doubt African-American Art of the 90s.* Ridgefield, Conn.: The Aldrich Museum of Contemporary Art, 1996.

_____. *White Lies: Race and the Myths of Whiteness.* New York: Farrar, Straus & Giroux, 1998.

Berger, Maurice, and Johnetta Cole. *Race and Representation: Art, Film, Video.* New York: Hunter College Art Gallery, 1987.

Beyond Reason, Art and Psychosis: Works from the Prinzhorn Collection. London: Hayward Gallery, 1996.

Bill Traylor Drawings, from the Collection of Joseph H. Wilkinson and an Anonymous Chicago Collector. Chicago: Chicago Public Library Cultural Center, 1988.

Bishop, Robert. *Folk Painters of America.* New York: E. P. Dutton, 1979.

_____ and Jacqueline M. Atkins, *Folk Art in American Life.* New York: Viking Studio Books, 1995.

Black Art—Ancestral Legacy: The African Impulse in African-American Art. Dallas, Tex.: Dallas Museum of Art, 1989.

Black History and Artistry. New York: Sidney Mishkin Gallery, Baruch College, City University of New York, 1993.

Bluestein, Gene. *Poplore: Folk and Pop in American Culture.* Amherst, Mass.: University of Massachusetts Press, 1994.

Borum, Jenifer P. "Strategy of the Tiger: The World of Thornton Dial." *Folk Art,* 18, no. 4 (Winter 1993/94): 34–40.

Bowman, Russell, *American Folk Art: The Herbert Waide Hemphill, Jr., Collection.* Milwaukee: Milwaukee Art Museum, 1981.

Bret, Guy. *Through Our Own Eyes: Popular Art and Modern History.* Philadelphia: New Society Publishers, 1986.

Bronner, Simon J., and John Michael Vlach, eds. *Folk Art and Folk Art Worlds.* Ann Arbor: UMI Research Press, 1986.

Cahill, Holger. *American Folk Art: The Art of the Common Man in America, 1750–1900.* New York: The Museum of Modern Art, 1932.

Cardinal, Roger. *Outsider Art.* New York: Praeger, 1972.

_____. *Outsiders.* Westport, Conn.: Praeger, 1979.

_____. *Primitive Painters.* Westport, Conn.: Praeger, 1979.

_____. "The Self in Self-Taught Art." *Art Papers,* 18, no. 5 (September/October 1994): 23–33.

Cerny, Charlene, and Suzanne Seriff, eds. *Recycled, Re-Seen: Folk Art from the Global Scrap Heap.* New York: Harry N. Abrams, Inc., in association with the Museum of International Folk Art, 1996.

Chalmers, F. Graeme. "The Study of Art in a Cultural Context." *Journal of Aesthetics and Art Criticism.* 32 (Winter 1973): 249–55.

Clifford, James. *The Predicament of Culture: Twentieth Century Ethnography, Literature, and Art.* Cambridge, Mass.: Harvard University Press, 1988.

Common Ground/Uncommon Vision. The Michael and Julie Hall Collection of American Folk Art. Milwaukee: Milwaukee Art Museum, 1993.

Cone, James H. *The Spirituals and the Blues: An Interpretation.* New York: Orbis Books, 1991.

Contemporary American Folk, Naïve, and Outsider Art: Into the Mainstream? Oxford, Ohio: Miami University Art Museum, 1990.

Conwill, Kinshasha Holman. "In Search of An 'Authentic Vision.'" *American Art,* 5, no. 4 (Fall 1991): 2–9.

Danto, Arthur. *The Transfiguration of the Common Place.* Cambridge, Mass.: Harvard University Press, 1981.

Davis, Gerald L. "What Are African American Folk Arts? The Importance of Presenting, Preserving, and Promoting African American Aesthetic Traditions." In *The Arts of Black Folk,* ed. Deirdre L. Bibby and Diana Baird N'Diaye. New York: The Schomburg Center for Research in Black Culture, The New York Public Library/Astor, Lenox, and Tilden Foundations, 1991.

Dewhurst, C. Kurt. *Religious Folk Art in America.* New York: E. P. Dutton, 1993.

Driskell, David C., ed. *African American Visual Aesthetics: A Postmodernist View.* Washington, D.C.: Smithsonian Institution Press, 1995.

Fagaly, William A. "Sister Gertrude Morgan." In *Louisiana Folk Paintings.* New York: Museum of American Folk Art, 1973.

Farber, Sam, Simon Carr, and Allen S. Weiss. *Portraits from the Outside: Figurative Expression in Outsider Art.* New York: Groegfeax Publishing in association with The Parsons School of Design Gallery, 1990.

Ferguson, Russell, et al., eds. *Out There: Marginalization and Contemporary Cultures.* Cambridge: MIT Press in association with The

New Museum of Contemporary Art, 1990.

Ferris, William. *Local Color: A Sense of Place in Folk Art.* New York: McGraw-Hill, 1982.

Ferris, William R., Jr., ed. *Afro-American Folk Art and Crafts.* Jackson: University Press of Mississippi, 1983.

Fineberg, Jonathan. *Art Since 1940: Strategies of Being.* New York: Harry N. Abrams, Inc., 1995.

The Four Moments of the Sun: Kongo Art in Two Worlds. Washington, D.C.: The National Gallery of Art, 1981.

Fuller, Edmund L. *Visions in Stone: The Sculpture of William Edmondson.* Pittsburgh, Pa.: University of Pittsburgh Press, 1973.

Gates, Henry Louis, Jr. *The Signifying Monkey: A Theory of Afro-American Literary Criticism.* New York: Oxford University Press, 1988.

Gaver, Eleanor E. "Inside the Outsiders." *Art and Antiques.* (Summer, 1990): 72–86 and 159–61.

Gilman, Sander. *Madness and Representation: Hans Prinzhorn's Study of Madness and Art in Its Historical Context.* Urbana: University of Illinois Press, 1984.

Goldin, Amy. "Problems in Folk Art." *Artforum* 14, no. 10 (June 1976): 48–52.

Gruber, J. Richard. *The Dot Man: George Andrews of Madison, Georgia.* Augusta, Ga.: Morris Museum, 1994.

Gundaker, Grey. *Signs of Diaspora; Diaspora of Signs.* Oxford: Oxford University Press, 1998.

Harper, Paula. *Purvis Young.* Miami: Joy Moos Gallery, 1993.

Hartigan, Lynda Roscoe. "Recent Challenges in the Study of African-American Folk Art." *The International Review of African-American Art* 2, no. 3 (1993): 27–29, 60–63.

_____. *Made with Passion: The Hemphill Folk Art Collection.* Washington, D.C., and London: Smithsonian Institution Press, 1990.

Hemphill, Herbert W., Jr., and Julia Weissman. *Twentieth-Century American Folk Art and Artists.* New York: E. P. Dutton, 1974.

hooks, bell. "Postmodern Blackness." In *Yearning, Race, Gender, and Cultural Politics.* Boston: South End Press, 1990.

In/Outsiders from the American South. Montgomery, Ala.: Montgomery Museum of Fine Arts, 1992.

Kahan, Mitchell D. *Mose Tolliver.* Montgomery, Ala.: Montgomery Museum of Fine Arts, 1981.

Karp, Ivan, and Steven D. Levine, eds. *Exhibiting Cultures: The Poetics and Politics of Museum Display.* Washington, D.C.: Smithsonian Institution Press, 1991.

Kemp, Kathy, with photographs by Keith Boyer. *Revelations: Alabama's Visionary Folk Artists.* Birmingham: Crane Hill Publishers, 1994.

Kraskin, Sandra. *Black History and Artistry: Works by Self-Taught Painters and Sculptors from the Blanchard-Hill Collection.* New York: Sidney Mishkin Gallery, Baruch College, City University of New York, 1993.

Kuspit, Donald B. "The Appropriation of Marginal Art in the 1980s." *American Art* (Winter/Spring 1991): 134.

Lampell, Ramona, et al. *O'Appalachia.* New York: Stewart, Tabori &

Chang, 1989.

Lipman, Jean. *Provocative Parallels: Naïve Early American/International Sophisticates.* New York: E. P. Dutton, 1975.

Lipman, Jean, Robert Bishop, Elizabeth V. Warren, and Sharon L. Eisenstat. *Five Star Folk Art: One Hundred American Masterpieces.* New York: Harry N. Abrams, Inc., in association with the Museum of American Folk Art, 1990.

Lippard, Lucy. "Crossing into Uncommon Grounds." In *The Artist Outsider: Creativity and the Boundaries of Culture,* ed. Eugene W. Metcalf and Michael D. Hall. Washington, D.C.: Smithsonian Institution Press, 1994.

_____. *Mixed Blessings: New Art in a Multi-Cultural America.* New York: Pantheon Books, 1990.

Lipsey, Roger. *An Art of Our Own: The Spiritual in Twentieth Century Art.* Boston: Shambhala Publications Inc., 1988.

Livingston, Jane, and John Beardsley. *Black Folk Art in America, 1930–1980.* Jackson, Miss.: University Press of Mississippi and the Center for the Study of Southern Culture for the Corcoran Gallery of Art, 1982.

"Lonnie Holley's Moves." *Artforum International.* (April 1992): 80–84.

MacGregor, John M. *The Discovery of the Art of the Insane.* Princeton: Princeton University Press, 1989.

Maizels, John. *Raw Creation: Outsider Art and Beyond.* London: Phaidon Press, 1996.

Manley, Roger. "Separating the Folk from Their Art." *New Art Examiner* 19, no. 1 (September 1991): 25–28.

_____. *Signs and Wonders: Outsider Art Inside North Carolina.* Raleigh: North Carolina Museum of Art, 1989.

Maresca, Frank, and Roger Ricco. *American Self-Taught: Paintings and Drawings by Outsider Artists.* New York: Alfred A. Knopf, 1993.

McElroy, Guy C., et al. *African-American Artists 1880-1987: Selections from the Evans-Tibbs Collection.* Seattle: University of Washington Press in association with the Smithsonian Institution Traveling Exhibition Service, 1989.

McEvilley, Thomas. "The Missing Tradition." *Art in America* (May 1997): 78–85, 137.

McKesson, Malcolm. *MATRIARCHY: Freedom in Bondage.* Heck Editions, 1997.

McWillie, Judith M. "Writing in an Unknown Tongue." In *Cultural Perspectives on the American South* 5. New York: Gordon and Breach, 1991.

Metcalf, Eugene W. "Black Art, Folk Art, and Social Control." *Winterthur Portfolio* 18, no. 4 (Winter 1983): 271–89.

_____. "Modernism, Edith Halpert, Holger Cahill, and the Fine Art Meaning of American Folk Art." In *Folk Roots, New Roots: Folklore in American Life,* ed. Jane S. Becker and Barbara Franco. Lexington, Mass.: Museum of Our National Heritage, 1988.

Metcalf, Eugene W., and Michael Hall. *The Ties that Bind: Folk Art in Contemporary American Culture.* Cincinnati: Contemporary Arts Center, 1986.

_____, eds. *The Artist Outsider: Creativity and the Boundaries of Culture.*

Washington, D.C., and London: Smithsonian Institution Press, 1994.

Meyer, George. *American Folk Art Canes.* New York: Museum of American Folk Art, 1992.

Miele, Frank J., ed. "Folk or Art? A Symposium." *The Magazine Antiques* 135, no. 1 (1989): 272–87.

Naïves and Visionaries. New York: E. P. Dutton in association with the Walker Art Center, 1974.

Nickens, Bessie. *Walking the Log: Memories of a Southern Childhood.* New York: Rizzoli International Publications, 1994.

Not By Luck: Self-Taught Artists in the American South. Lynne Ingram Southern Folk Art, 1993.

Outsider Artists in Alabama. Alabama State Council on the Arts, 1991.

The Passionate Eye: Florida Self-Taught Art. Orlando, Fla.: Terrace Gallery, Orlando City Hall, Orlando Public Art Advisory Board, 1994.

Patterson, Tom. *Southern Visionary Folk Artists.* Winston-Salem, N.C.: The Jargon Society, 1984.

_____. *Ashe: Improvisation and Recycling in African-American Visionary Art.* Winston-Salem, N.C.: Diggs Gallery, Winston-Salem State University, 1993.

Patton, Phil. *Bill Traylor: High Singing Blue.* New York and Chicago: Hirschl & Adler Modern and Carl Hammer Gallery, 1997.

Pictured in My Mind, Contemporary American Self-Taught Art from the Collection of Dr. Kurt Gitter and Alice Rae Yelen. Jackson, Miss.: University of Mississippi Press, for the Birmingham Museum of Art. 1995.

Powell, Richard J. *The Blues Aesthetic: Black Culture and Modernism.* Washington, D.C.: Washington Project for the Arts, 1989.

Prince, Dan. *Passing in the Outsider Lane.* Journey Editions, 1995.

Quimby, Ian M. G., and Scott T. Swank, eds., *Perspectives on American Folk Art.* New York: W. W. Norton, 1980.

Revelations: Alabama's Visionary Folk Artists. New York: Crown Hill Publishers, 1994.

Rosenak, Chuck, and Jan Rosenak. *Contemporary American Folk Art: A Collector's Guide.* New York: Abbeville Press, 1996.

_____. *Museum of American Folk Art Encyclopedia of Twentieth-Century American Folk Art and Artists.* New York: Abbeville Press, 1992.

Schjeldahl, Peter. "On the Wild Side." *The Village Voice* 42, no. 6 (February 11, 1997)

Signs and Wonders: Outsider Art Inside North Carolina. Raleigh, N.C.: North Carolina Museum of Art, 1989.

Sims, Lowery Stokes. "The Self-Taught Among Us: William Edmondson and the Vanguardist Dilemma." In *The Art of William Edmondson,* ed. Rusty Freeman, Jackson, Miss.: The University Press of Mississippi, 2000.

Sticks: Historical and Contemporary Canes. Kentucky Arts and Crafts Gallery, 1988.

Storr, Robert. "Between a Rock and a Hard Place." Paper no. 3 (August 15, 1994). The Andy Warhol Foundation, Pittsburgh, Pa. Posted on the World Wide Web at http://www.warholfoundation.org/article3.html.

Szombati-Fabian, James and Olona. "Folk Art from an Anthropological Perspective." In *Perspectives on Folk Art,* ed. Ian M. C. Quimby and Scott T. Swank. New York: W. W. Norton, 1980.

Thompson, Robert Farris. *Flash of the Spirit: African and Afro-American Art and Philosophy.* New York: Random House, 1983.

Thornton Dial, Sr.: Strategy of the World. Jamaica, New York: South Queens Park Association, 1990.

"Traditions and Transformations: Vernacular Art from the Afro Atlantic South." In *Dixie Debates,* ed. Richard H. King and Helen Taylor. London: Pluto Press, 1996.

Tuchman, Maurice, and Carol S. Eliel. *Parallel Visions: Modern Artists and Outsider Art.* Princeton and Los Angeles: Princeton University Press for the Los Angeles County Museum of Art, 1992.

Tuchscherer, Konrad. "The Lost Script of the Bagam." *African Affairs: The Journal of the Royal African Society* 98, no. 390 (January 1999).

Tully, Jed. "Outside, Inside, or Somewhere In-between." *ARTnews* (May, 1996): 119.

Volkersz, Willem. *Word and Image in American Folk Art.* Kansas City, Mo.: Mid-America Arts Alliance, 1986.

Weld, Allison. *Dream Singers, Story Tellers: An African-American Presence.* Fukui, Japan, and Trenton, New Jersey: Yoshida Kinbundo Co., Fukui Fine Arts Museum, and New Jersey State Museum, 1992.

Westmacott, Richard. *African-American Gardens and Yards in the Rural South.* Knoxville, Tenn.: University of Tennessee Press, 1992.

What It Is: Black American Folk Art from the Collection of Regenia Perry. Virginia Commonwealth University, 1982.

William Edmondson: A Retrospective. Nashville, Tenn.: Southern Arts Federation for the Tennessee State Museum, 1981.

Wilson, James L. *Clementine Hunter: American Folk Artist.* New York: Pelican, 1988.

Wilson, Sarah. "From the Asylum to the Museum: Marginal Art in Paris and New York 1938–68." In *Parallel Visions: Modern Artists and Outsider Art.* Princeton and Los Angeles: Princeton University Press for the Los Angeles County Museum of Art, 1992.

Yelen, Alice Rae, *Passionate Visions of the American South: Self-Taught Artists from 1940 to the Present.* Jackson: University Press of Mississippi for the New Orleans Museum of Art, 1993.

Index

Page references in *italics* refer to illustrations.

Abstract Expressionism, 48–49
Adam and Eve, 70–73
Adam and Eve (Arthur Dial), 65, 70, 134
Adam and Eve (Lockett), 68, 70–71
Adam and Eve (Virgous), 133
Adkins, Terry, 58, 60
Alechinsky, Pierre, 28, 29
Almon, Leroy, 78, 94, 94, 95, 139
Alone in the Jungle: One Man Sees the Tiger Cat (Thornton Dial Sr.), 100, 108–09
Andrews, Benny, 11
animals, allegorical, 106–25
Anthropomorphic Infant Form with Tutu in Stroller (Lucero), 29
Appel, Karel, 11, 21, 21, 32
appropriated images, 20–21
Arnett, William, 45–47, 96, 114, 118, 128, 156
Art Brut, 12, 13, 17, 156
Assassinations (Almon), 78, 94, 95
Avenue, The (Tobey), 16

Bad Picture (Diana's Last Ride) (Thornton Dial Sr.), 31, 32, 34
Baluba III (Tinguely), 25, 28
Barr, Alfred, 21–24, 25
Basquiat, Jean-Michel, 8, 11, 12
Bear (Marden), 17
Bearden, Romare, 57, 74
Beavers Dam the River and the Tigers Go Across, The (Thornton Dial Sr.), 107
Best Mountain (Light), 120, 121
biblical scenes, 67–73, 126–41
Big Black Bowl of Life, The (Thornton Dial Sr.), 88
Big Mama (Holley), 146
Biggers, John, 17
Bilhuber, Jeffrey, 45
biographies, artists', 50–52
Birch, Willie, 58, 58, 61

Black Madonna, The (Almon), 139
Black Mountain School, 38
Black Woman (Thomas), 172, 173
Bloom, Harold, 37, 47
Blue Willow Plate (Proctor), 128, 129
Bolden, Hawkins, 28, 44, 44, 45, 46, 49, 52, 58, 73–74, 158, 158, 159
Book of the 7 Dispensation by St. James, The (Hampton), 18
Booker, Chakaia, 39, 40
Bottle Rack (Duchamp), 24, 36
Bouabré, Frédéric Bruly, 17, 18
Brown, Roger, 54
Buchanan, Beverly, 57, 58, 58, 60
Bull's Head (Picasso), 36, 36–37, 38
Burnside, Richard, 70, 73, 168, 168, 169
Byron, Archie, 8, 73, 92, 152, 152, 153

Cage, John, 38, 39
Cal Arts, 38
Campbell, Mary Schmidt, 57
Cardinal, Roger, 12
Carr, Simon, 14–16
Cassou, Jean, 38
Cat (Thornton Dial Jr.), 125
Chagall, Marc, 35
Chaissac, Gaston, 17, 19
Children of the World Reaching Out (Lucas), 60, 102, 103
Christo, 44
Cimabue, 48
Clark, Stephen C., 24
Clinton Blows His Horn (Thornton Dial Sr.), 104
Coal Mine, The (Thornton Dial Sr.), 10, 11, 29
CoBrA artists, 11, 168. *See also* specific artists
Cole, Thomas, 43–44
Colescott, Robert, 19
Collage with Trucks (Young), 98, 99
Comfort of Prayer, The (Richard Dial), 166, 167
Conner, Bruce, 24, 28
Corcoran Gallery of Art, 12–13, 56–57, 118

Cropsey, Jasper, 43–44
Crucifixion (Arthur Dial), 135
Crucifixion (Thornton Dial, Jr.), 100, 127
Cutting Medication Short (Holley), 93

Dahomey appliqué, 71, 73
Dalí, Salvador, 35
Darger, Henry, 17, 20
Death and the Maiden (Alechinsky), 28
Deep Sea Water Turtle (Tolliver), 118, 181
Deer Can See Everything, The (Lockett), 117
de Kooning, Willem, 37
Devil's Home in the United States (Georgia Speller), 86
Dial, Arthur, 8, 65, 70, 72, 73, 134, 134, 135
Dial, Richard, 8, 166, 166, 167
Dial, Thornton, Jr., 8, 74, 76, 100, 100, 101, 125, 127
Dial, Thornton, Sr., 8, 10, 11–12, 17, 18, 23, 25, 28–29, 30–41, 31, 34, 47, 48, 49, 53, 56, 57, 59, 60, 62–63, 67, 78, 79, 80, 81, 82–83, 87, 88, 89, 100, 104, 106, 107, 108–09, 110, 110, 111, 112, 113, 114, 122, 134, 148, 151, 166
direct observation, 170–82
Don't Go Crossing My Fence (Holley), 165
Dubuffet, Jean, 8, 12, 13, 18–19, 21, 21, 156
Duchamp, Marcel, 24, 28, 36, 42
Duck (Sudduth), 178, 179

Eakins, Thomas, 48
Edmondson, William, 24
Edwards, Melvin, 54, 57, 58–59, 61
Evans, Minnie, 57
Everybody Got a Right to the Tree of Life (Thornton Dial Sr.), 60, 62–63

Family Pain (Byron), 73, 152, 153
Ferris Wheel (Sudduth), 178, 180
Ferris, William, 172

Fighting at the Foundation of the Cross (Holley), 26, 28, 60
Fischl, Eric, 38, 39
Fishing for Business (Thornton Dial Sr.), 80
Fishing for Love (Thornton Dial Sr.), 80
Flying Angel, The (Young), 138
Frank Owen's Blue Shack (Buchanan), 58, 58
Freedom Bird in the United States (Thornton Dial Sr.), 112

Garden of Eden (Lockett), 69, 71
Gates, Henry Louis, 56
Geertz, Clifford, 47
Giotto di Bondone, 48
God Created Man in His Own Image (Lockett), 140
Greenberg, Clement, 19, 25, 33
Griffin, Ralph, 74–78, 77, 123, 152, 156, 160, 160, 161
Grooms, Red, 38
Gundaker, Grey, 17

Hacklin, Allan, 38
Haitian voodoo flag, 73, 75
Hammons, David, 25, 28, 40
Hampton, James, 16–17, 18
Harvey, Bessie, 8, 74, 78, 122, 152, 160, 163
Hassinger, Maren, 54
Hello to Y'all (Smith), 143
Herrison (Duchamp), 24, 36
Hirshfield, Morris, 24
history, witness to, 84–105
Hogue, Sam, 44–45, 47, 48
Holley, Lonnie, 8, 17, 23, 25, 26, 28, 45, 49, 49, 50, 51, 52–53, 53, 56, 57, 58, 60, 93, 96, 132, 142, 146, 158, 164, 164, 165, 182
Homeless (Byron), 92
Homeless People (Lockett), 91, 114
homme du commun ideas, 21
House for My Father, A (Birch), 58, 58
Houston, Edward, 44
human figures, iconic, 142–53

I Had a Dream, a Dream About

Heavy Burdens (Thornton Dial Sr.), *89*
iconic human figures, 142–53
identity politics, 40–41
Indigo Mercy (Saar), 58, *60*
It's So Hard to Be Green (Booker), *39*

Jesus as a Child (Scott), *137*
Johnson, William H., 56
Julio (Thornton Dial Sr.), *122*

Kaprow, Alan, 40
Key, The (Pollock), *13*
Kimmelman, Michael, 50–51
King of Africa (Thornton Dial Jr.), 74, *76*, 100
Kopytoff, Igor, 42
Kraskin, Sandra, 14, 47, 48

Lady Holds the Bird (Thornton Dial Sr.), *113*
Lady Wondering About the Long Neck Goose (Thornton Dial Sr.), *112*
Large Banner Portrait: Jules Supervielle (Dubuffet), *21*
Laughing Magic (Hammons), *25*
Lawrence, Jacob, 11, 24
LeFalle-Collins, Lizetta, 59–60
Light, Joe, 45, 49, 74, 120, *120*, *121*, 126, *132*, *140*
Lippard, Lucy, 13
Livingston, Jane, 67
Lockard, Jon Oyne, 74
Lockett, Ronald, 8, 29, 49, 53, *68*, *69*, 70–71, 73, *85*, 91, *105*, 110, 114, *114*, *115*, *140*, *149*
Long Faced Lady in New York City (Thornton Dial Sr.), 78, *81*
Los Angeles County Museum of Art, 12
Lucas, Charlie, 56, 60, 67, *102*, *102*, *103*, 110
Lucero, Michael, 28–29, *29*

Makonde figures, *78*
Man Who Tried to Comfort Everybody, The (Richard Dial), 166, *167*

Manet, Edouard, 19
Mangold, Robert, 38
Marden, Brice, 16, *17*
McEvilley, Thomas, 18
Medicine Man (Griffin), 74–78, *77*, 160
Metcalf, Eugene W., Jr., 12, 14
Miller, Ivor, 17
Milone, Joe, 24
Minter, Joe, 96, *96*, 97
Miracle of Jesus, The (Singleton), *130*, *131*
Mississippi Burning (Thornton Dial Jr.), 100, *101*
modernism, 19–20, 24, 37
Morgan, Sister Gertrude, 56
Moses and the Ten Commandments (Thornton Dial Jr.), *141*
Moses, Grandma, 33
Motherwell, Robert, 38
Murray, John Bunyan ("J. B."), 8, 12, *15*, 16, 17, 29, 154, *155*, 156, *156*, *157*
Museum of American Folk Art, 13, 51
Museum of Modern Art, 20, 21–24
music, 33–35, 38–39, 64
Music Man in the Country (Georgia Speller), *177*

naïve art, 37
National Museum of American Art, 13, 17
Neshat, Sharin, 40–41
News, The (Thornton Dial Sr.), 59, 60
Next Generation: Southern Black Aesthetic exhibition, 52, 58
Not as Much as Grandmother's Pain (Holley), *182*
Nova Scotia College of Art and Design, 39

Outsider Art Fair, 12, 14, 17
Outsider movement, 12–14, 17–19, 30–41, 50–51, 52

Parsons School of Design, 12, 14–16

People at Church (Sudduth), 178, *179*
Perry, Dr. Reginia, 57
Personnages (Chaissac), *19*
Picasso, Pablo, 17, 32, *36*, 36–37, 38, 40, 47, 48, 49, 60
Pierce, Elijah, 56, 94
Pierce, Sister Gertrude, 57
Pindell, Howardena, 54
Pippin, Horace, 57
Pollock, Jackson, 8, 11, *13*, *28*, 29, 32, 33, 51, 156
postmodernism, 20–21, 48
Powers, Harriet, 57
Pregnant Lady (Lockett), *149*
Prehistoric Bird (Harvey), 74, *122*
primitive art, 37
Proctor, Mary, 126, 128, *128*, *129*
Prophet, The (Harvey), 74
protective messages, 154–69
Proud Family (Thornton Dial Sr.), *111*

Questioning Children (Appel), *21*

Ramirez, Martin, 12
Rauschenberg, Robert, 17, 28, 32, 37
Remembrance of a Princess (Lockett), *105*
Ringgold, Faith, *55*, 58, 59, 61
Road to the Spirit (Holley), *165*
Rockwell, Norman, 33, 38
Rolling Mill: Steel is the Master, Lady is the Power (Thornton Dial Sr.), *89*
Rothenberg, Susan, 61
Rowe, Nellie Mae, 51, 56, 57, 118, 158
Ryman, Robert, 19

Saar, Betye, 57, 58, *60*
Saussure, Ferdinand de, 30
Scarecrow (Bolden), *46*, 73–74
Schjeldahl, Peter, 14, 17
Schnabel, Julian, 29
Schwitters, Kurt, 60
Scott, Joyce, 57, 61
Scott, Lorenzo, 8, *136*, *136*, *137*
Self-portrait (Tolliver), *146*

Self-portrait with Reindeer (Sudduth), *147*
"self-taught," 43
Senorita (Conner), *24*
Sheba (Light), 74, *140*
Shimmering Substance (Pollock), *28*
Shipyard (Minter), *97*
Sims, Lowery Stokes, 12, 17
Singleton, Herbert, Jr., 130, *130*, *131*
Sitting and Waiting—The Man Needs (Thornton Dial Sr.), *87*
Smith, David, 110
Smith, Mary Tillman, 17, 18, 19, 21, *22*, 49, 52, 118, 142, *143*, 144, *144*, *145*
Smoke-Filled Sky (Lockett), *85*, 114
Southeastern Center for Contemporary Art (SECCA), 52, 58
Soutine, Chaim, 40
Soutter, Louis, 13
Spangled Blengins, Boy King Islands: One is a Young Tuskerhorian, the Other a Human Headed Dortherean (Darger), *20*
Speller, Georgia, 8, *86*, 174, 176, *176*, 177
Speller, Henry, 8, *171*, 174, *174*, *175*
Spirit of Grand Central Station— The Man that Helped the Handicapped (Thornton Dial Sr.), *148*
spiritual messages, 154–69
Squirrel (Thomas), *172*
Stick Figures at Goodbread Alley (Young), 98, *150*
Stone Walls (Diana's Land) (Thornton Dial Sr.), 32, *34*, 35–36
Storr, Robert, 21–24
Studio Museum, 56, 57
Sudduth, Jimmy Lee, 56, 61, 78–79, *147*, 170, 178, *178*, *179*
Support for the Works (Thornton Dial, Sr.), 82–83
Swords and Shields and Odds and Ends (Burnside), 70, 73, 168, *169*

Taking Care of Old Things (Honoring Lonnie Holley) (Thornton Dial Sr.), 23, *25*

Tanner, Henry, 48
Tar Beach (Ringgold), 55, 58
Thomas, James "Son," 56–57, 172, *172, 173*
Thompson, Robert Farris, 17, 144, 158
Throne of the Third Heaven of the Nations Millennium General Assembly, The (Hampton), 16–17
Tiger on Top (Thornton Dial Sr.), *113*
Tinguely, Jean, 25, 28, 32
Tobey, Mark, 16, *16*
Tolliver, Mose, 49, 52, 53, 56–57, 78–79, 118, *118*, 119, 146, 181
Top of the Line (Thornton Dial Sr.), *151*
Train (Henry Speller), *175*
Traps (Lockett), 114, *116*
Traylor, Bill, 40, 56, 57
Tuchscherer, Konrad, 17
Tully, Jed, 14
Two Ladies Dressed Up (Henry Speller), *171*
Two Quail Birds, Two French Birds, Two Love Birds with a Feed Basket (Tolliver), 118, *119*
Twombly, Cy, 8, 16, 17, 37–38, 60

Undiscovered (Lockett), *115*
Untitled (Bolden), *159*
Untitled (Bouabré), *18*
Untitled (Griffin), *123*
Untitled (Hogue), *48*
Untitled (Holley), *51*
Untitled (Lockett), *117*
Untitled (Smith), *22, 145*
Untitled (Murray), *15, 155, 157*
Untitled (Twombly), *17*
Untitled (Young), *27, 150*

van Gogh, Vincent, 12, 51
Venus de Gaz (Picasso), 36
"vernacular," 44
Virgous, Felix "Harry," 132, *132, 133*
Vogel, Susan, 40
voodoo flag, Haitian, 73

Ward, Nari, 60
Warhol, Andy, 35
Welfare Office (Arthur Dial), 72, 73, 134
Whitney Biennials, 30, 32, 33
Wild Horses (Young), 61, 98, 124
witnessing, 64–79
Wizard, The (Griffin), 160, *161*
Wölfli, Adolf, 13
Working Thought (Edwards), 58–59, *61*
Wyeth, Andrew, 33

yard art, 44, 44–45, *45, 47, 50,* 96, 102, *102,* 120, *120,* 144, 158, *159,* 176
You Can See It in the Street (Homeless People in New York) (Thornton Dial Sr.), 90
Young, La Monte, 39
Young, Purvis, 8, 27, 29, 53, 60–61, 98, *98,* 99, 124, 138, 150

Zuna and Zeb (Harvey), *163*

Photograph Credits